LACHLAN PHILPOTT PLAYS

Lachlan Philpott

PLAYS ONE

M. Rock — The Trouble with Harry — Little Emperors

OBERON BOOKS
LONDON

WWW.OBERONBOOKS.COM

This collection first published in 2018 by Oberon Books Ltd
521 Caledonian Road, London N7 9RH
Tel: +44 (0) 20 7607 3637 / Fax: +44 (0) 20 7607 3629
e-mail: info@oberonbooks.com
www.oberonbooks.com

A catalogue record for this book is available from the British
Library.

PB ISBN: 9781786824172
E ISBN: 9781786824189

Cover image: Sarah Walker

eBook conversion by Lapiz Digital Services, India.

Visit www.oberonbooks.com to read more about all our books and to buy them. You
will also find features, author interviews and news of any author events, and you can
sign up for e-newsletters so that you're always first to hear about our new releases.

10 9 8 7 6 5 4 3 2 1

Contents

*For Tanika Gupta. The best and most inspiring mate you could find.
And for Rossica who was there for me cheering me on through it all.*

Introduction by Tim Byrne

I first encountered Lachlan Philpott's work at the Northcote Town Hall as part of the 2014 Melbourne International Arts Festival, where *The Trouble with Harry* had its Australian premiere. It took me only a short time to realise I was in the presence of a major playwright; the rhetorical skill, one that could employ sophisticated poetic devices in the service of a driving momentum, was matched to an epic, enlightening vision of the past. As the play progressed, in the grip of a director and a cast completely in control of the tonal and rhythmic demands of the piece, something more important was revealed: here was an engagement with an unlocked queer Australian identity so necessary and immediate, in a language convincingly archaic yet vital and familiar, it felt genuinely revisionist. It's not often Australian theatre ruffles the rusted mythologies of our past, that makes such a confident case for the medium as vital contributor to our national identity, and I knew then I was hooked.

Philpott's *Harry* didn't burst unseeded from the zeitgeist, nor did it arrive unheralded from the mind of the playwright. So much that makes the play great is evidenced in his previous, and indeed subsequent, work. There's the approach to language, alternately novelistic and symphonic, where imagery and musicality are as important as characterisation or plot; there's the complex use of symbolism and metaphor, woven in a series of interconnected leitmotifs; there's the fearless engagement with grand themes and boldly ambitious milieux. There's some debate over whether or not Philpott can or indeed should be categorised as a 'queer playwright', in much the same way Christos Tsiolkas has struggled with the moniker of 'queer novelist'. It's true to say he engages primarily, but certainly not exclusively, with issues of sexuality and gender, that he uses a 'queer' lens in which to refract larger questions of identity and connection. There's something of the anthropologist about him; his true interest is in social groups, and the individual's place within them.

The three plays in this volume are indicative of Philpott's talent, but they are also distinct enough to give a sense of his scope. If *Harry* is the most significant – and given its achievements of depth and scale, it's one of the most significant Australian plays of the new century – then *Little Emperors* and *M. Rock* are perfect reminders

of the myriad directions the playwright may take us in future. They diverge stylistically but they share a common impulse: to interrogate the very idea of familial bonds, and the strains they place on individual identity. This isn't particular to these three Philpott plays; *Colder* places the tenuous parental dynamic at the centre of its drama, and *promiscuous/cities* is all about the ways we form family structures in the absence of the real thing.

M. Rock is concerned with family in a direct lineal sense, in the ways we pass on and inherit the expectations and preconceptions of our parents and children. Tracey is lost in a way that strikes us as entirely natural for a young woman her age, but her mother Kerry and grandmother Mabel are lost in more profound or problematic ways. Even within the dream-like reality of the play – with its loopy, echoing repetitions and insistent musical interludes that function like semi-conscious mnemonics, the piece takes on something of the *Traumnovelle* – Mabel's journey is comically farfetched. It isn't necessary that we *believe* in her experiences; it's enough that we merely conceive them as possible. It's the possibility that jars us out of our prejudice, our inferred ageism, and also links the worlds of the play. Tracey's clubs become Mabel's, her streets and her people become Mabel's, in ways that may seem unlikely but ultimately point us to a simple universal truth: we've all had grandmothers and we've all been young once, and somewhere in the middle, these realities converge.

Little Emperors is bolder and its subject matter more ambitious. It takes what Mei Fong refers to in her book *One Child* [2016] as 'the world's most radical social experiment' and strips it of its political, sociological and economic justifications, laying bare the emotional impact China's one-child policy has had on families around the world. In collaboration with Chong Wang and Mark Pritchard, Philpott examines the fraught relationship Kaiwen has with his sister Huishan and his mother Baohua. They live thousands of kilometres apart; he in Melbourne, where he operates clandestinely as a gay man and as an actor/director (it's not clear which is the more revolutionary); they in Beijing, where they bicker and wrestle with familial expectation. This is a family with a very specific cultural pressure, and yet the playwright is at pains to show the characters' desperate

need for an individuality that can transcend national constructs. Whether they do or not – and the play script diverges in this regard from the original performance at Malthouse Theatre – is less important than the fact that they try. Again, we're dealing with aspiration rather than actualisation, and the space that families can meter out to each other when they're willing to compromise.

The Trouble with Harry is the tragedy to these two comedies of manners, although Philpott's works rarely fit neat categorisation. This family is completely incapable of 'queering the space', so alarmed that the concept of the other might infiltrate their domestic prison that they banish the thought of it altogether. Annie, the wife and victim of this fatal disconnect, says of her domestic situation that it is 'bound together with anything we can find to keep it tight but it's all coming loose – getting ready to fall apart.' This is true of all the family situations in Philpott's plays, but here it feels frightening and insurmountable. The terminology that might be needed to explain Harry's situation hasn't been invented yet, and that reaching for words no one knows how to speak underscores the entire play.

To this end, the choric device of the Man and Woman, prurience personified and therefore the perfect snoops, not only structures the play but gives it its engine and impulse. It's also where the anthropology steps in: these voices of the people, the neighbours and acquaintances of Harry and Annie, bring to life the 'dreary, dun-coloured offspring' of an Australian society utterly antipathetic to difference, to appropriate Patrick White. In this watchful world, where 'curtains gape open' and 'Old Mrs Bone's tongue clatters away like a tram', the likes of Crawford and Birkett haven't got a chance, and the cracking of the brittle artifice is as brutal as it is inevitable.

The actual crime that brought Eugenia Falleni into the public eye is here treated rather discreetly, functioning ostensibly as the climax but feeling more like a denouement. It's in stark contrast to the way the 'crime of passion' is handled in Georg Büchner's *Woyzeck*, for example. That play takes a febrile interest in the psychological breakdown of the protagonist, not to mention an almost fetishistic approach to the murder, but

Philpott keeps Harry's torment subjugated throughout and only hints at the violence that defined the character in real life. The trial itself, which held the rapt attention of the public at the time, occurs outside the frame of the play. It's a deliberate decision to turn away from the salacious and the lurid, and the closest to a political statement the play makes. The villain of the piece isn't an individual, or a particular group, or even a moral position; it's a cultural weight, pressing on the hearts of its characters. That weight isn't named. We as a contemporary audience are left to name it, but even as we reach for terms like homophobia, xenophobia and misogyny, we don't quite hit at the play's central concern. Philpott teases us with versions of the truth, and then walks away from all attempts at an answer. *Harry* is a truly 'queer' play, in that sense. It embraces and champions the very idea of the outsider, of the impossibility of synthesising a queer identity with the mainstream norm. Harry's tragedy is that he tried, but Eugenia's triumph is that she pulled it off, albeit for a short time. At the very end of the play the Man says, 'They find him', and the Woman says, 'They get her'. This suggests that any clunking, binary understanding of gender belongs solely to the dominant culture, and that something vital about Harry/Eugenia, something beautiful and worthwhile, slips through the grasp of that culture just as it feels most in control of the narrative.

All the playwright's work shares this reluctance to shut anything down, to put a lid on the dramatic possibilities or the audience's interpretive options. And all three of the plays in this volume finish on a note of defiance and dignity in the face of a narrow, myopic cultural prejudice. Philpott mightn't wish to be identified as a 'queer' playwright, and certainly any attempt to pigeonhole him into a particular niche represents a diminution of his talent, but his plays are distinctly and irrevocably queer. That they're also the work of a major artist, whose vision expands well beyond the confines of his own experience, is self-evident.

M. ROCK

'The first time someone shows you who they are, believe them.'
Maya Angelou

For my grandmothers Elizabeth [Grandma] and Margaret [Gran].
And for yours as well.

Thanks to the following people for their contribution and support in developing this play:

Valerie Bader, Sally Blades, Aaron Beach, Josh Brennan, Benjamin Cisterne, Ross Gannon, Gisele Joly, Gary Jones, Madeleine Jones, Adrienn Lord, Brandon McClelland, Jenny McNae, Amanda Macri, Clementine Mills, Sarah Parsons, Whitney Richards, Penny Philpott, Tim Roseman, Polly Rowe, Jonny Seymour, Alex Williams.

M. Rock premiered at Sydney Theatre Company Wharf 2 Theatre on 14 June 2014.

It was commissioned by Australian Theatre for Young People and developed with support by dramaturg Jane Fitzgerald, director Fraser Corfield and Playwriting Australia as part of The National Play Festival 2013.

Cast
Tracey Clementine Mills
Mabel Valerie Bader
Chorus A Joshua Brennan
Chorus B Madeleine Jones
Chorus C Brandon McClelland
DJ Jonny Seymour

Creative Team
Director Fraser Corfield
Assistant Director Sarah Parsons
Dramaturg Jane FitzGerald
Design Adrienn Lord
Lighting Design Benjamin Cisterne
Sound Design Jonny Seymour
Production Manager Kate Chapman
Stage Manager Sarah Smith
Assistant Stage Manager Matthew Schubach
Theatre Technician Andrew Williams

Characters

MABEL MUDGE
68, M. Rock

TRACEY MUDGE
17, Mabel's granddaughter

THE DJ
Who should play in the booth throughout the performance
except for the times when others take over the altar

Other characters are to be allocated in chorus A, B
and C, and play a fluid range of roles. The playwright
encourages casting choices that will reflect the diversity
of our evolving society.

In the first production they were allocated in this way:

CHORUS A [MALE]: (In chronological order) Postie, Dan,
Hank, Canadian Girl, Lucky, Maude, ATM, Alley Cat,
Tourist, Funky, Kid 1, German, Czech Nurse, Fan.

CHORUS B [MALE]: (In chronological order) Grandad,
Kerry, AirFrance, Elvis, Skinhead Boy, Pilot, Boganman,
Vulture, Tourist, Girl in Truck, Bouncer, Zoozoo, Bird,
Waiter, Sven.

CHORUS C [FEMALE]: (In chronological order) The DJ
Goddess, Canadian Girl, Bluehair, Sylvie, Psychic at the
Mall, Boganwoman, Margaret, Matron, Aldi Detective,
Tourist, Yael, Tineka, Kid 2, German Woman, Dixie,
Gruff, Gypsy, Betty, Gita, Checkout Chick.

Notes on text:

/ denotes an interruption

// denotes lines to be spoken simultaneously

Italicized text (for example the lines of the DJ Goddess)
is to be mixed with music. It may be sung or spoken.
These lines are rarely meant to be earnest.

Before us, a dance floor. The altar, the DJ booth, is above. The DJ mixes, makes eyes at us as the voice of a disco goddess booms.

DJ GODDESS

Pilgrims. You've crossed the globe.

From Moscow, Melbourne, Mozambique.

The door bitch waves you thru.

And now you're here at the altar.

Let's ride high on a wave of euphoria.

Free yourself, love yourself, lose yourself. DANCE!

The music takes off. Lights on TRACEY *dancing, smiling, chewing gum.*

TRACEY

The DJ's Swedish and insane, keeps shocking me, rocking me, knocking me, socking me.

Can't take my eyes off him.

Skinny guy's making eyes comes up and pushes a pinger between my lips.

So I'm up all night, there in the centre, teeth showing, face glowing, tits showing, BAM.

She dances like crazy but as she speaks she loses momentum.

My mates vanish one by one, so does pill boy – can't get more.

Dance floor clears.

Glitter falls – just stuck on shoes now.

Music slows,

Last drinks,

Club shuts.

Music stops. TRACEY chews. Her dance comes in spurts now.

Out on the street birds chirp – catch
dawn bugs as peeps from the club
drift away down lanes.

She spits out very old gum and massages her jaw.

At the bus stop the only thing
dancing are my eyes in my head.

Her eyes light up.

Hear the song again.

Glitter's back fireworks BANG
some whistle roars.

Red car streaks by then bluuue
blacccckk greeeeeeeen,

SOUNDS AROUND GET
LOUD.

Coming on again!

Then the bus arrives. I pay the
driver say:

End of the line – fine,

And I sit up back and head that way.

She looks about the bus.

So where to go now? Clubs all shut,
pubs all shit.

The park? Just dog shit in black
bags this early.

The plaza? Visit some mates with
hangovers at work?

Blue rinse on the bus smiles my
way and I get an idea.

TRACEY bangs on MABEL's door.

MABEL enters in a pink dressing gown.

MABEL	Tracey!
TRACEY	Gran!
MABEL	What a nice surprise. It's very early.
TRACEY	For what?
MABEL	For you. Or is it late? Where have you been?
TRACEY	Out. Wonder if she smells the night on me. What's stronger? Smoke – sweat – Red Bull?
MABEL	Smoke. You look a bit…
TRACEY	What?
MABEL	Not sure. Tea? The kettle's on. I'll make you a cuppa.
TRACEY	Clock ticking like a djembe drum. Eyes in photos stare from the mantel.
	Mum and Dad when they were still together.
MABEL	Still take sugar?
TRACEY	Mum and Gran when they still talked. Four, please.
	Gran with Grandad still alive.
MABEL	Four?
TRACEY	Me aged twelve. Fuck, I was spotty.
	I used to stay here overnight. Smell of baked potatoes, grandad's pipe.

> Gran'd play records and we'd all dance. I'd do that right now if I had the chance.

MABEL Tea!

TRACEY Thanks. Got any Kingstons Gran?

MABEL goes to get biscuits. TRACEY looks around the room.

> Gran's collectables stare. Animals and porcelain kids with dumb painted eyes. Bo Peep blinks then an elephant winks and Gran spins round the kitchen table in a little dance.

MABEL returns with the biscuit tin.

> No. I'm tripping.

MABEL There's just Milk Arrowroots.

TRACEY takes one.

TRACEY Can't chew can't swallow can't put it back.

MABEL What's new with you?

TRACEY Biscuit mouth just mush it about.

MABEL When do you get your exam results?

TRACEY chews.

> When do you go on your trip?

TRACEY chews.

> Can your friend go with you or are you still going alone?

TRACEY chews.

> Tracey Mudge! What's going on?

| TRACEY | Can't seem to swallow my biscuit Gran. Be right back. |
| | On the way to the loo, I pass Gran and Grandad's bed. I see the cracked tiles where he fell and hit his head. |

Is that Mr Whippy playing in the distance?

	When Grandad was around Mr Whippy always came. He had a pocket full of coins and we'd play this game. We'd eat double choc-tops and he'd watch us dance and say the same thing every time he got a chance. /Each of you are one and only. Keepsakes.
GRANDAD	Each of you are one and only. Keepsakes.
TRACEY	'Cause Gran and me and Mum are all the same no brothers to scare us and no sisters to shame. Just one in each generation like babushka dolls – Gran then Mum then me, pull us apart at the waist and our heads roll around the table.

She spits and flushes. MABEL is there.

MABEL	You right in there Trace?
TRACEY	Yep. I find Gran's records – boxes and boxes of them. Dusty Springfield, Michael Jackson, Peter Allen.
	Let's put on a record?
MABEL	I'm about to head out. I've got the/

TRACEY Yeah yeah, just one. No questions,
 no tea. Let's dance!

*TRACEY puts on Peter Allen. She dances. MABEL watches
TRACEY. Her drugs have come back on and MABEL sees it in
a second. She turns the record off.*

 Come on Gran. Let's go to Rio!

MABEL I think you've already been. Think
 I'm a dill do you Trace? I read the
 papers. I know what's going on.
 What did you take?

TRACEY Don't know what you mean.

MABEL Take a look at yourself. Was it
 ecstasy?

TRACEY Gran! You sound like Mum. Don't
 be a killjoy.

MABEL Then don't you... I haven't seen
 you for weeks.

TRACEY Because I've been busy.

MABEL Then you turn up at eight in the
 morning in this state.

TRACEY I'm not in a state. I'm fine. I'm
 just... I love you Gran.

TRACEY dances.

MABEL I bet you love everyone! Your eyes
 are dancing in your head. That
 muck smeared all over your face.

TRACEY It's Maybelline! Come and dance?

MABEL You can hardly stand up.

TRACEY stops dancing.

TRACEY	Na, my feet are killing me. A little nap on your bed?
MABEL	I've got to get to rehearsals.
TRACEY	Tuck me in so tight I can't move.
MABEL	No. It's the first day of the Pirates of Penzance.

TRACEY moans.

You're not staying here alone.
You need to go home.

TRACEY gives her a look.

I know it's an exciting time in your life. Going out, meeting people and finding a whole new world but you're about to go travelling alone. You need to be careful.

TRACEY	Wish you could come.
MABEL	You do not.
TRACEY	Wish we'd got in to *Race Around the World*.
MABEL	Well if your mother had sent in the tape.
TRACEY	You'd have been the coolest partner.
MABEL	You would've driven me crazy.
TRACEY	Let's not fight.
MABEL	This isn't a fight. It's just… when you're young/
TRACEY	Ok it's a lecture. Here we go/

MABEL

When you are young you have this idea in your head of the person you think you'll become.

TRACEY isn't listening.

I thought I'd marry an Italian man with eyes as green as the Mediterranean. That I'd be slim and beautiful and save babies in Africa and dine with the Queen of Denmark and breed Husky dogs and have my own slot on talkback radio. I thought I'd grow apples and arrange them to paint then turn them into cider… but… there comes a time when the person you think you are going to be gets lost and…

Are you listening to me Tracey?

TRACEY

Yes Gran. Follow your dreams. And I already am. I'm following my dreams.

MABEL

I'm not talking about that Tracey.

TRACEY

And I'm grateful you helped me plan the trip.

MABEL

Good. You should go home.

She hands TRACEY a plastic shopping bag full of groceries.

Here. Take these to your mother.

TRACEY looks in the bag.

TRACEY

Scones. Did you poison them?

MABEL raises her eyebrow.

MABEL	There's some corned beef too. Ignore the use-by date, it's perfectly fine and… hang on.

MABEL goes and returns with an envelope and a tiny parcel.

TRACEY	Brown paper packages.
MABEL	Tied up with string, yes. Just in case I steal away with the Pirate King and don't see you before you leave – here's something for your trip.
TRACEY	Hankies?

MABEL shakes her head.

Undies?

MABEL	Who do you think I am? What I was trying to say before is you can get lost but don't lose yourself.
TRACEY	I'll come and see you before I leave. I promise.

TRACEY kisses MABEL who remains as the DJ plays again.

DJ GODDESS	*You can get lost but don't lose yourself.*
	You can get lost but choose for yourself.
	Choose your own way and guide yourself.
	Keep who you are inside yourself.
TRACEY	I wait for the bus and my head hurts a bit. Gran's not seen me in that state and it feels kind of shit.

TRACEY opens the envelope MABEL gave her, smiles and pockets the cash.

Thanks Gran!

She unwraps the little gift: it's a rabbit's foot. She doesn't know what to do with it.

Gran won't tell Mum 'cause they don't speak now. Since Grandad died Mum's been a real cow. Mum reckons Gran has lost the plot and Gran insists that's rot. Things came to a head last New Year's Day just before we went away. Mum heard Gran was online dating and found her on the computer salivating to this guy she said looked like Freddy Krueger so Mum tells Gran that she's a dirty cougar. Mum says Gran gives people too much trust. That they'll rip her off and leave her in dust. There was the Christmas Day when Gran left out the prawns, she missed some appointments, forgot to do her lawns, this scrap of foil made her microwave explode and she gave all Grandad's clothes to some hipsters down the road. Mum tried to send Gran to a nursing home.

TRACEY goes.

MABEL sorts piles of knitted squares she's done.

MABEL She took me to Grey Gardens, Green Gardens or whatever it was called, geriatric gardens was what it was and it was not the place for me, all those dried up twigs… and this piped music that made my skin crawl. There was a dining room that stank of cabbage or worse and a terrible old Scottish creep, Angus,

who lifted up his kilt and showed
me his giblets in the hall which led
to the little cell I was meant to fade
away in – a view of a thorny rose
bush and the sound of some old
duck next door moaning in pain.

My only child wanted to send me
away. I'm not ready for that. And
I'm not losing my marbles. I'm just
busy.

The Players are doing Pirates. They'll
need me in rehearsals. And there's
the African knitting, the cinema
circle, feeding Hilda's cat when she
has her chemo. And there's a man
blowing me kisses on RSVP…

So buzz off Kerry and let me be.

I have plans. And dreams.

TRACEY When your exams finish being a
 kid is done. You just want to go wild
 and have fun.

The postie hands TRACEY *an envelope with exam results on
the front.*

KERRY snatches the envelope.

KERRY Can I open them?

She doesn't wait for an answer, she rips it open and takes a look.

Maths isn't great but Biology's
good. They're not as terrible as I
thought they'd be. Imagine if you'd
done some work. You could have
been a doctor instead of a nurse.

TRACEY Don't want to be a doctor, Mum.

I have a few days before I leave and I mean to visit Gran. But I don't visit her because I meet /Dan.

DAN Dan.

TRACEY We hang out, go out, talk a bit.

My exam results came. Got into nursing.

DAN You want to be a nurse?

TRACEY Yes.

DAN Bed pans and needles and…

TRACEY Nurses are important Dan. Have you ever been in hospital? What are you going to do?

DAN Party.

TRACEY Like for a job?

DAN What's it matter? Live for now. Coming to the party tonight?

TRACEY grimaces.

TRACEY Just… I'm feeling kind of bad. I promised I'd see my Gran before I go.

DAN makes a face.

DAN You want to see your Gran tonight?

TRACEY You'd like her. My Mum reckons we're alike.

DAN makes another face.

You should see all her records.

DAN You want me to ditch the party to play records with your Gran?

TRACEY realises it isn't very cool.

TRACEY	So I have the choice. Party with Dan.
DAN	Or wake up Gran.
TRACEY	She won't be asleep.
DAN	It's only six weeks. She'll be here when you get back.
TRACEY	I know that. It's just…
DAN	Call her from the airport.
TRACEY	So I go to the party. Meet all these new people. *Add me on Facebook.* I dance all night and get no sleep, run home and grab clothes from a festy heap, hug Mum who's reading in her bed/
KERRY	Call me Tracey!/
TRACEY	And Dan drives me to the airport with my throbbing head. Facebook me Dan.
DAN	Don't forget to call your Gran.
TRACEY	Aww, you softy. Wanna catch up when I get back?
DAN	Six weeks is a long time.
TRACEY	But you said…

DAN's gone.

Whatever.

TRACEY joins a queue and pulls out the rabbit's foot. She still doesn't know what to do with it.

Call you in Duty Free but maybe you don't hear the phone.

TRACEY goes. MABEL appears and listens to TRACEY's message.

TRACEY'S VOICE

Um Gran. I'm sorry. I know I was going to drop over and see you before I went but… so I'll be back soon. Thanks for the money and the rabbit foot. I'll send you a postcard from every country I go to. Promise.

TRACEY appears with a drink.

My trip? I find out vodka cures jet lag. Meet a freaky French guy, Frank, eat real curry puffs buy pirate DVDs and a copy bag, see an elephant on a highway and a dead dog floating legs up down the river, eat mango on a beach where hundreds of people got swallowed by the tsunami.

MABEL goes and checks the post box. Nothing.

See snow for the first time in New York. Freeze my tits off, buy a jacket, vomit hot dog on it in Times Square. Lost on the subway, I get helped by a blind man. Meet a black guy named Walker, kiss and feel up Walker in St Mark's Place. Feed a squirrel in Central Park, circle the Statue of Liberty in a boat then Aer Lingus at JFK. Church bells ring as I leave a crazy Dublin club. Do my first black Guinness shit, meet three redheads named Sinéad, get my lip pierced aaaaaah bed bugs in the hostel, scratch my skin raw on a ferry to England. Gay club in London and some girl tries to kiss my lip… *it's infected.* Red

buses, Piccadilly, the beefeaters, the palace, this Japanese guy in a pub teaches me Korean swear words. Amsterdam, space cake, Belgium, beer halls, Austria, *The Sound of Music* tour with a bus-load of gays, the Eiffel Tower, smoke and Nutella crepes, creeps wolf-whistling me and then at Charles de Gaulle this snooty airline lady says:

AIR FRANCE Your flight is cancelled.

TRACEY No!

AIR FRANCE Yes. The next flight I can get you on is… Sunday.

TRACEY Sunday? I haven't got enough money for another week in Paris. If I don't fly there today it won't be worth bothering.

AIR FRANCE Then don't.

TRACEY But I'm gonna miss out on Africa.

AIR FRANCE Désolée.

TRACEY Right.

There is this guy behind me in the queue.

HANK Cute accent. Where you from?

TRACEY Sydney.

HANK Explains the tan.

TRACEY Yeah. There's sun there.

HANK I know. I played there.

TRACEY Played what?

HANK	I'm a DJ.
TRACEY	What's your name?
HANK	Come to Berlin and find out.
TRACEY	I can't, so how about you just tell me.
HANK	Messerschmitt.
TRACEY	Bullshit. No!
HANK	You know me?
TRACEY	Are you kidding? I love you. Well, I love your stuff. That's you, really?
HANK	Really.
TRACEY	Could I really just go to Berlin?
HANK	Why not? It's closer than Nairobi.
TRACEY	//I'm running out of cash.
HANK	//I can't believe you've never been.
TRACEY	And I have to start uni.
HANK	Berlin's clubs are the best.
TRACEY	They are?
HANK	Like nothing else in the world.

MABEL waits at the airport.

MABEL	Tracey's due back on the 6AM flight. The terminal is hot and busy – full of people waiting – sniffer dogs sniffing. Hello boy.

She looks up and sees KERRY.

	Hello Kerry.
KERRY	Mum! How did you get here?

MABEL	The train.
KERRY	All those steps?
MABEL	I know. It's a miracle isn't it?
KERRY	Trace'll be pleased to see you.
MABEL	Nice to see you too.

They wait in silence – icebergs between them.

	Have you heard from Trace while she's been away?
KERRY	No. Have you?
MABEL	She said she'd send a postcard. You know the mail these days though.
	A steady flow of travellers come out. We're surrounded by hugs and kisses.

They look at each other. Then back at the arrivals board.

	Tracey's flight vanishes from the arrivals board and still we wait and wait and wait.
KERRY	What could be keeping her? I hope she hasn't been caught bringing in something.
MABEL	Just long queues…
KERRY	I'll go and check that she was on the flight.

KERRY goes.

MABEL	I watch two young men reunite. Gays. They smile, kiss on the lips.

MABEL smiles as she watches them. KERRY returns and looks unimpressed by the gays.

KERRY	Mum!
MABEL	What, Kerry?
KERRY	Tracey wasn't on the flight.
MABEL	Oh. Well, I'm sure there is a simple reason. She's a sensible girl.
KERRY	You think she's sensible? You know nothing. She went crazy last year Mum. Off the rails.
MABEL	She was studying!
KERRY	What? Parties and boys.
MABEL	Just letting off steam.
KERRY	Sneaking in at all hours.
MABEL	No?

KERRY nods righteously.

	Just spreading her wings a bit?
KERRY	How far does she need to spread them?
MABEL	Kerry!
KERRY	Where the fuck is she Mum? Why hasn't she been in touch? She didn't have much money. Did you give her money?

MABEL shakes her head.

Did you?

MABEL stops shaking her head.

Oh Mum. I told you… You never listen to me. She has to be back to start uni next week.

MABEL	I know that Kerry.
KERRY	This is your fault.
MABEL	My fault?
KERRY	Filling her head with silly dreams. What if she's been kidnapped or…
MABEL	Breathe Kerry. She's just missed her flight.
KERRY	I knew something like this would happen. I didn't want her to go but you encouraged her.
MABEL	Of course. She's young and…
KERRY	Because you wanted to go.
MABEL	That's not true.
KERRY	But you couldn't and so you found a way to live through her. She has her whole life to travel but you pushed her to go, always in her ear about it. Knitting her scarves and giving her your savings! She hasn't been stable.
MABEL	Because she went vegetarian?
KERRY	What? She's so much like you.
MABEL	//I eat meat.
KERRY	//She trusts people. Always thinks the best. The world isn't like that now…
MABEL	It'll be fine.

KERRY	She's probably run off and joined some cult.
MABEL	Be more trusting of her.
KERRY	Don't you talk to me about trust. You let any shonk who smiles at you through your door. There is evil out there, don't you watch the news?
MABEL	We're driving back to Kerry's and that song's running through my head.

She sings quietly.

	Unpredictable as weather, she's as flighty as a feather, she's a darling, she's a demon, she's a lamb.
KERRY	Mum.
MABEL	Yes.
KERRY	Stop it, please.
MABEL	Sorry. We'll make a few calls and find her.
KERRY	To whom? The police?
MABEL	I don't think/
KERRY	Foreign Affairs, Interpol?
MABEL	I was thinking Qantas? We can double check her itinerary. She was meant to fly back from Africa so that's where she ought to be.
KERRY	Why did I let my baby go to Africa?
MABEL	Bit late to say that now.

KERRY stares at her answering machine. A flashing light.

MABEL/KERRY There's a message!

KERRY and MABEL grasp each other. KERRY presses it and they listen.

Music cranks. TRACEY enters and dances. We hear her message remixed in with the music.

Mum. I didn't get home.

Mum, they cancelled my flight.

Mum, I lost my phone.

But don't worry Mum, I'm alright Mum.

Mum um mum. Um mum, mum um tell Gran.

Mum um mum, um mum, mum mum tell Gran I'm…

The message cuts.

KERRY She didn't say where she is.

MABEL Could you hear something in the background?

KERRY She's probably dancing in some strip club.

MABEL There you go. She's having some fun. She'll be in touch soon and home before you know it. I'll call Qantas, see what they know.

MABEL picks up the phone.

TRACEY Check into a hostel in Zoogarten. Cold and it feels like an asylum. Two American girls stand in front of the mirror blow-drying their hair gossiping about Beyoncé.

CANADIAN GIRLS	We're Canadian actually.
TRACEY	The light flickers and I see a stain on my mattress.
	It's getting late so I jump on the train to the club. Wait for Messerschmitt.
	Outside, the tattooed bouncer looks me up and down.
HANK	Hey there. You made it.
TRACEY	Yeah.

The DJ stamps their wrists.

	We don't pay, we stride inside, ride a rickety old lift to the top of an old office building. /The Weekend Club.
HANK	The Weekend Club.
TRACEY	Bass pounds, laser lights, muscle tops, tits, sweat and heels.
HANK	I'm on.

HANK goes and plays at the booth. Tracey watches him.

TRACEY	This blue-haired girl pokes me.
BLUEHAIR	Hey. You with Hank?
TRACEY	Hank? Um, yeah.
BLUEHAIR	How do you know him?
TRACEY	We met in Paris.
BLUEHAIR	At Batofar? Hank's the best.
TRACEY	Yeah, I know.
	As we dance the girl points at the city below, the lights shimmer,

	glimmer like Berocca on the twisting river.
BLUEHAIR	This is where the communists sat with their binoculars and shot traitors escaping. Drink?
TRACEY	We throb in the spaceship rays of laser light. A dude in the corner rings a bell. A girl in a lobster suit clicks her claws, we dance in bubbles that float down from above.

HANK winks at TRACEY from his booth.

Hank's music pulses, lifts me up.
My hands in the air and…

TRACEY really dances.

I see baby Moses in papaya reeds
Danger Mouse taste chocolate
mousse I'm treacle trickling
down my spoon I am the crimson-
coloured pencil lost and found.

I may never leave the dance floor.
Never. Ever. Ever.

I want to dance all night. Won't
think about anything else. Uni.
Mum. The dirty mattress at the
hostel.

She dances until the music fades.

I take a break. Meet Elvis and Sylvie
on the rooftop. They're artists.

ELVIS	I'm an actor.
SYLVIE	I'm a sculptor.
ELVIS	We live in a squat in Friedrichshain.

TRACEY	I lie a bit about myself. So yeah, I'm an artist too.
ELVIS	What do you do?
TRACEY	I'm a singer-songwriter.
ELVIS/SYLVIE	Wow! Cool!
TRACEY	A mermaid muscle man passes by and blows Elvis a kiss. You know him?
ELVIS	Everyone knows Ariel.
SYLVIE	Where you staying?
TRACEY	A hostel. It sucks.
SYLVIE	Ja hostels suck.
TRACEY	On the edge of a ledge on the Berlin rooftop Elvis and Sylvie tell me about their new collaboration.
ELVIS	It's like bodies in space but everything is baba ghanoush.

SYLVIE *laughs a little.*

TRACEY	Right.
	Nothing either of them say about their art makes any sense but I like the way Elvis looks deep into my eyes when he speaks. I like the little laugh Sylvie makes whenever she finishes a sentence.
SYLVIE	Singer-songwriter huh?

***ELVIS* and *SYLVIE* look at each other impressed.**

ELVIS	You have to sing us one of your songs.

TRACEY waves her hand.

SYLVIE	Stay with us if you want.
TRACEY	Really?
ELVIS/SYLVIE	Ja!
TRACEY	That'd be amazing.
ELVIS	Let's dance!

They dance.

TRACEY	We boogie til the dance floor clears and Hank packs up his discs.
HANK	That's it. I'm done.
TRACEY	I went all night!
HANK	Of course you did Club Kid.
TRACEY	Club Kid!
	We go down the lift and out of the club. The tattooed man on the door dozes as we pass. People behind us leave the dark of the club and disappear into day. Alexanderplatz empty, just a homeless girl and her dog asleep outside the station. Workers pass by in the day's first tram. We walk – DJ Messerschmitt, Elvis, Sylvie and me. Our ears ring a bit so we go to the park. It's full of club kids huddled round fires.

We hear German Mr Whippy.

	Mr Whippy!

HANK smiles.

HANK	Breakfast?

TRACEY	Ice cream in the middle of winter! This skinhead joins the line and hugs Hank.
SKINHEAD	Thank you for the music tonight. You're the best.
TRACEY	Isn't he ace?
	The skinhead and the ice cream man wink at me. Hank rattles a pocket full of change.
HANK	Whatever flavour you want.
TRACEY	But all I want to do is go back to the club. I want to dance forever. I'm never gonna go home.

MABEL is still on the phone. Qantas hold music morphs into something dancey. MABEL and KERRY paso doble while we hear the lyrics below.

DJ GODDESS	*Difficult daughter, difficult mum,*
	Each one blames the other one.
	Difficult mornings, difficult nights.
	One pulls hair, the other bites.

They stop. MABEL picks up the phone again.

MABEL	Things are awkward between Kerry and me. She might say:
KERRY	I don't blame you Mum.
MABEL	But she does.
KERRY	Well you started all this. With that silly *Race Around the World* thing.
MABEL	It wasn't silly.

KERRY	There are things all over the internet. Girls who disappear in foreign places. You encouraged her to go away and find herself. *You* gave her money.
MABEL	She's not dead Kerry, we just don't know where she is.
KERRY	What did Qantas say?
MABEL	I'm still on hold. I don't want to lose my position in the queue now dear.
KERRY	Let's hack into her Facebook.
	It's asking for a password.

MABEL shrugs.

I'll try my name.

MABEL rolls her eyes.

Account locked! What now?

MABEL	I start to worry about Tracey. I pace the aisles of Woolies so absorbed I miss all the specials. Churning through things in my head. Should I have intervened that morning? Were there signs I missed? Are you in trouble Tracey?
	Then I have a dream. Tracey's running up a pathway. She turns back and beckons me and we come to a clearing where a giraffe drinks from a pool.
KERRY	A drinking giraffe?

MABEL	She's dancing to some tribal beat, a whole crowd around her clapping their hands.
KERRY	Cannibals?
MABEL	I didn't see a pot. It's more of a sign.
KERRY	Of what?
MABEL	That Tracey's in Africa.
KERRY	You're being ridiculous, Mum.
MABEL	No it's in my waters dear. I can feel it. Our Tracey's in Africa.
	After the dream I see signs everywhere. A cloud above in the shape of an elephant. A movie about poor old Nelson Mandela. A lion in soap suds in the sink and a man with a hippo birthmark on his forehead.
	Then I turn on the radio and…

We hear Toto's 'Africa' play.

	I go and see that psychic at the mall. Hope she'll see Tracey in her crystal ball.
PSYCHIC	No. But show me your hands. Mmm mmm.
MABEL	Yes? What is it?
PSYCHIC	This deep line is worry.
MABEL	Is it?
PSYCHIC	There's somebody you're worried about.

MABEL looks down.

	It's a young girl. A young woman?
MABEL	Yes! Is she alright? Can you see her?
PSYCHIC	I can see an ice cream van. I hear its wonky song blaring. She's smiling because there are a lot of flavours. The berry one looks good, lots of fruit chunks. The chocolate one maybe too rich for /me.
MABEL	Yes? Yes?
PSYCHIC	Someone is buying her a cup, no a cone.
MABEL	Who?
PSYCHIC	A man with a pocket full of coins.
MABEL	No? Who is he? Is she alright?
PSYCHIC	She chose banana.
MABEL	What does that mean? Can you see where she is?
PSYCHIC	She's lost perhaps?
MABEL	Is she alright? Is she in danger?
PSYCHIC	Not yet but I see it coming, sirens and flashing lights, blood and ice and icicles.
MABEL	Icicles? No!
PSYCHIC	Yes. She needs help to get back.
MABEL	Yes. Yes. How can I help her?
PSYCHIC	You must find her.
MABEL	I want to.
PSYCHIC	Then go.

MABEL	I don't know how to find…
PSYCHIC	Trace/
MABEL	Oh my god yes that's her name.
PSYCHIC	No, no let me finish my sentence. Trace her steps. Look for signs. You'll find her if you do. Be strong.
MABEL	I will be.
PSYCHIC	Be prepared to find parts of yourself you don't yet know are there. Pack your bag and go.

MABEL carries a little back pack.

MABEL	And that's how I end up on this plane.
PILOT	Good morning Ladies and Gentlemen. I hope you had a pleasant sleep. The sun is rising and if you take a look out the windows on the right side of the plane, we are just about to pass over Mount Kilimanjaro. See it peeking through the clouds?
MABEL	I am tracing Tracey. First stop Kenya. The birthplace of humankind. Exciting but it's not a holiday.

The DJ stamps her passport.

I stand outside the airport, swollen feet and daunted by the task ahead.

Men squabble over me and a big man runs off with my bags.

Where are you going?

LUCKY	Come! Come!
MABEL	A taxi so rusty it looks like a pumpkin coach.
	Will you take me to my hotel?
	Lovely day for it isn't it?

LUCKY doesn't respond.

	The world is full of kind people, I don't care what Kerry says.
	Been driving for long?
	He turns on the radio. The music blares as we bump on pot holes, weave through traffic on the busy road. I look out the window for Tracey. Maybe we'll just pass her and it'll be easy.
	But we don't. I look for signs everywhere but mostly I see ladies with things balanced on their heads.
	Strange noises, strange smells. I'm such a long way from home.
LUCKY	Here we are: The Flaming Flamingo Hotel.
MABEL	I'm hoping Tracey will run out in a bright red kaftan and squeeze me with hugs but she doesn't. A couple of Australians from my flight are there.
BOGANMAN	Aussie. Aussie. Aussie.
BOGANWOMAN	Oy. Oy. Oy!
BOGANMAN	Need some Aeroguard love?

BOGANWOMAN	Travelling alone?
BOGANMAN	Don't eat on the street!
BOGANWOMAN	We're gonna stay in the hotel.
BOGANMAN	Yeah, the cricket's on in the bar.
BOGANWOMAN	Want to come and have a beer?
MABEL	Driver?
LUCKY	Yes.
MABEL	I'm not here for this. Can we go?

LUCKY takes off his sunglasses and smiles.

	I didn't mean to call you driver. It's just…I don't know your name. I'm Mabel. Mabel Mudge.
LUCKY	My name is Lucky.
MABEL	Lucky. Good sign. He's a kind man, I can tell by his smile.
LUCKY	What do you look for in my country? The big five? Will you go on Safari?
MABEL	Well yes. I'd love to see a lion, a rhinoceros. But…that's not why I'm here.

LUCKY smiles again.

I look out the window. No Tracey. Just some school boys laughing on their bikes.

We drive around the city and I tell Lucky what's happened.

So, I think Tracey might be here.

LUCKY	So many people, so many places to look.
MABEL	I show him the brochure for the gorilla trek she booked.
LUCKY	This place is near my village. It's an amazing trek. When you find your daughter/
MABEL	Granddaughter.
LUCKY	But how can that be?

They smile at each other.

I will help you find her. And when we do I will take you both to see the gorillas.

MABEL's phone rings. She looks at her phone and ignores it.

MABEL	Who's the pretty woman in that photo on the dash board?

LUCKY frowns.

The city never ends, the whole of Africa walks by under the heat of the beating sun but no little Aussie girl.

Then out of Nairobi. The taxi bumps past staring goats that nibble at our slipstream. We bounce up and down. My teeth clatter together, things rattle about in my head.

Is it much further?

LUCKY	We are close.

The taxi slows.

	This is my village.
MABEL	Where Lucky?

LUCKY points.

	Those three huts in the distance?
	Oh! And how far away are the gorillas? Because I need to find Tracey.
LUCKY	There will not be anyone there until tomorrow. For tonight you must rest.
MABEL	But there is no hotel here?
LUCKY	NO! You will stay with us.

The taxi stops. A smiling girl opens the door, reaches out for MABEL's hand.

	This is my daughter, Margaret.
MABEL	G'day Margaret!
MARGARET	Welcome. Come and say hello to the river.

MARGARET leads MABEL to the river.

MABEL	She leads me to the water. Birds circle above.
VULTURE	CAAW CAAW
MABEL	They're beautiful. What are they?
MARGARET	Vultures.
MABEL	The water is so still after the journey. I take off my shoes. Stand in the cool mud and it hugs my toes. I close my eyes.

We hear Africa. The sound builds into a cacophony and then changes to a drumming.

TRACEY	Elvis and Sylvie live in an old airship factory with Fritz, Jens, Claudio, Fabien, Maryanne, Charlotte, Juan, Kimbo, Peter, Malu, Sophie, Terry, and a three-legged cat, Maude.
MAUDE	Meoow.
TRACEY	She's a big cat.
ELVIS	She's half tiger.
TRACEY	We light a fire on the cement floor and huddle around it. This place is amazing.
ELVIS	Stay as long as you want.
TRACEY	I can put in money.
ELVIS	We don't pay rent.
SYLVIE	Dinner!
TRACEY	Buy some food?
SYLVIE	We don't buy food, we bin raid.
TRACEY	Bin raid?
ELVIS	We're vegan.
TRACEY	Vegan?
ELVIS	Makes bin raids very safe.
TRACEY	Even Maude?
MAUDE	Meow.
TRACEY	What is this?
SYLVIE	Onion. With breadcrumbs.

TRACEY	Well… Thank you.
ELVIS	Tracey is singer-songwriter. Maybe tonight she will sing for us?

TRACEY smiles awkwardly.

TRACEY	They all make art but no idea when 'cause they live for nights at the clubs. They're just like me. We go out each night, come home in the morning, sleep in the afternoon and do it all again. Hank plays most nights and when he plays I'm there. He doesn't meet me out the front anymore but Elvis knows the door bitches and always gets us in. We see other DJs but Hank's the best. I always stand just below him – watch him from the dance floor, try to catch his eye, just like the first night.
	He's a DJ King. The dance floor gets packed and I always stay til the end, wait until he's done and I run up and say. Hank!
HANK	Hey Club Kid!
TRACEY	Great set.
HANK	Thanks.
TRACEY	I follow Hank out of the club down the street.

HANK turns back.

HANK	Where you headed?
TRACEY	Dunno. What about you?
HANK	Home. I'm starving. I'm going to cook breakfast then get some sleep.

TRACEY nods.

> Want to come over for some
> *weisswurst?*

TRACEY Some what?

HANK Weisswurst, convict girl.

TRACEY Convict girl. We walk through
 streets.

 Pickled old women march by,
 dragging dachshunds and buggies.

 We stop outside a grey building on
 /Oranienburgerstrasse.

HANK Oranienburgerstrasse. It was empty
 when the wall came down and I
 took it so now it's mine.

TRACEY Who do you live with?

HANK Just me and my vinyl. Are you
 hungry? Come up.

TRACEY Hank's house is full of records.
 Everywhere I look. It reminds me
 of Gran's.

 Through the window, the television
 tower and a park. In the park a big
 dog licks a small girl.

TRACEY turns and looks into HANK's eyes.

 Sausages sizzle in the pan. Behind
 us, Hank's bedroom door's ajar.
 Hank's bed.

HANK Oh don't look in there, it's a terrible
 mess.

He shuts his bedroom door.

An awkward moment for TRACEY.

TRACEY

So, we eat, then Hank falls asleep.

HANK snores.

And convict girl wants to stay and go through his things, his records, his… but I don't. I leave. I wander the wintery streets that should lead back to the squat. But every street looks the same and I'm lost.

For the first time in a while, I realise that nobody knows where I am. There's a man on a corner watching me. He stops when I do. Is he following me? Has a look in his eyes I don't like. Is he… I see a hospital. There's a couple of nurses laughing outside. I go in. Sit in casualty. Watch this girl bleed and some old man cry. A nurse makes a joke with him and he stops crying and smiles and then when the nurses go back to work he cries again. I sit next to him. He just stares into space. I don't know what to say so I reach out and hold his hand. It's like a wrinkled old claw.

Then the matron's back, glaring at me.

MATRON

Was tun sie hier?

TRACEY looks confused.

Was tun sie hier?

TRACEY

I run.

There's a phone in the street outside the hospital.

TRACEY rummages through her pockets.

I should ring home. Ring Mum or Gran. Should…

TRACEY has no cash.

Need cash, go to an ATM.

ATM Beep beep beeeeep.

TRACEY Dosh running down, frown but I can keep going. Got enough for one more night out. Worry tomorrow.

Music.

Forget it all in a club where people smile at me, dance with me, take my picture for magazines.

A photographer takes TRACEY's pic with ELVIS and SYLVIE. They look at it.

SYLVIE/ELVIS *[To each other.]* You look hot!

ELVIS nudges SYLVIE and they look at TRACEY.

SYLVIE Tracey, we worry about you.

TRACEY Why?

SYLVIE You don't eat. I make you food but you don't touch it.

TRACEY I know I just haven't got used to…

SYLVIE What?

TRACEY Vegan bin food. But I will and I'm fine Sylvie, really.

SYLVIE You look so thin, like you're hardly there.

TRACEY I'm fine, let's dance!

They dance.

I'm under the mirror ball and it's all
coming on.

Then gazing over the dance floor
I see this woman, this old woman
grinning like a mad bitch…

**An apparition of MABEL with a plate of corned beef dances
towards TRACEY.**

DJ GODDESS *Corned beef white sauce, corned beef
white sauce,*

Scones.

Scones.

*Kingstons, custard, fruit flan, mustard,
gravy, cooked by Gran,*

Scones.

Scones.

*Roast lamb, casserole, roast pork, toad
in hole,*

Scones.

Scones.

*Carrots, corn, mint peas, roast spuds,
cauliflower cheese,*

Scones.

Scones.

The lights flicker and MABEL's gone.

TRACEY Gran? Gran?

Gran?

A drum beat.

I leave the club and walk up the alley. My stomach is growling like I never ate.

I see a cat on a bin.

ALLEY CAT Meoow.

TRACEY Get out of my way!

She pulls the lid up and rummages through.

I eat the end of a hot dog, a sandwich crust, an old banana. Lick out a mackerel can. Yoghurt and a bit of chocolate cake and…

SYLVIE stands next to her smiling.

SYLVIE Ja. Eat Tracey. Dats gut. Eat.
 You are one of us now.

TRACEY Stomach full. I look up to the sky,
 a blanket of stars.

MABEL The sky twinkles above me. We
 sit by the fire. Lucky, his daughter
 Margaret. Me and the insects.

They all look at the sky.

Look at all the stars.

LUCKY They're winking.

MARGARET Like eyes. All the eyes of people we
 ever loved.

An animal shrieks.

LUCKY Hyenas.

MABEL How close will they come?

He shrugs.

	So it's just the two of you now is it? No Mrs. Lucky?
LUCKY	She was bucked by a hippo.
MABEL	Really?
LUCKY	And then ripped apart and feasted on by lions.
MABEL	No?
LUCKY	The hyenas licked her bones clean.

His daughter gives him a dirty look.

| MARGARET | Dad! |

He spits. MARGARET gets up.

	My mother left, /she
LUCKY	Shall we eat?
MABEL	I'm starving!

A silent moment between MABEL and LUCKY until MARGARET brings out food.

| | Oh Margaret! |

MABEL examines it.

	What is it?
MARGARET	Ugali. Scoop it with your hand.
LUCKY	And that's goat. The juiciest part is the eyes. Eat them! In our village we say it will help you see.

MABEL hesitates and looks at the eyes on the plate. LUCKY and MARGARET laugh.

| MARGARET | We do not really eat the eyes. That is… no, no doesn't matter. Just eat! |

MABEL does so.

MABEL If you'd come to my place I would
 have made corned beef with a nice
 white sauce, mash, peas, beans and
 for pudding a flan.

MARGARET A flan?

MABEL With kiwifruit and pineapple on
 top. Flans are wonderful.

MABEL shivers a little.

MARGARET Are you cold?

*MARGARET brings MABEL a knitted rug. MABEL recognises
it. Has she knitted that square?*

As she wraps herself up, LUCKY gets out his drums and plays.

MABEL Oh Lucky!

MABEL claps along.

MARGARET We use the drum to bring our
 people home – to call them back
 because there is danger or they are
 missing out on fun.

LUCKY Would you like to try?

MABEL Me?

LUCKY If you'd like to bring them in, then
 you can.

MABEL Have you got enough goat to go
 around?

She's timid at first but then she gets a rhythm.

LUCKY You're good. Call them in, Mabel.

*The noise of the insects gets louder, a monkey screeches, gorillas
grumble, cheetahs cry and an elephant trumpets.*

MABEL

For a moment I forget why I am there. I forget that I'm racing time and chasing Tracey. Drumming by the fire, I feel different. Not the Gran they know at home, cooking Grandad dinner and wiping dribble off his chin, the specials hunter at Woolies, the old woman drawn on a tea towel.

She sees a rhino pass by.

I'm African Gran. Heart beating under African stars. The glinting eyes of African animals watching me.

The sound crescendoes then becomes soft as TRACEY's heartbeat.

Freezing, TRACEY puts her hands in her coat pockets. She finds the rabbit's foot. Looks at it, smiles, puts in back.

TRACEY

Berlin's tough when you're running low on cash but it's Hank's night off. I want to make him a surprise dinner. Pay him back for brekkie. And no food from bins – I wanna cook meat. Roast it like Gran would. So, I go to Aldi, spend ten euros on pork and potatoes. But I haven't got quite enough for a candle…

She slips a candle into her jacket pocket, glides through the checkout and…

ALDI

Halt fräulein. What did you just slip into your pocket?

TRACEY is caught shoplifting. We hear her heart pound.

Birdsong.

MABEL

In the morning we go to the gorilla sanctuary.

She shows the photo.

Tourists and drivers and staff. Have you seen this girl?

Nobody. Nothing.

A gorilla watches me from a rock. I hold up the photo…have you seen…She shakes her head and pulls her baby in close. Turns her back to me.

We drive around all day. Every time we stop, I hold up Tracey.

Nothing.

Children in fresh school uniforms point and grin at me from a bus.

CHILDREN

Mzungu! Mzungu!

MABEL

They must wonder what I'm doing. Some strange little white woman with wrinkles in places no black gran cracks.

We return to the village and I go down to the river.

I feel like Meryl Streep in *Out of Africa*. The music swirls behind me as I wander through marula trees.

The 'Out of Africa' theme plays as MABEL walks. The music scratches to a halt and MABEL shakes her head.

Pull yourself together Mabel, you've got work to do.

LUCKY appears.

	I keep losing myself Lucky.
LUCKY	That's good!
MABEL	No it's not. I'm here to find Tracey.
LUCKY	And you will.
MABEL	It's my fault she went in the first place.
LUCKY	You think it's your fault?

MABEL nods her head.

| | When my wife left, I blamed myself. Kept asking myself what did you do? What didn't you do? I drummed and drummed but she never came back. But when I finally found her she was fine. She had just made another life, found another Lucky. |
| MABEL | Oh Lucky. I'm sorry. |

He shakes his head.

	At least you still have Margaret.
LUCKY	There is nothing like a daughter.
MABEL	You can say that again.
LUCKY	Does Cherry know you're here?
MABEL	Kerry.
LUCKY	You should tell her.

MABEL shakes her head.

LUCKY holds out his phone.

| MABEL | Kerry?! |
| KERRY | Mum? Where are you? |

MABEL	Kenya.
KERRY	What?
MABEL	Kenya.
KERRY	You're shitting me right?
MABEL	No dear.
KERRY	Have you lost your mind? Africa is dangerous! What about your eye appointment? Your medicine?
MABEL	Yes. I thought finding Tracey /was more important.
KERRY	Why didn't you tell me?
MABEL	You would have stopped me. I don't want to be stopped right now.
KERRY	You'll catch Ebola or rabies or…
MABEL	Senile dementia. Yes yes, I know that.
KERRY	You'll get kidnapped or murdered.
MABEL	Maybe I will. But I'm going to find Tracey first.
KERRY	Well, you're way off course.
MABEL	What?
KERRY	Don't play deaf on me you gallivant. She never left Europe.
MABEL	*(To herself.)* The icicles!

She has an idea, and her silence gives her away.

KERRY	Don't you even think of it, Mum! What the hell has got into you?

MABEL	I'm worried about Tracey and I am trying to find her!
KERRY	Who do you think you are? Who are you with? Why didn't you tell me you were going? The last thing I need is to worry about you /too, Mum!
MABEL	/Then don't, dear. Life's too short.

We hear a vehicle. MABEL looks up.

KERRY	Mum? Mum? Come home right now!
MABEL	A safari truck stops. The tourists stare at me – a random Gran in the African village.
	I have to hitch a ride Lucky. I need to keep going. How can I ever repay you?
LUCKY	I don't need repaying. What goes around comes back.

They hug.

MABEL	I wave to Lucky as he disappears in the dust. I'm sitting next to this girl.

HANK returns to the booth and plays.

	Lost on her i-pod in the middle of Africa.

She turns and smiles.

GIRL	Deep house trance. Want to listen?

She offers MABEL the left earbud, they move to the music.

MABEL	It's wonderful. Who is it?
GIRL	Messerschmitt. He's from Berlin.

MABEL	Berlin?
GIRL	Ja. The club scene is amazing there. I went for a holiday and got lost. Night after night after night. So much fun. I forgot myself.
MABEL	And I know that it's a sign. Berlin!

The ALDI store detective stares at TRACEY.

TRACEY	I paid for these things.
ALDI	Yes you did but then I saw you slip something into pocket. Arms in air bitte, Fräulein.

The shop detective feels TRACEY's pocket, finds the rabbit's foot and holds it up.

Es tut mir leid.

TRACEY	Close call.

TRACEY kisses the rabbit's foot.

Knock on Hank's door. Nothing.

DJ Messerschmitt isn't home.

TRACEY tries to light the stolen candle but can't. HANK enters.

HANK	What are you doing here Club Kid?

TRACEY shrugs. Yawns.

TRACEY	I thought I'd make you dinner.
HANK	Dinner?

TRACEY nods.

I already ate. I was on a date.

TRACEY	A date?
HANK	You don't know what that is?

TRACEY	I'm Australian, not an idiot! How did it go?
HANK	Not my type.
TRACEY	Who is your type then? May I come in? Are you still hungry? Maybe I could…
HANK	No. I need sleep.
TRACEY	But.
HANK	I'm sorry you waited. Will you be ok to get back?
TRACEY	I'll be fine. Or I could…

TRACEY throws herself at HANK.

HANK	No!
TRACEY	No? You don't like me?
HANK	Of course I like you. You're fun and sweet and…
TRACEY	What?
HANK	You're seventeen.
TRACEY	Eighteen.
HANK	I'm way too old for you.

It's awkward.

	Have you been in touch with your family? Do they know you're in Berlin?
TRACEY	Of course they do.
HANK	Do you have enough money, Tammy?
TRACEY	It's Tracey.

I'm gonna go.

She leaves quickly, forgetting the shopping bag. HANK picks up the bag and calls after her.

HANK Tracey!

It's too late. She's gone.

TRACEY stands in the cold feeling sorry for herself. It starts to snow as the following tune seeps from a nearby club.

DJ GODDESS *When is it time to go home?*

When your legs turn to stone?

When you can't lift your arms?

When you gaze across the dance floor that was full,

But now it's just full of memories.

A dark figure in a hood approaches TRACEY and stops.

ELVIS Give me all your money!

TRACEY Get the fuck away. I've got a weapon!

She rummages in her coat pocket and pulls out the rabbit's foot, holds it out like a knife.

Fuck off and leave me alone!

ELVIS pulls his hood off.

ELVIS Tracey! It's me. It was a joke.

TRACEY Elvis?

ELVIS What are you doing out here in the cold? What's that thing?

He bursts out laughing.

TRACEY A rabbit's foot.

ELVIS Animal product!

She laughs.

 Were you going to scratch me or
 stab me?

TRACEY makes a face at ELVIS.

 Let's get you home.

ELVIS puts his arm around TRACEY.

 But Tracey. The rabbit foot. We're
 a vegan house. It will upset Sylvie.
 You must keep it hidden.

They go.

The DJ stamps MABEL's passport.

MABEL Tegel Airport, Berlin! A bus and
 then I check into a cheap hotel.
 Cold floors. No idea where to start
 so I take the U-Bahn and get off
 at Potsdamer Platz. The Jewish
 Memorial. Some girls bow their
 heads then one of them smiles,
 giggles, disappears behind a pylon
 and…

A girl runs straight into MABEL.

 Watch it!

YAEL I'm sorry did I hurt you?

MABEL No.

YAEL Good. We're nannies from Tel Aviv.
 We're just a bit excited, it's our day
 off.

MABEL Do you like the memorial?

YAEL	It's fun. But we're just killing time. We're going clubbing tonight.
	What's your name?
MABEL	I'm Mabel. Mudge.
YAEL	I'm Yael. You're travelling alone?

MABEL nods.

	Is it lonesome?
MABEL	Well… Sometimes perhaps. But I am on a mission.

MABEL pulls the photo of TRACEY from her bag and shows YAEL.

	Have you seen my granddaughter?
YAEL	Is she lost?
MABEL	Kind of.
YAEL	How did you lose her?
MABEL	I wish I knew.
	I look at the nannies. All about the same age as Tracey – an innocence about them that might fool you if you didn't know better.
	So, do you go to a lot of clubs?
YAEL	When I'm not changing Brunhilda's nappies.
	Clubs are the best thing about Berlin.
MABEL	So I hear. Are you going out tonight?
YAEL	You bet.

MABEL	Do you think that I could join you?

YAEL looks confused for a moment but then goes with it.

YAEL	You like to dance?

MABEL does a daggy little boogie. YAEL smiles and goes.

Meet you at midnight. Mabel Mudge.

MABEL	Midnight?

Why start so late?

I head back to my hotel room to wait. Sour shopfraus turn signs and lock doors and I sit in my room watching re-runs of *Inspector Rex* then some po-faced lady reads the news.

MABEL's phone rings. She looks at the screen and ignores it.

I look through my bag. Nothing to wear. The shops are closed. I'll have to improvise. I look around the hotel room. Curtains? No! Too Von Trapp. Bedspread? Way too hot for dancing. The shower curtain! That's it!

She wraps the shower curtain around herself and puts on her coat.

I'm in the lift, the lobby, the U-Bahn and then I'm looking up at a very dull looking building in Alexanderplatz waiting for the nannies.

YAEL	Hello Mabel.

MABEL opens her coat and flashes her dress.

MABEL	Made it myself!

YAEL It's… I'm not sure there's a word.

MABEL Thanks!

 We line up at a big red door. I'm
 starting to freeze. My fingers, my
 brain. I have to get inside. We reach
 the front of the line, the nannies
 pass and vanish. But in front of me
 there's a tattooed bouncer fellow
 man saying:

BOUNCER Sorry lady. You can't come in.

MABEL Why not? I can pay.

BOUNCER Private function.

MABEL You just let my friends in. You can't
 turn me away. I need to /dance

BOUNCER I said no.

*MABEL turns away and thinks. She has an idea and
disappears.*

*She returns in a hat she's made from a shopping bag. The
BOUNCER rolls his eyes.*

 I said no.

MABEL Fine then.

MABEL gives up and pulls out the photo of TRACEY.

 Look, I don't even want to come
 into your crummy club. I'd much
 rather be home in bed but I'm
 looking for this girl. Have you seen
 her? Do you know her?

The BOUNCER shrugs.

 Thanks for nothing.

MABEL walks.

I stand shivering in the street for an
hour hoping Tracey might arrive.
I watch cars and trams and taxis,
asking every person who passes;
Do you know this girl? Have you
seen her? Every time a girl gets out
of a taxi. Tracey? Tracey?

*A wind whips up. Leaves whirl past and a page of a street
magazine flutters in and lands on MABEL. She looks down
at the page and sees…*

Tracey? Tracey! Tracey!

She shows the BOUNCER.

Look, that's her!

BOUNCER The skinny one?

MABEL She was here. See?

He looks at her like she's insane and won't let her in.

My Tracey's here. I knew it. I need
to get inside that club.

BOUNCER Not on my watch Granny.

MABEL turns away.

MABEL I have to try something new.

 I hail a taxi.

FUNKY Heading home already?

MABEL I don't have much choice.

FUNKY They say in Berlin everyone has
 choices but it depends who you are.

MABEL You look like someone I know. This
 man I met /in Kenya. Lucky.

FUNKY	In Kenya? Lucky? You know my baby brother?
MABEL	Yes I do.
FUNKY	I'm Funky.
MABEL	Pleased to meet you.
	And boy oh boy, am I pleased. I sit next to Funky and we drive around the city. I tell Funky all.
FUNKY	So your daughter didn't want you to come here?
MABEL	No, she wants to put me in a home.
	We go from club to club but at every single one the same thing happens. They take one look at me and refuse to let me in.
	I can't believe this Funky.
FUNKY	Do you like kebabs?

MABEL grins.

MABEL	Funky takes me to this little van in Kreuzberg.

FUNKY hands MABEL a kebab.

	Thank you!

They eat.

FUNKY	Those club kids… They dance all night and then go all day.
MABEL	No idea how. It's been a long time since I went to a club.
FUNKY	Me too. I pick them up and see them chewing and groping; their

eyes wide as saucers, why do you want to go in there?

MABEL If Tracey is caught up in it all, I need to get inside.

FUNKY What if you get caught up too?

MABEL An old duck like me?

I'm not looking for that. Please help me find her.

FUNKY On two conditions. You call your daughter, let her know you're safe.

MABEL sighs.

MABEL And?

FUNKY You take a look in the mirror. What is it you're wearing?

MABEL I didn't bring anything for night clubs. I found it in my hotel room and…

FUNKY nearly kills himself laughing.

FUNKY You need something that says this is me and I am here to dance.

MABEL nods.

I'll pick you up tomorrow. There is someone you should meet.

Disco interlude. TRACEY dances like a maniac with SYLVIE.

MABEL Hello Kerry? Yes. I know it's the middle of the night. But I'm close, love. I think she's here I know where. I'll be in touch.

TRACEY	Sunday morning I'm wide awake after a big night and in comes Elvis dressed up like I've never seen him. Nice tie.
ELVIS	Thanks. I'm going to visit my Oma.
TRACEY	On Sunday morning?
ELVIS	She counts on me.

ELVIS looks deeply into TRACEY's eyes.

TRACEY	I wonder if Elvis' Gran looks deep into your eyes when she speaks to you so you almost have to look away? Can I come with you Elvis?
ELVIS	You want to meet my Oma?
TRACEY	Yeah. But I don't have anything nice to wear.

ELVIS shrugs.

ELVIS	It doesn't matter. You could wear a shower curtain and she wouldn't mind.

TRACEY doesn't get his joke.

TRACEY	We catch the U-Bahn across the city. Elvis points out stations and places that were in the/
ELVIS	Old east. And the old west.
TRACEY	How do you know all this?
ELVIS	My grandparents got separated from their family when the wall got built. It's my history.
TRACEY	We get off the train and walk down a quiet street. East or West?

ELVIS	East.
TRACEY	We cross a wide busy road.
ELVIS	The road to the Brandenburg gates. For military parades to show the power.
TRACEY	We enter an old apartment building, climb endless stairs.
ELVIS	Each floor has a different smell. Boiled liver.
TRACEY	Beans?
ELVIS	Okra.
TRACEY	Cake.
ELVIS	That'll be Oma.

ELVIS knocks hard on the door. TINEKA opens it. She smiles, reaches out and pulls him in to hug.

Oma I've brought a friend.

She looks past TRACEY and stares at the wall behind, holds out her hand vaguely.

TINEKA	I'm Tineka.
TRACEY	That's when I realise she's blind.
TINEKA	Come in.
TRACEY	She leads us through a clutter of memories, precious ornaments and photographs piled up everywhere. Like my Gran's house, but in Berlin.
TINEKA	Poppy seed cake?
ELVIS	Bitte Oma.
TINEKA	Coffee?

TRACEY Danke.

TRACEY bites into the cake and finds it bitter and salty. She tries to swallow it but struggles.

TINEKA Have you got a job yet, Elvis?

ELVIS I'm making my art, Oma.

TINEKA How, when you go out so much?

TRACEY Elvis can hide nothing from her. But she lights up when he talks about his art.

ELVIS The baba ghanoush is the sensory exotic, the migrant consumable. You get that, Oma?

TINEKA nods.

TINEKA Of course.

She turns to TRACEY.

 Australia?

TRACEY Yes.

TINEKA Invader or native?

TRACEY Invader I guess.

ELVIS Tracey is a songwriter, Oma.

TINEKA Ah! Sing me the Matilda Waltzing.

TRACEY Um… Maybe next time?

 When Elvis goes outside to smoke, there is this silence between us with little breaks when the heater cracks.

An awkward silence until the heater cracks.

 I look at Tineka's skin, the wrinkles on her hands and face, the wedding

83

ring that hangs down on her bony ring finger.

When did you go blind?

TINEKA	My sight faded slowly at first, and then a few years back, I lost it all.
TRACEY	That must have been tough.
TINEKA	I miss looking into people's eyes.

ELVIS comes back and winks. He gently kisses TINEKA on the cheek.

ELVIS	We should go now.
TINEKA	No more cake?
ELVIS	Next time.
TRACEY	The eyes in photos and ornament animals follow us to the door.
ELVIS	That's my Oma.
TRACEY	Blind.
ELVIS	But sees more than I do. She's lived through the war, the wall, the unification. You don't have to protect her from anything except the truth about her poppy seed cake.

They laugh.

TRACEY	I think of that morning I went to Gran's – eyes dancing in my head and what she said. I want to tell Elvis but he keeps giving me this look.

ELVIS stares at TRACEY lovingly.

	Elvis, why do you keep looking at me like that?
ELVIS	I need glasses.
TRACEY	The streets are busy. People shopping and working, walking dogs, kids laughing in the ice. The sun comes out.

There is a rare glimpse of the sun.

| ELVIS | Oh my, the sun! |

They smile.

TRACEY	And there's the Weekend Club.
ELVIS	All closed up.
TRACEY	So hectic at night. It looks a bit sad in the middle of the day.
	Some kids yell something at Elvis and me.
KID 1	Liebe-Vogel.
TRACEY	German words surround me.
KID 2	Guten tag.
GERMAN 1	Aus meinem Weg.
GERMAN 2	Entschuldigung.
TRACEY	In the clubs I don't need German but when I hear it on the street I realise; all I've been doing is dancing in clubs.
ELVIS	What's wrong with that?
TRACEY	Maybe I should broaden my horizons a bit. Get away for a few days.

85

ELVIS	We should get the train to Prague.
TRACEY	What's in Prague?
ELVIS	Beer. And great clubs!

MABEL hums to herself.

MABEL	Funky takes me to Kurfürstendamm. Shops everywhere but he knows the one. Man in the shop smiles and says:
ZOOZOO	I'm Zoozoo. I'll help you.
MABEL	He grabs at my scarf and says:
ZOOZOO	This is good.
MABEL	I knitted it myself.
ZOOZOO	The rest must go.

MABEL transforms before us.

Try this, try that.

Try this top and try this hat.

Those pants, that shirt.
These boots, that skirt.

Yes.

No.

Ooh. Oooooooooh.

Yes!

ZOOZOO and FUNKY smile at the new MABEL.

Take a look in the mirror.

MABEL	Oh. Zoozoo.
ZOOZOO	Don't mention it, say nothing darlink. Just doing my job.

ZOOZOO waves her off and goes.

MABEL As I leave the shop people turn their heads.

We hear a wolf whistle.

A worker drops a bag of cement on his foot.

The sun comes out.

The sun's out and I feel a million deutsch marks until these two American girls pass and one growls:

DIXIE COUGAR!

MABEL What did you just say?

DIXIE Who me?

MABEL Yes you, Britney Spears. Did you just call me cougar? No-one calls me that.

DIXIE Whatcha gonna do Granbag?

MABEL Before I can tell her what I'll do, Funky pulls me into the car and cranks up the music. We glide across Berlin. At Check Point Charlie I see a girl cross right in front of us. Same age, same hair, same walk as… Tracey?

Stop the car, Funky!

Tracey! Tracey!

The girl turns back.

It's not her. The girl looks at me like the idiot that I am.

FUNKY	Come on Mabel. There's someone I want you to meet.
MABEL	Who?
FUNKY	Hank.
MABEL	He parks and we walk the bridge to Museum Island. We wait outside the Pergamon beside these ancient statues. Who's Hank?
FUNKY	He's a DJ.
MABEL	A DJ! A little bird searching for seed looks at me and cries:
BIRD	doodoobudoo doodoobudoo

A shadow of a very tall man appears before MABEL.

MABEL	I see a man in the distance walking our way. I know instantly who it is. It's in the way his heels click on the cement. Even the bird knows it. I swear it chirps /Messerschmitt.
BIRD	Messerschmitt. Messerschmitt.
MABEL	Funky vanishes and Hank and me, we hit it off. We wander past stolen jewels of Islam but I don't really look at a thing. Except him. He's such a spunk.
	We talk about outer space/
HANK	Doppelgangers/
MABEL	The Marquis de Sade/
HANK	High-ranking crossdressers/
MABEL	Lichtenberg's slippers. We talk and walk, unaware of the time until a

gruff woman stands in front of us hands on hips and says:

GRUFF Das Museum ist geschlossen.

MABEL Already!

HANK Dinner?

MABEL We walk arm in arm by the Spree.

Wild geese fly by with the moon on their wings.

We arrive at a place with a charming little doorbell. Hank's eyes gleam like sleigh bells.

HANK Schnitzels with noodles, bitte. What do you love most of all?

MABEL Musicals.

HANK Musicals?

MABEL I know them all.

HANK Wow! What's your favourite?

MABEL Brown paper packages tied up with strings.

HANK *The Sound of Music.*

MABEL But it's not just musicals I love. I used to be in a record club. A record would arrive in the post and I'd take all the porcelain creatures from around the house and put them on the kitchen shelves and DJ for them.

Tell me about your DJing. How do you know what track to play? What happens if you need a wee? And sampling? That funny scratching

noise…like Salt-N-Pepa made. What is that?

But what I really want to know is how it feels to bring a crowd together on the dance floor.

HANK It's hard to explain… Like something tribal from deep inside.

MABEL Like I felt with that drum in Africa.

They look into each other's eyes for a second too long. The waiter interrupts.

WAITER Some dessert? We have very crisp apple strudel.

MABEL looks away.

MABEL Excuse me a moment. Powder my nose.

I could have danced all night!
I could have danced all night!
And still have begged for…

I catch myself in the mirror in the schnitzel house toilet.
What on earth are you doing Mabel? You haven't even told Hank why you're here. Don't go forgetting yourself. But I glow like a ripe nectarine. I don't want this night to end. Someone pushes on the door. Sorry, won't be a minute.

MABEL and HANK are face to face.

Hank?

HANK Mabel. Are you alright?

MABEL Yes. Just… This is the ladies Hank.

HANK	I don't care. I couldn't wait. I'm not even hungry. Not for schnitzel anyhow.
MABEL	And before I know it, Hank and I are kissing in the schnitzel house toilet.
	It's getting hot in here.
HANK	So take off all your clothes.
MABEL	Hank!?
HANK	Mabel!
MABEL	We can't do this here.
HANK	Then let's go.
MABEL	We leave the schnitzels on the table and walk hand in hand down Leipzigerstrasse. A mannequin in a shop window winks at us.
HANK	I'm so pleased to meet you, Mabel.
MABEL	Same here. But…it's getting late.
HANK	Late?
MABEL	Yes. I should probably go.
HANK	No! The night is young. I'm playing at Weekend Club. You must come.
MABEL	Well alright. I need to get some cash out first. Can we find a bank?
HANK	You don't need money. Tonight's on me.
TRACEY	ATM.
ATM	Beep beep beep beep

TRACEY

Withdraw cash.

ATM

Beep blaah.

She has no cash.

TRACEY

What to do? Pawn something? I find a pawn shop, hock my iPod and my camera. 200 euros. Elvis meets me at the station with bottles of beer. /Prague, here we come!

ELVIS

Prague, here we come!

MABEL

At Weekend Club I glide past the doorman holding Hank's big hands.

I stand at the edge. Wave at Hank! The dance floor feels vast; an ice rink and I haven't skated in oh so long.

HANK

Get yourself out on the floor Mabel.

MABEL

Can I do this? I hit the ice and... Yes I can!

I glide. You can do this Mabel!

I spin, I pirouette.

MABEL dances.

I feel sixty, fifty, forty again. Find my feet, my hands, my shoulders, my hips. I can do this!

I teach kids new moves, I take up space like I own this place. I may never leave the dance floor. Never. Ever. Ever.

MABEL dances some more.

HANK

Mabel?

MABEL	Yes Hank?
HANK	Do you want to go home?
MABEL	Home?
HANK	It's just I'm done and the club's closing.
MABEL	Closing?
HANK	We can go on to another club.
MABEL	I shouldn't have a late night.
HANK	Night? Mabel. It's ten am.
MABEL	No!
HANK	Come back to my place?

MABEL stills and looks into HANK's eyes. They go.

TRACEY	Prague's pretty. It's like some fairy-tale place.
ELVIS	With tourists drunk on Czech beer.
TRACEY	And loads of bohemian crystal shops. We trot around the cobblestone streets. I see my maths teacher's double begging in the square. And the lady who moved in next door to Mum shining crystal in a shop window.
ELVIS	Doppelgangers.
TRACEY	Yeah!
ELVIS	Where is your doppelganger, Tracey?
TRACEY	We are at this famous bridge when a horrible gypsy appears and tries

to sell me her kid. She pushes it into my arms and says:

GYPSY Buy. You buy.

TRACEY You can keep your snotty little brat.

ELVIS Tracey!

TRACEY And she curses me just like that.

GYPSY I curse you.

TRACEY Ten minutes later I slip and whack my head. I'm bleeding so much, must look like I'm dead. My leg is twisted around a pole and my shoes have flown off and lie in a hole.

 That gypsy bitch. It's all her fault.

ELVIS We need to get you to a hospital.

TRACEY At the hospital they tell me:

CZECH NURSE You've broken your leg. We will put you in traction.

TRACEY So I'm stuck in Prague and I'm out of action.

 Elvis? Can I use your phone?

TRACEY calls MABEL's house.

 Gran? Gran are you there?

 I'm in Prague and something's gone wrong. Sorry I've been out of touch so long. I'm in a hospital and I need a next of kin. I slipped on a bridge and broke my shin. I'm with a friend and I'm ok. They just want to know how I'm gonna pay. Gran?

MABEL	For three days and nights I…forget why I came. I forget the Mabel I know and find myself with Hank.
	We stay in bed all day and…enjoy the view out the window – the television tower, the leaves budding on trees in the park. And I mean to tell Hank why I'm here. That I'm looking for Tracey. That I'm not staying. That I'll need to go home to my life. But it never comes up in conversation. And we go out at night and when I dance, I fly like a jet. /Club Hindenburg!
HANK	Club Hindenburg! I have to play. Mabel, this is my friend Betty.
MABEL	Hi!
BETTY	You are with Hank now Ja? We love Hank. He goes against the grain and we all like that. If hot dogs are in he eats cats, stone cold. If people wear flares he's in tights. And you two look hot together. I always told him find someone your own age.
MABEL	His own age?
BETTY	Ja.
MABEL	How old is he?
BETTY	How old do you think?
MABEL	Judging from the last few days… eighteen?

BETTY laughs and puts her finger to her nose and taps it.

BETTY	Let me tell you something babydollface. In a club nothing is what it seems. You meet a woman and it turns out she's a man. You meet a man but he dresses as a school girl or a fox or... You meet someone who looks young and...
MABEL	What?
BETTY	They just know the secret to life.
MABEL	The secret to life. Is that why I'm here?
BETTY	Honey that's why we are all here. Are you in love?
MABEL	With Hank?
BETTY	I can see the way he's looking at you!

BETTY dances away.

MABEL	Another night in a club and then we walk hand in hand by the Spree. Lights dancing on the river.
HANK	I loved watching you dance under the mirror ball.
MABEL	With my two left feet? Hank, the music you play. Where does the inspiration come from for that...?
HANK	This is something I can't put to words. You have to feel it for yourself.
MABEL	How?
HANK	Come.

HANK takes her hand. MABEL giggles.

MABEL Where are we going Hank?

HANK holds her from behind and covers her eyes.

HANK Listen. Tune in to the world.

We hear a collage of intense and textured sounds.

MABEL smiles with delight and as she reaches her first sound orgasm, fireworks explode above them.

HANK uncovers her eyes. MABEL shudders.

MABEL What was that?

HANK It's a sound orgasm.

MABEL I've never had one of them before.

MABEL squeezes HANK's hand.

 Thank you!

HANK Mabel, there's something I need to
 ask you. Don't get me wrong. I'm so
 glad I found you but…what are you
 doing in Berlin?

MABEL I'm about to tell him all about
 searching for Tracey but something
 stops me because I realise I'm not
 looking anymore. If I'm meant to
 find her, I will. Instead I say:

 When you're young, you have this
 idea of the person you think you'll
 become but… there comes a time
 when the person you think you
 are going to be gets lost and unless
 you want them to walk past you
 when you're having your hair done
 then you have to drop everything
 and track them down. Do you
 understand?

HANK nods.

MABEL

We look down at the river.
Reflected in the water I see myself.
Mabel Mudge. The school girl, the
girlfriend, the wife, the mother, the
grandma, the widow. The…what
next?

More fireworks.

TRACEY is still in traction.

TRACEY

Elvis sits with me and we watch life
happen out the hospital window.

A nurse passes by.

What are the fireworks for?

CZECH NURSE

The tourists. And the end of winter.

(To ELVIS.) Watch out for the icicles.

ELVIS

I have something for you Tracey.

*ELVIS reaches into a bag and pulls out a bunch of withered
flowers.*

TRACEY looks awkward.

TRACEY

They're beautiful. Did you pick
them?

ELVIS

From a bin.

TRACEY

It's the thought that counts right.
Um… Is the thought what I think it
is?

ELVIS nods.

Oh Elvis. I think you're really sweet
but…

ELVIS

You don't feel that way about me.

TRACEY	I'm sorry.
ELVIS	Maybe you will use this situation to write a hit song.
TRACEY	Oh Elvis. I wish I could. The thing is; I made all that up.
ELVIS	I know.
TRACEY	You do?

ELVIS nods.

When I met you I wanted to sound interesting. You were all arty and baba ghanoush and I… I should have just told you I'm Tracey Mudge from Milperra and I'm training to be a nurse. I'm sorry.

ELVIS Sorry for what? We all want to be someone.

He takes the rabbit's foot out of his pocket.

TRACEY My rabbit's foot!

ELVIS It fell out of your pocket when the gypsy cursed you. I kept it safe for you.

He gives it to TRACEY.

I think I need to go back to Berlin.

He goes.

As we hear a remix of the following call.

DJ GODDESS/TRACEY *Gran? Gran? Are you there? There?*

I'm in Prague and I need a next of kin.

I slipped on a bridge but I'm ok.

They just want to know how I'm gonna pay.

Gran? Gran? Are you there? There?

KERRY shakes her head and goes.

MABEL	I move into Hank's.
	We go to flea markets.
	Trawl through vinyl – fossick for gold.
HANK	Kraftwerk/
MABEL	Depeche Mode/
HANK	Bowie, Hendrix/
MABEL	Glass, Wham.
	I'm learning.
HANK	This Saturday in March, the sun comes out.
MABEL	Suddenly all this pollen's about.
HANK	The wind through the blinds must have blown it all in.
MABEL	It's gone up our noses and made us both zing.

They stare at one another, crazed.

	We bang and we bang all over the flat. The neighbour's dog moans, the bed squeaks like a rat. Yes/
HANK	/Ja
MABEL/HANK	YES /JA
	YES /JA
	YEEEES /JAAAA

HANK	No… Ouch.
MABEL	You stopped!
HANK	I had to.
MABEL	Why?

HANK holds his groin in agony.

HANK	Mabel I've torn something. I can't move.
MABEL	You're alright Hank, let's keep going.
HANK	No. It burns. I can't… Mabel I can't stand up.
MABEL	Then lie down.
HANK	I can't. I have to play Hindenburg tonight. With the warm weather, the dance floors will be full. It's too late to cancel.
MABEL	Let me help you up then.

She tries to help HANK up but it fails.

HANK	I can't move. What will I do?
MABEL	I don't know. Call a friend?
HANK	They'll all be busy.

A pause.

MABEL	I'll do it. I'll go and play the set.
HANK	But you can't…
MABEL	I can. And I will. I've watched you play. I can do it.

HANK moans.

HANK	What will you tell Sven?

SVEN looks around.

SVEN	Where's Hank?
MABEL	He's injured himself.
SVEN	Who's gonna DJ? Who's gonna play?
MABEL	I will.
SVEN	You?

MABEL nods.

	You're not serious!
MABEL	I can do it. I can DJ.

He laughs.

SVEN	The clubbers come for Messerschmitt.
MABEL	Well Messerschmitt can't play. And it's too late to get someone else.
SVEN	Do you know the reputation my club has?
MABEL	Look kid, I have been on this earth three times longer than you. I can host a party.
SVEN	Yeah?
MABEL	Yeah. You ever turned bingo to bolero? Cooked flan while you fandangoed?
	No? I've watched Bankstown boys breakdance, boogie woogied in Balmain, I pogoed to public enemy in Penrith I…/

SVEN What?

MABEL Listen, are you gonna let me play?

 He stares out at the river and
 watches a group of clubbers walk
 towards Hindenburg. And I think,
 he's gonna tell me to hightail it out
 of there.

SVEN I don't have a choice. I have to…
 God help me.

Reality hits MABEL.

 What am I meant to call you? If the
 patrons ask who is this…

MABEL Um…

SVEN What is your name?

She whispers in his ear.

DJ GODDESS Ladies and gentleman. Please
 welcome your DJ for this evening.
 GRAN.

MABEL And out I walk.

SVEN Don't walk! Strut!

MABEL Out I strut then.

*She stops in the middle of the dance floor and stares at the
empty DJ booth.*

 Don't be shaky Mabel Mudge.
 You've turned nobs your whole life.
 It's just like a night at home.

She trips on the step up and everything goes quiet.

MABEL stares out at the crowd.

 All eyes on me.

Is this the person I thought I was going to be?

Up here above the dance floor?

I've been chasing her. Have I finally caught her?

MABEL goes to the DJ booth. She puts on a track.

Nothing happens.

No one moves.

Girls with drinks stay leant on walls.

A boy in a beanie points at me and laughs.

A couple leave.

SVEN I'm not paying you to stare at them. Get them to dance or get the fuck out, Gran.

LUCKY Stay calm Mabel.

We hear LUCKY playing the bongo.

Just warm up the kids, a little drum beat.

The African village, call them in from the dark to /the fire.

MABEL The fire. The fire. I try to strike a match but my fingers shake.

SVEN First strike,

MABEL Fizz.

SVEN Second strike,

MABEL Fizz.

SVEN Third strike,

LUCKY/MABEL	There it is.

A drum beat begins.

MABEL	I hold it out to the kindling.
	A little smoke. A little breath. And then a flame.
	A girl in a bikini squeals. She moves onto the floor.
	A couple snake around her. Orange flames lick at their feet.
LUCKY	Bring them in to dance naked round the flames.
MABEL	They're moving out onto the floor.
	Arms fly into the air.
MABEL/LUCKY	They're off!
MABEL	Let's burn this goddam house down.

The music explodes. It's a kooky mix that's sampled from her life. The dance floor takes off. MABEL watches and smiles.

SYLVIE approaches MABEL at the booth.

SYLVIE	I'm Sylvie. We came for Hank but we love you. You're amazing. Wish you were my Gran.
MABEL	I don't know what to say.

SYLVIE smiles and walks away.

MABEL remembers the photo of TRACEY. She reaches into her pocket and follows SYLVIE.

Sylvie! Do you know this girl?

The photo is wet with sweat and it falls apart in her hands.

TRACEY I watch a lot of Czech TV. Arty stuff,
 serious news.

The nurse comes in.

CZECH NURSE Be patient, you'll be able to move
 about soon.

TRACEY Can't wait.

CZECH NURSE There's a movie starting.

The nurse looks at the TV.

TRACEY/CZECH NURSE *The Sound of Music.*

We hear the film cracking away.

TRACEY I wish you were here Gran, with
 a bag of Violet Crumbles. I stay
 awake until the Von Trapps push
 the car down the driveway and get
 stopped by that Nazi and then I
 drift off. I have the weirdest dream
 about you, Gran.

*MABEL plays on the podium. TRACEY watches her as if in a
dream.*

As MABEL returns home to HANK, her phone sounds.

MABEL Mabel speaking.

KERRY Mum?

MABEL Kerry?

KERRY Where on the earth are you? I'm…

MABEL Hang on love. Another call coming
 through.

SVEN Gran?

MABEL Yes.

SVEN	It's Sven. We want you to play again tonight but you need a better name. Gran kinda sucks.

MABEL tries to get back to KERRY but hangs up on her. KERRY is furious.

MABEL	Did you hear that Hank?
HANK	Gran sucks.
MABEL	It doesn't seem fair. I do one gig and…
HANK	That's the way it goes.
MABEL	They want me to play again! They want me!
GITA	This is radio Berlin and I am Gita Goebbels. And now in the studio I welcome, M. Rock!
MABEL	Guten tag Berlin!
GITA	They say you are the oldest DJ in the world, is that right?
MABEL	Oh Gita, you know we ladies never give away those sorts of secrets.
GITA	The first time I heard you play I thought this is it. Something new. And you now have your very own night: Brown Paper Packages.
MABEL	Tied up with string!
GITA	Your sounds surprise – hit you every time – whack whack… such joy. I won't miss your gigs now. People say all sorts of things about you. You survived the bubonic plague. You were raised by a

	pygmy tribe in Africa. You are half human half owl which is why you can last all night. Tell me, what's your secret?
MABEL	I know how to host a party.

KERRY appears next to TRACEY.

TRACEY	I wake up one morning and Mum's just there. She's weeping a bit, stroking my hair. Stop it Mum.
KERRY	I thought I'd lost you. That you'd never come back.
TRACEY	Na. Berlin swallowed me up for a while but it spat me back out. I want to go home.
KERRY	We can't.
TRACEY	Please? I can use crutches.
KERRY	It's not about you Tracey. It's your Gran.
TRACEY	What?
KERRY	She went to find you.
TRACEY	She did?
KERRY	And Berlin swallowed her up as well.
TRACEY	What is it with that place?
KERRY	We have to find her. She's so frail. I just hope she's survived.

The DJ underscores the train journey, as the DJ GODDESS sings.

DJ GODDESS	*You can get lost but don't lose yourself. You can get lost but choose yourself.*

You can love him but don't lose yourself.
Choose to love him but keep yourself.

TRACEY We take the train to Berlin and
 make the 'Find Gran Plan'.

DJ GODDESS *Lust, lose, trust, use, keep your shoes,*
 don't choose…

KERRY Museums first,

TRACEY Then galleries.

DJ GODDESS *Lost, lose, trust, use, keep your shoes,*
 don't abuse.

KERRY Tea houses,

TRACEY Antique stores?

KERRY It's going to be a challenge.

TRACEY Like *Race Around the World*!

 Mum?

 I'm sorry I made you worry.

KERRY You're going to be paying this off
 for a while, Tracey.

TRACEY The train pulls in at Ostbahnhoff.

They stand in front of a billboard. Their mouths drop when
they see it's a massive poster of MABEL as M. Rock in diamanté
headphones.

TRACEY/KERRY Gran? / Mum?

KERRY Have you drugged me Tracey?
 Am I on a trip?

MABEL At the supermarket some guy nearly
 runs over Hank with his trolley and
 stands in front of me.

FAN	M. Rock?
MABEL	Yes.
FAN	Oh my fucking god. I can't believe you're here.
MABEL	In Aldi?
FAN	I was there at your first gig at Hindenburg. Can you sign my neck?
MABEL	Sign your neck?
FAN	I'm gonna get it tattooed.
MABEL	Then the checkout chick points, grabs the microphone and screams:
CHECKOUT	It's M. Rock. M. Rock!

The chant 'M. Rock, M. Rock, M. Rock' echoes for a while.

TRACEY	From the taxi windows we see billboards of Gran all over Berlin. /M. Rock?
KERRY	M. Rock? I don't believe this.
TRACEY	We have to go to Hindenburg.
KERRY	Why?
TRACEY	To check her out.
KERRY	Check her out? You on crutches in some club named after a doomed airship? I'm jet-lagged and pissed off and I just want you both to come home.
TRACEY	I know that.

KERRY Do you know how hard this has
 been for me? I don't want to lose
 you again. Enough of this nonsense.

TRACEY Then let's go and get Gran and
 bring her home.

KERRY relents.

 There's a huge queue outside
 Hindenburg.

KERRY This is ridiculous.

TRACEY The crowds in knitted bikinis,
 crocheted shorts, whistles, glow
 sticks. Chupa chups, smiles.

KERRY Will you look at these idiots. You're
 not coming in on your crutches.

TRACEY But Mum!

KERRY Stay there. Don't you dare move!

SYLVIE Tracey!

TRACEY Sylvie!

 Tineka!?

SYLVIE You know Tineka?

TRACEY Yes.

SYLVIE We bring the Oma now. She loves
 it. Dances on the podium all night
 and get us to the front of the line.
 Come on! I'll get you in!

The crowd screams 'M. Rock! M. Rock! M. Rock! M. Rock!'

***Backstage, MABEL puts on her diamond studded headphones
and wraps herself in a shower curtain cape.***

HANK It's time to get out there Mabel.

HANK squeezes her hand and goes.

MABEL and KERRY come face to face.

KERRY Mum?

MABEL Kerry?

KERRY What's going on?

MABEL doesn't know what to say.

 I thought you were looking for Tracey.

MABEL I was.

KERRY Then what are you doing here?

MABEL I'm...

KERRY What? Go on...explain this, is this
 some joke? Who's taken advantage of
 you this time? What are you wearing?
 You look like a fucking idiot. You
 must be the laughing stock of Berlin.

MABEL How dare you say that to me!

KERRY I'm your daughter.

MABEL And I'm your mother!

KERRY I wish you'd act like it.

MABEL What do you mean by that?

KERRY We'd all love to run away and avoid
 our own lives.

MABEL I ended up here because I went
 looking for Tracey. Maybe I lost my
 way a bit /but

KERRY Lost your way a bit?

KERRY cackles like a witch. TRACEY enters.

	You've done ridiculous things in the past but this, this takes /the cake.
TRACEY	Leave her alone Mum!
KERRY/MABEL	Tracey!
TRACEY	Gran!

Slow motion. They smile and move towards each other but HANK steps between them, oblivious to the reunion, he gently kisses MABEL.

HANK	They must have /you out there.
TRACEY	Hank?
HANK	Tammy?
TRACEY	Tracey!
TRACEY/MABEL	Gran? /Hank? You know her?

HANK shrugs and nods.

TRACEY	What the fuck? What the fuck Gran? What is this? A nightmare?
HANK	It must be a bit of a shock.
TRACEY	Shut up Hank!
	What's going on? Are you two fucking?

HANK and MABEL look at each other and then at TRACEY with meek smiles.

	But I met him first. And this is my club. I found it first. I thought you came to Berlin to find me!
MABEL	I did come to find you Tracey.
TRACEY	Well you didn't do so well.
MABEL	No. I didn't.

TRACEY	I needed you! I broke my leg and I rang you from Prague and you…
MABEL	I came to find you. And then they wouldn't let me in.
TRACEY	Because you're an old woman!
MABEL	But then when I finally got into your world, things changed for me. What was I meant to do?
TRACEY	Not this Gran. Look around. You shouldn't be here.
MABEL	You think?
TRACEY	Yes. Go home! Leave me this Gran. It's mine.
MABEL	It's yours is it? This place is yours?
TRACEY	Yes.
MABEL	Is everything yours? And if it is what does that mean? That when you're young you can have everything and go everywhere you like but when you're old? When you're old people say no.

MABEL continues:

No you're not busy you're losing your mind. No, you can't come into the club and dance. No, we don't need you.

Do you know how no feels?

No?

When your Grandad died I lost my best friend. What did you want me to do? Mope about waiting for an occasional visit from you while your

mother plotted my move to Grey Gardens?

KERRY I never plotted anything/

MABEL You did!

KERRY You're one to talk! You ran away!

MABEL I would have stayed if I thought you needed me.

KERRY Oh Mum!

We hear the crowd calling for M. Rock outside.

TRACEY They're cheering for you Gran.

MABEL I know.

KERRY shakes her head.

Do you know what? In this club nobody says no. When I'm up there all I hear is YES and it feels bloody good. And do you know what else feels good?

MABEL goes to HANK and holds his hand.

I imagine this upsets you both as well.

So if you need me to stop it all then I will. I'll pack up my records, wave goodbye and we can head to Tegel right now.

But I will never be that Gran, that woman you think you need again.

The crowd gets louder.

HANK They're raising the roof out there.

KERRY Yes, I can hear them, Hank.

TRACEY What do you play Gran?

MABEL smiles and waves her hands about.

 Are you good?

MABEL Good? Tracey, I'm great. Come out
 with me and hear for yourself.

*TRACEY looks at KERRY and she nods. TRACEY throws her
crutches away and she and MABEL walk hand in hand.*

TRACEY Laser beams meet and shine on
 Gran and me. We enter together and
 the crowd hushes, they part for us as
 we cross beneath the mirror ball. We
 climb into a crane which lifts us up
 to the DJ booth at the top of it all.

MABEL takes the DJ's place at the booth.

MABEL One match is all we need. The flame!

She raises her arms high and the crowd hushes.

 LET'S BURN BERLIN! LET'S
 BURN!

MABEL plays and it goes off.

*As TRACEY speaks we see snaps of M. Rock's tour. M. Rock
with Michelle Obama, M. Rock with Aung San Suu Kyi, with
Lady Gaga, Kanye West, a Korean boy band, and in front of
a mirror-covered Lear jet holding HANK's hand.*

TRACEY So Gran's not coming back. Not for
 the moment anyway. She has way
 too much going on.

 Before we fly home, we meet Gran
 and Hank for brunch. They're
 really sweet together and Hank tells
 me his age. But that's a secret.

I promise Gran I'll let The Players
know she can't accompany for The
Mikado. And we say goodbye. I'm
happy to leave. I want to get home.
I can always come back if I want.
There's time.

Gran does better than me with the
postcards. I get them from Ibiza,
Rio, Goa, Chicago and Nairobi.
She says the Germans want her for
Eurovision. With Hasselhoff.

I send her a birthday card. Happy
Birthday Gran. Hope she gets it.
She's off to play Arctic Circle,
Brooklyn Zoo and Glastonbury.

They all want her. They want you
Gran. Maybe you'll come home
and do the Mardi Gras.

When we Skype we talk about little
things, my nursing residencies –
bed pans and needles, how much
I love what I'm doing at uni. How
Hank's getting grey. Gran jokes
about coming home and buying
Green Gardens. Turning the whole
nursing home into a massive club
with multi dance floors, swimming
pools with giant blow up bedpans
and synchronised go-go dancers
dressed as sexy nurses.

But for now Gran's busy doing it
for the kids out there. For all her
grandkiddies across the world.

And for me.

THE TROUBLE WITH HARRY

For Mark

This play is inspired by interpretations of the life of Eugenia Falleni. Falleni lived much of her life as Harry Crawford. Falleni was convicted of the murder of 'her wife' Annie Birkett in Sydney in 1920.

'Falleni's story provides an opportunity to consider the depiction and treatment of one working-class, Italian-Australian manwoman in the 1920s... Falleni's wives were depicted as innocent victims, thus maintaining a heterosexual narrative. The refusal to conceive the possibility that Falleni's wives may have known him to be a woman and desired her as a man-woman was "not a failure to know, but a refusal to know" and speaks of the threat of both lesbian desire and cross-gender identification, and of their power to disrupt heterosexuality and the male/ female gender binary.'

Ruth Ford, 'The Man-Woman Murderer': Sex Fraud, Sexual Inversion and the Unmentionable 'Article' in 1920s Australia *Gender & History,* Vol.12 No.1 April 2000, pp. 158–196.

'When in middle age, she finally established an intimate connection, she was forced by her social circumstances and the strict moral confines of her day to maintain her deep secret from almost everyone, including her beloved'

Mark Tedeschi, Eugenia p. 13.

'There is evidence to support almost any interpretation.'

Rebecca Edmunds, Researcher, Sydney Living Museums. As quoted in *The Sydney Morning Herald*'s article: He Was a she. But a killer? Feb 19, 2012.

The play has been developed with the support of The Australia Council, Belvoir, Brisbane Powerhouse, Cre8ion, Focus Theatre, The Playwrights' Center Minneapolis, The Playwrights Foundation San Francisco, TheatreofplucK Belfast and Playwriting Australia.

I am indebted to all those who have researched and written about the life of Eugenia Falleni, in particular to Suzanne Faulkiner for her brilliant work 'Eugenia: A Man'.

I am also indebted to Alice Livingstone and Pete Nettell for their original commissioning of the project, to Mark Adnum for his research, to Niall Rea of TheatreofplucK, Belfast and to Jane FitzGerald for her dramaturgy of the early drafts of this work.

Thanks to my long term collaborator and mate Alyson Campbell who has played many pivotal roles in contributing to the development of this play, including directing a stunning production of the work in Belfast and Melbourne.

This play was first produced by Theatreofpluck at The Mac, Belfast as part of Outburst Festival in November 2013.

Harry Crawford	Michelle Wiggins
Annie Birkett	Louise Mathews
Harry Birkett	Matthew Mitchell
Josephine Falleni	Roisin Gallagher
Man	Gordon Mahon
Woman	Stephanie Weyman
Director	Alyson Campbell
Designer	Niall Rea
Sound Designers	Felipe Hickmann Eduardo Patricio
Stage Manager	Siobhán Barbour
Costume Designer	Susan Scott

For their creative contribution to the development of this play I gratefully acknowledge the actors and creatives who include Julia Billington, Kate Box, Belinda Bromilow, Tahli Cohrin, Jeremy Cohen, Michael Cutrupi, Jeanette Cronin, Rebecca Edmunds, Spa Enari, Celia Ireland, Teresa Famularo, Elaine Ferguson, Anni Finsterer, Jane FitzGerald, Robert Frost, Sam Haft, Josh Hecht, Damon Herriman, Gisele Joly, Jodie Kennedy, Alice Livingstone, Annette Madden, Sean Marshall, Rebecca Massey, Louise Mathews, Chris Mead, Matthew Mitchell, Andrea Moor, Amy Mueller, Shannon Murphy, Pete Nettell, Emma Palmer, Meredith Pennman, Cole Scott-Curwood, Will Sheehan, Nadia Tass, John Turnbull, Jess Tovey, Laura Turner, John Waters and Doris Yunane.

Characters

HARRY CRAWFORD/EUGENIA FALLENI
Early forties, to be played by anybody but a biological male

ANNIE BIRKETT
Mid-thirties

HARRY BIRKETT
14

JOSEPHINE FALLENI
17

MAN
40 to 60, plays a range of roles

WOMAN
40 to 60, plays a range of roles

This play is a fluid dance. Nothing is fixed in place, nor should it be.

The space should offer a suggestion of both a domestic interior and the surrounding street. The interior is Crawford and Annie's house, never quite allowed to become a home. The exterior echoes the neighbouring homes, streets, shops, pubs and the shadows of the laneways of inner-city Sydney in 1917 to the present day.

Man and Woman address us today and they inhabit both the same and a very different space. Their identities should not be fixed either. By this I mean they are not reporters, or neighbours or people who sat in the court. They have a capacity to walk through walls, freeze time, replay moments, use microphones, cameras and other contemporary tools of surveillance.

Notes on text:

/ denotes an interruption

// denotes lines to be spoken simultaneously

Bird calls echo.

WOMAN	It's dawn at Lane Cove River Park.
MAN	A puppy circles a laughing /boy.
WOMAN	Boy throws a ball, pup chases, then catches a scent,
MAN	Some new smell in his snout/
WOMAN	Pup's nose in the air, then to the ground/
MAN	He sniffs, whines, follows, stops.
WOMAN	There's something burnt black.
MAN	Puppy lifts his front paw, pulls back, yelps.
WOMAN	The boy's mouth drops.

Beat.

MAN/WOMAN	Dead body.
MAN	Charred body.
WOMAN	Cooked remains of some poor wretch;
MAN	Some poor whore burnt black.

Beat.

MAN/WOMAN	The crime site.
WOMAN	Police rope off blackened bushes.
MAN	Detectives arrive; stand huddled smoking next to the smoking bones.
WOMAN	Smell of burnt flesh hangs as a bat in a tree in the day.

MAN	Clues linger in the stillness after the struggle.
WOMAN	Forensic evidence, fingers curled.
MAN	Remains of skin grip splintered bone.
WOMAN	Well-worn shoes, broken teeth.
MAN	Frayed woollen cloth torn.
WOMAN	An empty bottle broken, cracked.
MAN	Some cheap chain ripped from a neck glints in the morning sun.
WOMAN	Veil of smoke blankets it all.
WOMAN/MAN	The burnt thing,
WOMAN	The detectives,
MAN	The lantana.
WOMAN/MAN	Kookaburra sitting in a gum tree looks the other way.

Bird calls end.

ANNIE enters in her best clothes.

WOMAN	That's her before the fray/
MAN	Before the feud/
WOMAN	Before the flickering flames.

HARRY enters similarly dressed.

MAN	And there's the boy.
WOMAN	Look on his face – him knowing nothing.

CRAWFORD enters.

MAN	And there *he* is. / Before it all.

WOMAN Before it all. The rumours,

MAN The revelations,

WOMAN The headlines. /Before:

MAN Before:

The family get into position for a formal photograph.

WOMAN/MAN The trouble with Harry.

A flash. The photograph taken, all disperse except CRAWFORD.

He remains alone and for a moment seems to sense our gaze.

He whistles a bright tune and takes a look up and down the street.

WOMAN enters.

WOMAN This is the day they move to /
 Cathedral Street.

CRAWFORD Cathedral Street. Here we are then.

ANNIE enters. CRAWFORD smiles at her as they look about.

ANNIE Help me with these boxes! They
 won't unload themselves.

MAN enters, watches them.

CRAWFORD fusses as ANNIE takes a look along the street.

HARRY enters with a chest and trips over.

MAN Boy drops the china and the mother
 lets loose/

ANNIE My good plates!

HARRY shrinks away.

CRAWFORD They'll be fine.

WOMAN But it's him they notice. Something about him. A grin like butter wouldn't melt…

CRAWFORD winks at WOMAN.

 A twinkle in his eye?

CRAWFORD whistles.

 What a charmer.

CRAWFORD shakes MAN's hand.

CRAWFORD I'm Harry Crawford.

MAN And his handshake's firm. /You know what they say.

WOMAN You know what they say.

CRAWFORD And this is Annie. The wife.

ANNIE looks at them all, then turns and goes inside. CRAWFORD follows ANNIE.

WOMAN She thinks she's above it all?

MAN Give her a /chance.

WOMAN Her name from the *first* marriage on the side of the tea chests /Birkett.

MAN Birkett.

WOMAN A strange little bat of a thing. She draws the curtains and hides inside in the dark – never outside much longer than it takes to hang up smalls on the line, humming away hidden behind her knickers.

MAN And then there's the boy.

HARRY returns and tries to whistle as WOMAN and MAN watch on. He can't manage it.

WOMAN	Left to fend for himself after /the stink.
MAN	The stink.

HARRY looks about at his new yard.

WOMAN	It's near tea time. Sun going down, winter coming – air getting cold as mama's stare at an elbow on the table,
HARRY	Street lamps flicker/
WOMAN	Get the washing in!
HARRY	Tram bell rings/
WOMAN	Kerosene, burning wood/
HARRY	Garbage – piles of it burning/
MAN	And horse and dog and cat do – all of it always under your feet.
HARRY	A baby screams, a dog barks/
WOMAN	Bed bugs shit on stained sheets and run up and down the pillows,
MAN	Fleas jump floorboards. Rats rummage in the gutter.
WOMAN	Potato peelings in the sink, dirt under nails, grey meat dances as it boils in a pot.

A light on ANNIE in the kitchen. She hums.

WOMAN/ANNIE	I set the table.
ANNIE	Knives and forks/
WOMAN	Pepper and salt/
ANNIE	Cups and saucers/

WOMAN	Peas and beans/
MAN/WOMAN	Husbands and wives/
WOMAN	Love and hate.
MAN/WOMAN	The truth and the lies.
ANNIE	For a moment alone, just me.
WOMAN	But for the bugs and the mice and the fleas.

ANNIE sings.

The song she sings can be just hers.

A light swings above ANNIE lights up only her face.

Her song in the light.

ANNIE sings. MAN watches her sing in the light until ANNIE realises and shuts the curtain.

Paint chips, seasons change and after a time they're not so new.

CRAWFORD whistles as he passes WOMAN.

Change the tune and keep it down! Enough to drive you to/

CRAWFORD	Just bringing some cheer.
WOMAN	That's what you call it?

HARRY crosses with a grocery box.

HARRY	Old Mrs Bone's tongue clatters away like a tram;
WOMAN	Back inside young Harry Birkett, busy hands are happy hands, there's a lot of packing to be done.
HARRY	Yes Mrs Bone.

WOMAN	And every night at five o'clock the men/
CRAWFORD	The workers/
MAN	The husbands, the boys/
WOMAN	The larrikins, the chugalugs/
HARRY/CRAWFORD /MAN	All of us out none of us home.
HARRY	All in ties all of them grey/
MAN	Trudge from work to the pub/
WOMAN	Human steam trains – clouds of smoke sucked into their lungs and blown back out on the street to sit on a stool at the bar in the noisy pub.
MAN	Ten to six. /Clock ticks.
CRAWFORD	Clock ticks.
MAN	And everyman in the bar,
WOMAN	Every single rat on those floorboards shakes his sorry drunken neck,
MAN	Lines up empties cause it's closer to five to than ten to.
WOMAN	Time's henchlady shakes her fist,
CRAWFORD	She's coming to get us and pull us away!
MAN	From the fun to the cold hard dining table.
CRAWFORD	*[Jokes.]* The welcoming arms of the wife.

WOMAN — Potatoes boiling everywhere, steam rising from saucepans to the fingers on the hands of the clock/

MAN — The bell gets rung – the bar hag shouts;

WOMAN — If you can't drink them leave them. If you can't leave them drink them.

CRAWFORD — The coins all gone/

MAN — The drinks get skulled/

CRAWFORD — The doors get slammed/

MAN — /And the pub gets shut.

WOMAN — And the pub gets shut. /They're out. He's coming.

ANNIE — They're out. He's coming.

WOMAN — The bed bugs, the fleas,

ANNIE — The rats in the roof.

WOMAN — The mice and the moths, /they whisper; he's coming.

ANNIE — They whisper; he's coming.

WOMAN — Corned beef sweats,

ANNIE — Peas and chokos turn to mush.

MAN — The women stand out on the street – pursed lips hands on hips all;

WOMAN — Dinner's getting cold…

MAN — Kids whine, babies howl,

WOMAN — Sausage spits fat from the heat of the stove, yells out the window and all the way home to /be decent.

ANNIE	Be decent. / *Show a bit of decency at least.*
MAN	*Show a bit of decency at least.*
ALL	Be decent.

ANNIE sings again.

MAN	See her through the window.
WOMAN	The only one inside.
MAN	The only one not out for blood.

CRAWFORD enters.

ANNIE	There you are then. Cold out?
CRAWFORD	Getting so. What were you singing then?
ANNIE	Singing?
CRAWFORD	Heard you as I was coming up the street.
ANNIE	I was singing about love.
CRAWFORD	Love is patient love is kind.
ANNIE	Where's that from?

CRAWFORD shrugs. They kiss tenderly.

WOMAN	The eyes of the lady in the photo on the mantle stare out. Her mother, his mother, every grizzling old long – dead mother sighs and disapproves. If she could spit in his eye – lazy good for nothing lump of…

ANNIE pulls away.

CRAWFORD	What?

ANNIE	Nothing.
WOMAN	She would spit in disgust. If she could open her mouth and yell – but she is trapped in silence dead like she was trapped in silence living.

CRAWFORD notices a box on the floor.

CRAWFORD	What's in the box?
ANNIE	The boy brought it home. Guess.
CRAWFORD	A parlour game! A dozen bottles of good brown ale?
ANNIE	Wishful thinking!
CRAWFORD	A passion fruit cream sponge? A fresh ham?
ANNIE	Stop thinking of your stomach.

The box moves.

CRAWFORD	It's alive. Is it old Mrs Bone's head? Did he chop off her ugly mug? She still yelling; *You owe me for your rotten tobacco Mr Crawford.*
WOMAN	You owe me for your rotten tobacco Mr Crawford.

They laugh. He tries to get at the box but she stops him. There is a sound from inside it.

ANNIE	Harry. It's a bantam.
CRAWFORD	A bantam! Open it up.
ANNIE	I don't like the look in its eye.
CRAWFORD	Go on! It won't be liking the dark. It might suffocate.

ANNIE	Won't, there's a hole in the side.
CRAWFORD	Annie.

He opens the box and looks at the bird.

	Covered in lice. We won't be eating that tonight.
ANNIE	Harry! Don't say that. Upset the boy. He's afraid what you'll say.
CRAWFORD	Because he knows he's not allowed.
ANNIE	Let him. For a time?
CRAWFORD	He knows the rules.
ANNIE	But. Please?
CRAWFORD	Perhaps until we fatten it up a bit to eat.
ANNIE	Harry!
CRAWFORD	Sad looking thing. It's a hen then?
ANNIE	Yes.
CRAWFORD	How do you know?
ANNIE	
CRAWFORD	How do you know? Look into its eyes.
ANNIE	No!
CRAWFORD	I think it's a cock.
ANNIE	Look into its eyes? How can you tell anything from/
CRAWFORD	Well that's about as good as looking through all the feathers for a thingamajig.

ANNIE Stop! There *are* ways of finding out. Time will tell us without us needing to…

CRAWFORD How long do we wait? No, I've changed my mind. He can't have it. We're not on a farm. You'll need to tell him.

ANNIE gives him a look.

You're the one who goes on about decency. Give him one of your talks about respectability. *What'll the neighbours say when they get woken up at the crack of dawn?*

ANNIE It's a hen.

CRAWFORD It is not a hen, look at the size of it.

ANNIE They said it was a hen when they sold it to him.

CRAWFORD Pulled the wool over the boy's eyes but not mine. How much did he pay to be tricked? It's a rooster and it'll cock-a-doodle-doo until they send us packing or we all go mad. It'll have to go.

ANNIE He could train it to be quiet.

CRAWFORD With a bit of wire around its beak? Cocks aren't dogs, love.

ANNIE But – please give him a few days, Tally-ho?

CRAWFORD Tally-ho Tally-ho. You know how to get what you want from me.

They look at each other. A smile spreads across ANNIE's face. She hugs him.

The morning it wakes me up I'll chop off its nut and we'll have roasted chook for tea. Speaking of tea…

He sits and rubs his hands together. She brings his dinner. He looks at the empty place at the table.

Where is our boy?

ANNIE He's up the street.

CRAWFORD Still working? Maybe he's buying a whole farm to bring home?

ANNIE Harry…The boy was asking…

CRAWFORD The boy was asking what? Can I bring home a bull?

ANNIE No.

CRAWFORD Not all that clap-trap about wicket keeping, he can't even catch.

ANNIE No. He was asking how to shave his beard.

They look at each other. Something makes this moment awkward.

ANNIE finishes eating, clears the table, and goes out to her sewing. CRAWFORD affectionately watches her leave and remains at the table.

In the street, HARRY carries a box of groceries. He tries to whistle but can't get it. He stops and stares up at the sky.

WOMAN That boy – like all the rest. Not much between his ears, not much meat on him either, all that running he does for penny pinching Mrs Bone. He'll probably get sent off to France, get stabbed dead in the mud.

HARRY feels the stare of Mrs Murphy.

Evening Harry.

HARRY Evening Mrs Murphy.

She watches HARRY go.

WOMAN If I could escape there, I would.
 I'd get away, let the French trench
 mud spatter my petticoat; find
 me a young soldier. Imagine the
 crisp uniform and me in a barn
 undressing him. Us hiding from the
 Hun in that barn, him and I, kissing
 first and then…after he's done it to
 me he falls asleep and I get into the
 uniform and I look like a soldier,
 leave him all white and bony on the
 hay, with a rifle in my hand and a
 purpose – an enemy to kill – and
 I'm out of the barn and running
 – the krauts shoot at me, but I'm
 running fast, getting away from…

*HARRY is home. He tries to sneak past CRAWFORD, but
CRAWFORD gets up and blocks him and smiles. This appears
to be a routine. They have a moment of fun trying to outwit
each other but CRAWFORD wins out and HARRY concedes.*

CRAWFORD You've been busy.

HARRY It was Mrs Bone.

CRAWFORD Always is.

HARRY Took such a time to get all the
 orders out. Then she asked me
 upstairs to help her.

CRAWFORD I bet she did.

HARRY	Whenever I go up she has something she needs to show me or ask me and/
CRAWFORD	Did she give you anything extra for your troubles?
HARRY	No.
CRAWFORD	Nothing?
HARRY	No. But…
CRAWFORD	What?
HARRY	She played some music.
CRAWFORD	Music?
HARRY	Mozart.
CRAWFORD	That's something you can put in your pocket and save.
HARRY	It's not. No.
CRAWFORD	Something you can bring home and offer as a contribution isn't it? Pay for new arrivals?
HARRY	Oh.
CRAWFORD	Yes. Annie, the boy's home.
ANNIE	His tea's there.
CRAWFORD	Tell me this. How much did you pay for that mangy sack of lice?
	What made you bring it home?
HARRY	It looked lonesome.
CRAWFORD	They told you it was a rooster?
HARRY	It's a hen.

CRAWFORD	What makes you think that?
HARRY	They told me.
CRAWFORD	And you believed them?
HARRY	Yes.
CRAWFORD	You believe everything you hear?

ANNIE enters, shows what she has been sewing – a coarse green dress. It's not very good sewing and they all know it.

HARRY	That looks like an army tent.
ANNIE	What do you mean?
HARRY	Put a red cross on it and all the sick soldiers can come inside you.
CRAWFORD	*[Jesting.]* Are you mocking your mother's sewing?
HARRY	Keep them safe from the Hun.
ANNIE	You are strange boy.
CRAWFORD	If I were you young Harry Birkett I'd be watching my tongue. Chicken Little's life depends on it.
ANNIE	It's not finished but I need your help. I need to adjust it. I need one of you to put it /on.
CRAWFORD	The boy will.
HARRY	I won't.
CRAWFORD	Well I can't.
HARRY	But I'm hungry.

ANNIE puts the dress on HARRY. He resists at first but then he gives in and enjoys it.

CRAWFORD/ANNIE	Oh, isn't that lovely?

ANNIE	Could have been my daughter!
HARRY	Very funny!

CRAWFORD and ANNIE laugh.

CRAWFORD	We're playing with you boy.
HARRY	I'm hungry!
ANNIE	Hold still then!
HARRY	Don't stab me with the pin.
ANNIE	I've got the shakes!
HARRY	Don't! You'll prick me.
CRAWFORD	Annie!
ANNIE	/Oooh!
HARRY	/Ouch! She got me!
ANNIE	An accident, wasn't deep.
CRAWFORD	Look on his face! She's kidding with you boy.
HARRY	But /she…
CRAWFORD	Take a deep breath. Look at his face. What's that on your face?

CRAWFORD and ANNIE look closely at it and make a noise.

HARRY	What?
ANNIE/CRAWFORD	Fluff!
HARRY	It's not fluff.
CRAWFORD	You're covered in fluff, you'll be needing a razor.
ANNIE	My boy's becoming a man!

CRAWFORD	If he's going to shave do you think the boy might need some trousers?
ANNIE	Some trousers?
HARRY	Trousers! Would you?
ANNIE	Oh I don't know. I could try and sew some but… I'm very busy with all the mending. I don't know now, what do you think dear?
CRAWFORD	You do sew a lot already.
ANNIE	Mm. Women sew and men… men…
CRAWFORD/HARRY	Drink!
ANNIE	Yes. Men drink!
HARRY	Can I get trousers? Is it time?
ANNIE	If you stop whining like a girl and act like a man….We'll see.
CRAWFORD	Eat your dinner.
ANNIE	Don't sing at the table! If you sing at the table /you won't get married for forty years.
CRAWFORD	You won't get married for forty years.
HARRY	You two did!
CRAWFORD	You call that singing?

HARRY goes.

MAN	See them through the window in the rotting milky light.
WOMAN	A man and his wife, conversation in the night.

144

ANNIE Does it look like a tent?

CRAWFORD What do you want with another
 dress?

ANNIE I thought we might…

CRAWFORD What?

ANNIE Go to the theatre or dancing.
 I thought…

CRAWFORD You thought we might go dancing?

ANNIE I just…

CRAWFORD So you'll get dressed up to the nines
 and we'll be walking out the door
 and then you'll change your mind.

ANNIE I don't plan it that way.

CRAWFORD No.

ANNIE We made it to The Tivoli that night.

CRAWFORD We did. / *The Monster and the Girl.*

ANNIE *The Monster and the Girl.* /I was
 terrified.

CRAWFORD That monster didn't even /look real.

ANNIE But you put your arm around me and
 I felt safe. You held me tight until
 they slaughtered him and I was so
 glad when he died. But the look the
 usher gave us.

CRAWFORD He probably fancied you. If I'd have
 seen him I would've/

ANNIE It wasn't that. He looked at us both,
 at us together…Something he saw…

CRAWFORD What?

ANNIE When we're out together sometimes
 people…look at us that way/

CRAWFORD I don't know what you mean.

CRAWFORD and ANNIE sit in silence.

MAN Lights going off up and down the
 street.

WOMAN Bulbs snap to black in windows.

MAN Things said like stars in a galaxy.

WOMAN All the things left unsaid, the
 darkness between.

MAN Up in number eleven Tommy
 Bracken gives Elizabeth Bracken a
 slapping.

WOMAN In number nine Kevin Johnson
 picks at the hogget, gobbles it quick,

MAN Before he gets caught – smacked on
 the wrist.

WOMAN In number three the mother stares
 from the wall, accuses him of things
 she could never say out loud,
 reminds him to watch his back.

ANNIE gets up and closes the curtain.

MAN Say your prayers, touch wood,

WOMAN Bad luck awaits, peeks through door
 slits, ready to get you.

HARRY passes through on his way to bed.

CRAWFORD Harry?

HARRY Yes.

CRAWFORD Where's the bird?

HARRY Out the back.

CRAWFORD She better stay away from my
 garden.

ANNIE Don't let her near his precious
 tomatoes!

CRAWFORD Don't you start Annie! Did you
 clean your shoes for tomorrow,
 son?

HARRY Yes.

CRAWFORD Did you give your mother a kiss
 goodnight?

HARRY Did you?

CRAWFORD Yes.

HARRY You didn't.

CRAWFORD Not yet. Kiss your mother and tell
 her/

HARRY/CRAWFORD Sweet dreams and sleep well.

CRAWFORD I'm going to check that bird hasn't
 dug up my beauties.

He goes. ANNIE gives HARRY a little hug.

HARRY Mrs Bone was asking me…

ANNIE Mrs Bone was asking you what?

HARRY What he does with all those
 tomatoes.

ANNIE And what did you say?

HARRY Said that while he waits for them to
 go red he tells them things he can't
 say to us.

ANNIE ruffles his hair.

	Are you afraid?
ANNIE	What have I got to be afraid of?
HARRY	It's just that sometimes you seem… I don't know.
ANNIE	Your imagination gets the better of you. I'm not afraid of anything, love. Things are fine. They're good, aren't they?
HARRY	Yes.
ANNIE	Think of the kiddies at Frog Hollow. Poor little mites who don't even have shoes and dream of no more than picking a fat pocket at the football grounds. You're growing up so fast. You won't…
HARRY	What?
ANNIE	Cause trouble. Not you. You've always been so good.
HARRY	Yes mother. It's just…
ANNIE	Please, no questions about trousers.
HARRY	No mother. It's about…Father. Do you think he sees us from heaven?
ANNIE	I'm sure he does. Though how many of us he sees might depend on if there's a pub up there. Why are you thinking of *him*, boy?
HARRY	I don't know.
ANNIE	Then don't. Don't think about things long past dear. Say your prayers for what's to come.

*He begins to do so. **ANNIE** watches him.*

That's the way.

What are you praying for?

HARRY If I tell you it won't come true.

You think he'll let me keep her?
The hen?

ANNIE He just might. He's got a good heart
Harry.

HARRY If she stays…I'd like to give her a
name…I'd like to call her Lena.

ANNIE Lena? Strange name to choose for
a chicken. What made you think of
that?

CRAWFORD interrupts them.

CRAWFORD Cold out so I covered them up.
We'll be needing the hot water
bottles soon. And your feathered
friend might freeze if there's frost.

HARRY Can I bring her in?

CRAWFORD/ANNIE No.

ANNIE Get some sleep. /Good boy.

CRAWFORD/HARRY Good night.

MAN The husband and wife push the
door shut,

WOMAN Whisper in the dark.

MAN As the boy sneaks that cock past
their room.

WOMAN/MAN Is that how it is?

WOMAN	She jumps under the covers as candlelight dances about on the walls.
MAN	Her toes twitch under the blankets as she giggles.
WOMAN	He gives her the eye, undoes his fly, the buckle of his belt clunks to the floor.
MAN	A little grunt, a sigh, then/
WOMAN	The squeak and strain of rusty springs.
WOMAN/MAN	That's how it is.
MAN	See the boy through the window of the little back room.
WOMAN	Holding that bird and looking out.
MAN	What's he whispering?
WOMAN	A prayer for something better in that stale room.
MAN	As lice from the bird hop up and down his arm.
WOMAN	A branch scrapes at the window and beckons the boy out.
MAN	The secrets hidden in the dark.
WOMAN	Things waiting to be held up under the light.

JOSEPHINE enters.

JOSEPHINE	When I was born I was given away. Father didn't want me and mother...mother.

Got passed on like some stray cat
then the old woman took me. Now
she lies upstairs, will die upstairs
tonight. In the lightest room she will
soon be dead and without her kind
heart the world might go dark.

When she goes cold I'll pack my
bag, go and find Father, knock on
his door.

I stayed with him when the old
woman hacked blood and they
thought I shouldn't be near. That
time she lived and I went back. But
not tonight.

Tomorrow I'll have to track down
Father at some new address.
Cathedral Street. They moved
again. They move all the time
but every place is the same – the
stink of the lanes and gossipy
watch of the women. And in the
house, Father wheezes through the
night. The Birkett sews her way to
salvation, stitch something coarse
into something soft and hope
nobody will notice the seam – cloth
bunched like a prayer between her
fingers.

I'll find their door and stand there.
When they hear me knock they'll
know. They'll open it up and see
me, still young but something about
me – my skeleton of secrets. Smile
and all my teeth might drop like
pebbles and clatter down their hall.

Morning. A rooster crows. CRAWFORD waits at the table.

HARRY goes to pass him to leave for school but is stopped.

CRAWFORD	You told us it was a hen.
HARRY	It is.
CRAWFORD	Then what was that racket this morning?
HARRY	
CRAWFORD	It's a rooster boy and you know what I said about being rid of it. It'll have to go or we will be evicted.
HARRY	No.
CRAWFORD	Go and get the bird.
HARRY	I have to go to school.
CRAWFORD	You heard me boy. And bring the axe as well. I'm going to chop off his /neck.
HARRY	No. Please. Don't chop off her head. She's not doing no harm. Please?
CRAWFORD	Oh, go on then. Go to school. We'll deal with your little friend tonight.

He goes. CRAWFORD goes as well.

WOMAN	Morning Crawford.
CRAWFORD	Mrs Snape.
WOMAN	Some ghastly crowing this morning woke Bubba up. You're keeping a rooster.
CRAWFORD	We won't be for long.

CRAWFORD winks and leaves.

JOSEPHINE enters, followed by MAN.

WOMAN	Who's that then?

JOSEPHINE scowls at her.

MAN	Looks like trouble.
WOMAN	Looks like /Crawford.
JOSEPHINE	Crawford. Does he live here?
MAN	He does. And who might you be?
JOSEPHINE	His daughter.
WOMAN	Didn't know Mr Crawford had a daughter.
JOSEPHINE	Well, there you go.
MAN	And what's your name dear?
JOSEPHINE	What does that matter to you?
WOMAN	We look out for each other, watch for thieves, lend a cup of milk if someone else's has turned sour. Your daddy lives in there.

JOSEPHINE at the door. ANNIE answers. They look at each other for a moment.

ANNIE	You found us.
JOSEPHINE	The old woman died.
ANNIE	Oh.
JOSEPHINE	I can't stay there now.
ANNIE	No.
JOSEPHINE	The undertakers took her.
ANNIE	That's what they do.

JOSEPHINE Her eyes were open when she died
 and full of the fear but they pushed
 them shut. They put her in a box
 and took her up the hill to Edgecliff.
 Half way between…

ANNIE What, girl?

JOSEPHINE Home and the White City
 Fairground.

ANNIE It won't be your home anymore.
 You better come inside then.

JOSEPHINE Wonder if she could hear them
 screaming on the roller coaster.

ANNIE Who?

JOSEPHINE Her in her box.

ANNIE We'll need to tell your father.

JOSEPHINE He doesn't care. Never came to see
 her. Never came to see me either.

ANNIE I know that isn't true.

JOSEPHINE I was sometimes visited by a *woman*.

ANNIE Oh?

JOSEPHINE And sometimes father sent things
 for me but…know him better
 through stories. The old woman
 told me so many. Good stories they
 were too with meat enough on their
 bones for a feed, but you probably
 know all the stories since you
 married him.

ANNIE Don't believe every story you hear.

JOSEPHINE I don't.

ANNIE	He did go to see you.
JOSEPHINE	I must have been out.
ANNIE	He's been busy enough making ends meet, getting money enough to pay for you to be there.
JOSEPHINE	Never asked to live with her. Father chose so father can…
ANNIE	What?

JOSEPHINE shrugs.

JOSEPHINE	So this is the new place. You and father move so often. I used to think it was because you were trying to lose me but then I figured it out. Better than the last.
ANNIE	It's a decent enough street.
JOSEPHINE	Households are like little hotels.
ANNIE	What do you mean by that?
JOSEPHINE	People coming in and out and leaving all sorts of things so you know the lot.
ANNIE	There's a bed here for you as long as you need it. I'm sure your father'll be…pleased to have you here.
JOSEPHINE	And you? Are you pleased to have me here?
ANNIE	I'll do what's decent, girl.
JOSEPHINE	In your decent street. That's good of you. Where is my father?
ANNIE	He's at work. And so is little Harry.

JOSEPHINE	Where does *father* work now?
ANNIE	At The Hero of Waterloo. He's a useful.
JOSEPHINE	I bet.

WOMAN looks through the window. JOSEPHINE sees her.

ANNIE	And now we have our own little hotel with beds to be made and slept in then made up again.
JOSEPHINE	Who is that?

WOMAN turns away.

ANNIE	What are you talking about?
JOSEPHINE	Some woman looking through the window. You didn't see her?
ANNIE	No.
JOSEPHINE	Might have been the hag I saw on the way here. Stared at me like she knew everything passing through my head, started asking questions about who I was.
ANNIE	Neighbours with nothing to do…

ANNIE shuts a curtain.

	Best we mind our own business.
JOSEPHINE	Those eyes. Looked like poor old Mrs De Angelis. It might have been her ghost.
ANNIE	Don't say things like that.
JOSEPHINE	Well who else would she haunt now she's dead?
ANNIE	Josephine!

JOSEPHINE

If you don't like people staring you should take that ugly old crow off the wall. Don't know how you can bear her looking at you like that. Who is she anyway?

ANNIE

She's my mother.

JOSEPHINE

Scares the life out me.

ANNIE

Josephine!

JOSEPHINE

Josephine, Josephine. Why not make it easy and just call me Harry? Harry the son, Harry the daughter and Harry the/

ANNIE

It's not your name.

JOSEPHINE

How do you know? I could well be a Harry like the others.

ANNIE

What are you talking about?

JOSEPHINE

I could change my name. People do.

ANNIE

You're upset. To lose somebody, even someone as old as Mrs De Angelis…

JOSEPHINE

You know, perhaps I am. I was looking through all her things. Things she collected because she thought they were precious. Treasures she hid from me and the other boarders. In the end they were easy to find. Such pathetic hiding places – so while she was lying nearly dead in the other room I was laying out all her jewels on the white bedspread, the one she was afraid to die on in case it stained.

Not much when you look up close. Things like that.

ANNIE Perhaps you should…

JOSEPHINE What? /Shut up?

ANNIE Have a lie down. Perhaps you should…

JOSEPHINE Lie down? I'm not dying.

ANNIE No.

JOSEPHINE I don't need to rest. Do you think she's watching like your mother?

ANNIE Who?

JOSEPHINE Old Mrs D. She knew so many things about us. She knew *mother*, remembered much more than father about that sort of thing but then he is so useless at remembering. She told a good story. She would sit by me as I went to sleep, hunched like some old fish wrapped in a rug and tell me all sorts of things. She told all about father when he was… She told me about how you two met. The things she knew. Sad – all her stories gone to the grave and all that's left is stained petticoats and tin dressed up like silver. Rats picking through it all. That's why I left so quick.

 Don't worry. I won't stay here for long.

ANNIE I didn't say anything about that.

JOSEPHINE Didn't need to. When will the
 Harrys be home?

ANNIE The Harrys?

JOSEPHINE Imagine how funny it would be at a
 party.

ANNIE At a party?

JOSEPHINE Yes. *At a party*. You could say this is
 my son Harry and this is my second
 husband, Harry, second not third,
 right? And this is Harriet, Harry's
 daughter but just call her Harry.
 I call them all that and it means I
 don't even have to open my eyes.

ANNIE We don't often go to parties.

JOSEPHINE No. I remember how dull things
 can be here. You with your sewing
 and him with his tomatoes. I might
 start doing jigsaws. To fit in.

ANNIE Enough.

JOSEPHINE What do you mean?

ANNIE You know.

JOSEPHINE No. I don't.

ANNIE You think I've forgotten the last
 time you came and stayed? You
 think any of us have?

JOSEPHINE How could anyone forget that
 terrible place, the wasps nest out
 the back and the in-bred neighbours
 smashing bottles all night. Is that
 why you moved?

ANNIE	I'm not talking about why we moved. I'm talking about what you did when you stayed.
JOSEPHINE	I…
ANNIE	Don't go digging around like that again.
JOSEPHINE	
ANNIE	Don't. You can stay here because of your father. You can stay here because you need to, since you probably drove the old woman to an early grave but you've got the devil inside you I'm not inviting the devil to stay for long.
JOSEPHINE	Devil don't want to be here.
ANNIE	You'll need to find some work.
JOSEPHINE	I will.
ANNIE	There are jobs at the arsenic factory.

JOSEPHINE glares at ANNIE.

	They'll be home soon. I need to get the tea ready.

ANNIE goes.

MAN	Look at her there staring up at nicotine stained plaster vines on the ceiling.
WOMAN	Sour little thing. No wonder he's kept her at bay.
MAN	And what of the mother?
WOMAN	Died of fright in childbirth!

JOSEPHINE	Last time I stayed with *Dad* I had a little dig. Dig in the dirt, through drawers, piles of things in the shed. Things someone buried or hid, hoped would be forgotten. Some wiggling worm's coming up to the surface. Dug about and I found things. A tin. Not so well hidden – full of feeble little secrets. I showed the boy, we went through all the things inside. Things that didn't seem to belong to anyone. The boy held them up, kept asking questions and then we found the name on things… Lena. Lena…
	Burrowing. I found the thing in father's drawer. The snake the… smelt it, held it, it made me laugh. Father heard me giggle, caught me with it, his drawer open and me with my fingers squeezing the… thing, rolling the thing about in my hands.

JOSEPHINE laughs.

	I held it between us and asked him; *Is this thing yours?*
ANNIE	*[Off.]* Come and help me with the potatoes, girl. Josephine?

JOSEPHINE rolls her eyes and goes the other way.

MAN	The door slams. She runs up the street.
WOMAN	Up the hill, down the hill hear the sounds as they get closer?
MAN	The sideshow on the wind?

WOMAN	The accordion playing songs for men who hide from war.
MAN	Dirty children run in circles giggling.
WOMAN	Toffee apple grins, fairy floss fingers.
MAN	The rides and the freaks in the little alley at the side.
WOMAN	Twins born sisters but now bearded brothers.
MAN	The chicken man and his cock-cock-cocky old rooster lady.
WOMAN	The girl who cut off her head with the butcher's knife, swapped it with her brother's, sewed them both back and then fooled mummy.
MAN	The boy who grew a tail and wagged it so hard it knocked the vase off the table, daffodils all over the floor.
MAN/WOMAN	And him.
JOSEPHINE	There he is.
MAN	Throwing darts at the balloons near the fat lady who shouts;
WOMAN	Danny Dart's never missed,
	Come and see him throw,
	Try and beat him without cheating,
	Come and have a go.
MAN	And I see her…

He winks at JOSEPHINE.

JOSEPHINE	Danny sees me and he nods, I feel myself blush. Hello.
	He always gives me a shot for free, stands behind me, holds my arms as I point the sharp dart and
JOSEPHINE/WOMAN	POP.
MAN	Darlin'
JOSEPHINE/WOMAN	POP.
JOSEPHINE	He tells the fat thing;
MAN	I'm taking me tea break.
JOSEPHINE/WOMAN /MAN	POP.

WOMAN nods, picks at her fingernails with a dart as he leads JOSEPHINE away.

JOSEPHINE	But Danny don't drink tea.

He drinks from a hip flask.

	He takes me round the back where it's quiet, touches my cheek and says/
MAN	It won't be long and I'll have money. We can leave this and be together.
JOSEPHINE	He kisses me, tongue all over mine. His hands reach up my skirt and as the day melts away into night, carnival music in my ears, I close my eyes and I see pretty lights and laughing clowns as he has his way with me. Lights all dancing and someone screaming in the distance. Danny fucks me. Whispers in my ear – whispers;

MAN	Better get back to work.
JOSEPHINE	See you soon?
MAN	You bet my sweetheart.

ANNIE starts singing.

JOSEPHINE	I stand near the queue for the bearded lady and watch Danny go back. Walk home thinking how it's going to be, the two of us…
ANNIE	Where did you get to?
JOSEPHINE	I had a walk.
ANNIE	Fresh air's good for you. Nice flush in your cheeks.
	Look at that. You've stained your dress. What is it?

JOSEPHINE shrugs.

	I want to have a talk.
JOSEPHINE	Oh?
ANNIE	Things went wrong before didn't they Josephine?
JOSEPHINE	They did.
ANNIE	I didn't mean to… Since you'll be staying here for a while…let's start again shall we? Your father'll be home soon and the boy and… I'm sure it'll be nice. The four of us. I know last time you stayed you were younger, sillier. I can see you've grown up so I'm going to be decent and give you a chance.

JOSEPHINE sits down, hands in lap, and fiddles with a ring.

JOSEPHINE	I saw some soldiers on my walk.
ANNIE	I'm sure you did.
JOSEPHINE	Father didn't go to war.
ANNIE	No, he… where did you get that ring?
JOSEPHINE	From the old lady. She gave it to me before she died. Because I'd grown up so much.
ANNIE	It's lovely.
JOSEPHINE	Don't look too close.

ANNIE goes.

WOMAN	A man in a suit and a hat and tie coming down Cathedral St. / Copper!
MAN	Copper! It's the copper who came when the Murphys fought.
WOMAN	And the one who nicked Eddie Bracken.
MAN	Where's the copper heading?
WOMAN	Who's in trouble now?
MAN	Curtains gape open,
WOMAN	Heads pop over fences.

We hear ANNIE singing.

He's at number three! Crawford's door!

Knock at the door.

Bet it's the girl. Wonder what she's done?

Another knock.

JOSEPHINE	Birkett is oblivious; a toad singing at the sink.

JOSEPHINE opens the door and stares at the cop.

WOMAN	Neighbourhood spies dive to hide.
JOSEPHINE	Hello. What do you want?
MAN	Is your mother in?
JOSEPHINE	The singing hag out by the sink is not my mother. Who might you be, sir?
MAN	I've been sent by the courts. I'm looking for a Mrs Falleni. Is she in?
JOSEPHINE	Mrs Falleni?
MAN	Yes.
JOSEPHINE	The bullfrog's Birkett not Falleni.
MAN	And you are?
JOSEPHINE	Josephine.
MAN	Josephine who?

ANNIE enters.

ANNIE	Someone at the door?
	Why didn't you say? Hello.

ANNIE pushes JOSEPHINE towards the kitchen.

Go and keep an eye on the stew girl.

JOSEPHINE pauses then goes.

How may I…

MAN	I'm looking for somebody. A Falleni. Eugenia, sometimes known as Lena Falleni. Do you know or have you ever heard of her?
ANNIE	Lena? My son has a chicken of that name. But I can't imagine you're…
MAN	She is in no trouble. I have some information concerning the death of a relative.
ANNIE	That's sad. But since I don't know her…What sort of name is Falleni?
MAN	I believe it is Italian.
ANNIE	*Italian.* I see. I certainly know no Italians. We're a decent neighbourhood. Is there anything further?
MAN	No.
WOMAN	As the copper goes curtains snap shut in front rooms along the street.
	Who's caused the trouble? Is one of the *ladies* in the house up to no good?

JOSEPHINE stands behind the woman.

Who's done what behind whose back?

JOSEPHINE passes WOMAN and glares at her. Worried, ANNIE sits at the kitchen table.

✾✾✾✾✾

MAN	The men are at The Tradesmen's Arms.

WOMAN	Yellow tiles to the shoulders. /The stench of beer.
MAN	The stench of beer.
WOMAN	They swill, they smoke, joke.
JOSEPHINE	I follow the copper to the pub.
	/Copper goes inside.
WOMAN	Copper comes inside.
JOSEPHINE	See him at the bar – jangling coins in his palm.
MAN	Thinking of finding Falleni, then thinking of ale.
JOSEPHINE	Father's in there, he's near.

CRAWFORD *stands next to the cop.*

	He's just near that Cop; they're both at the bar.
CRAWFORD	/Evening.
MAN	Evening. Getting cold out.
CRAWFORD	Freeze off your balls.
MAN	You're tellin' me.
CRAWFORD	You come here much? Not seen you here before.
MAN	Not from these parts – no.
WOMAN	What can I get you, loverly gents?
CRAWFORD	New barmaid.
MAN	She's copping a few looks from the boys.

CRAWFORD	She's got more teeth than the publican's wife.
MAN	But does she bite?
WOMAN	Last drinks.
MAN/CRAWFORD	For the road?
MAN	Go on then.
JOSEPHINE	Father and the cop drinking inside.
	Me at the window, the barmaid snarls;
WOMAN	What do you want here girl? You know the rules. It's closing time. Clear off.
JOSEPHINE	I'm looking for my/
WOMAN	Everyone's looking for their daddy. He'll be out soon enough and if I were you I'd wait down the street away from what's about to hit you.

JOSEPHINE moves and waits on a wall.

ANNIE	It's back – the creeping feeling – something gnawing – dog at a bone, the feeling, starts again. Everything held together – bound together with anything we can find to keep it tight but it's all coming loose – getting ready to fall apart.

ANNIE packs a suitcase to leave.

JOSEPHINE	Men from the swill pour onto the street.
WOMAN	The copper, Tommy Bracken, Harry Crawford, full of piss.

MAN	*[To JOSEPHINE.]* Hello hello what have we got here then? A pretty young whore?
JOSEPHINE	Let me be, I'm waiting for my Father.

As she says this CRAWFORD passes JOSEPHINE.

	Father? Father /doesn't hear me. Doesn't see me in the dark leant on the peeling paint.
WOMAN	Doesn't hear her. Doesn't see her in the dark leant on the peeling paint. /He just walks past.
MAN/JOSEPHINE	/He just walks past.
JOSEPHINE	He walks past and I don't know what to say and I don't know how to say it and I can't follow.
MAN	Street empty now.
WOMAN	And as if she's been drinking, that girl on the wall, as if she's just downed the beers and turned the glasses over on their heads – her muttering/
JOSEPHINE	Father/
WOMAN	But not moving/
JOSEPHINE	Father/
WOMAN	Whispering it at first, repeating it like all her marbles are lost and rumbling down the lane.
JOSEPHINE	Father?
WOMAN	Gets louder and harder then/

JOSEPHINE	Mother!
WOMAN	She drowns out the tram/
MAN	Stops the dog up the street who sniffs the bitch on heat/
WOMAN	Stops the mice and the fleas the rats the bugs.
MAN	Even Mrs Bone misses a beat – slips on the pedal as she plays herself a sad old song.
WOMAN	Some grey man pissing in the laneway stops – looks around/
MAN	That you Vera?
WOMAN	Piss dribbles on his fingers and shoes. But no mother comes.
MAN	Mother? She was shouting for her daddy.
WOMAN	That's not what I heard.
MAN	Clean your ears out, love.

ANNIE's packing is frantic. She stops, stares at the picture of her mother on the wall.

	It's dark in the street.
WOMAN	The corner shop's shut. /Crawford's coming back.
MAN	Crawford's coming back. Wonder what to?
WOMAN	Did that Copper drop a bomb?
MAN	Who's been done and what did they do?
WOMAN	That rotten girl?

MAN	Birkett, the boy?
WOMAN	The whole damned lot of them?
MAN	The cops might lock them all away.
WOMAN	The eyes of the mother in the picture glare. Why they hung her up to smudge their lives in her face she will never know, but whatever's coming to them they deserve and she can't wait to see them get it.

CRAWFORD enters whistling.

ANNIE	There you are then. Is it cold out?
CRAWFORD	Getting so.
ANNIE	What were you whistling then? I could hear you coming up the street.
CRAWFORD	Did you think I was the dunny man with his big brown hands? Or the ice man with his blue ones. The paper boy? No! It was Tally-ho with a love song for his darling.

CRAWFORD tries to cuddle ANNIE and play about at a dance but she pushes him off.

ANNIE	You're drunk.
CRAWFORD	Not. Just had the one. What's wrong?
ANNIE	Josephine's come. The old woman's dead.

CRAWFORD sobers.

CRAWFORD	Dead?
ANNIE	Sad news.

CRAWFORD	Terrible. She was old but I did not expect…
ANNIE	The girl's in shock.
CRAWFORD	Shock?
ANNIE	Saying all sorts of nonsense.
CRAWFORD	Like?

ANNIE shakes her head; she doesn't want to talk about it. CRAWFORD touches her on the shoulder.

	Harry will be pleased she's come. They always seem to have such fun. Remember that day at Billy Goat Swamp? The picnic. How they hid and we thought we'd/
ANNIE	What I remember is the trouble she caused.
CRAWFORD	There was that.
ANNIE	Another mouth to feed.
CRAWFORD	We'll manage.

JOSEPHINE enters, overhears.

	She won't stay long. And she won't go snooping again. She learnt her lesson.
ANNIE	She's always at me.
CRAWFORD	What's she been saying this time?

JOSEPHINE comes into the room and stares at CRAWFORD. He doesn't get up.

JOSEPHINE	I went to find you but I wasn't sure where to look. I tried to get into the

hotel but they pointed me to that back room.

CRAWFORD The sow's hole.

ANNIE A hotel's no place for a woman.

JOSEPHINE Did she tell you?

ANNIE Tea's ready.

JOSEPHINE Did she tell you?

CRAWFORD Yes and I'm sorry for your loss. Did she suffer?

JOSEPHINE It was horrible. She screamed like an ogre from the pain and she wet herself with sweat and urine. She hacked up blood and…no. She died in silence.

ANNIE Eat your tea.

JOSEPHINE Not hungry. Whatever it is smells like death.

ANNIE Death?

JOSEPHINE Death everywhere all around me and what am I to do?

Pause.

CRAWFORD You can stay here.

JOSEPHINE Then what? I got no job.

CRAWFORD You can find one. A girl like you.

JOSEPHINE As somebody's maid? How long will that last?

ANNIE Perhaps if you watched your tongue a bit.

CRAWFORD Annie.

ANNIE You've had a shock. Let's all have
 some peace. Eat up and be quiet.

They eat.

 When you're done there you can
 get some rest. You'll sleep in the
 front room.

JOSEPHINE I'd like to wait up for Harry.

CRAWFORD He'll be late tonight. Old Mrs Bone
 sends him here and there in the
 dark of night. Treats him like her
 slave boy.

JOSEPHINE But there's a storm coming.

CRAWFORD He's a big boy.

ANNIE takes JOSEPHINE's plate.

ANNIE Go and lie down dear. I'll bring
 some warm milk.

JOSEPHINE But you'll tell? About…

ANNIE Not now girl.

JOSEPHINE Then when?

She goes. CRAWFORD notices the case that ANNIE has packed.

MAN And through the slit in the curtains
 I can make them out. Is he saying?

CRAWFORD Packed your things again I see
 Annie.

ANNIE returns and faces CRAWFORD.

WOMAN What's being said?

MAN Something like this?

ANNIE	That girl is a plague, she always brings trouble. The police came today. I'm not having the boy raised around this.
MAN	Or something like this?
ANNIE	They came looking for Falleni.
CRAWFORD	How would they…
ANNIE	Maybe the dead woman planned it all. Mix up some name in a letter to plant a seed of doubt so they investigate. All they need to do is knock on the door and every neighbour's tongue is wagging.
CRAWFORD	She wouldn't have…
ANNIE	Wouldn't she? Everybody watches us. Will we have to live like rats… hidden in the dark?
WOMAN	Or this?
MAN	Maybe it's like this?
CRAWFORD	Tell me about what?
ANNIE	It's nothing at all love. A copper came to the door looking for some foreigner.
CRAWFORD	A foreigner?
ANNIE	An Italian. Odd mistake – but the way people move about, guess they just had the wrong address. The neighbours must have thought we had ourselves a bit of trouble but the Copper left soon enough. How's the stew?

CRAWFORD Needs salt.

CRAWFORD stands behind ANNIE and puts his arm around her. They are silent.

MAN The girl in the front room sits on the spare bed.

WOMAN Wind outside blows secrets about – things tapping at windows.

MAN Shadows dance on walls.

JOSEPHINE/WOMAN Distant thunder comes closer.

JOSEPHINE The blanket. Wool scratches my neck and arms.

 The sound of rain, someone laughing up the street.

 Feel hungry but I couldn't eat dinner. Think of the sideshow, the lights swinging in the wind and fizzing in the rain. Danny Dart.

 The old woman's gone. The smell of her room – bible next to the bed, John the Baptist's head on a platter.

 Overheard the truth whispered once while I lay praying in the dark.

 Now I know to close the door and not bother praying.

HARRY enters with milk.

HARRY You awake?

 Mother told me to bring this in.

JOSEPHINE Thank you. You worked late.

HARRY Yes.

JOSEPHINE	Why are your fingers crossed?
HARRY	Mrs Bone and I… We saw a white horse.
JOSEPHINE	So?
HARRY	If you see a white horse you have to keep your fingers crossed until you see a dog.
JOSEPHINE	Or what?
HARRY	I don't know.

She wrestles with him and gets him to uncross his fingers.

JOSEPHINE	Now you'll find out.
HARRY	I'm sorry to hear the news about your grandmother.
JOSEPHINE	She wasn't my grandmother. I was taken to her by… *Father* when I was very young. She used to tell me she was my grandmother.
HARRY	But she wasn't?
JOSEPHINE	What difference does it make? That's what she wanted to believe.
HARRY	Who was she?
JOSEPHINE	Some barren old woman who couldn't do better than stillborns. She told stories of how she kept trying and every time cords wrapped around their necks or…
HARRY	Why did you live with her?
JOSEPHINE	So father could work.
HARRY	What happened to your mother?

JOSEPHINE looks away.

JOSEPHINE You learnt to whistle yet?

HARRY shakes his head.

 Have things been good here? Since
 you moved?

HARRY Mother sews and he smokes and
 mutters away at his tomatoes.

JOSEPHINE All the secrets they must know.

HARRY I have a chicken. A rooster.

JOSEPHINE Which then?

HARRY A rooster. Lena.

JOSEPHINE Lena?

HARRY *[Whispers.]* Because of the name on
 the tin we found. Those things in
 the tin in the shed. I thought…

JOSEPHINE Finding that was our secret Harry.
 Don't you remember what I said?
 You don't think things through do
 you? What did my father say when
 he heard the bird's name?

HARRY The only thing he says is if she
 keeps waking us up, he'll kill her.

JOSEPHINE He couldn't kill a flea.

HARRY Been trying to blindfold her so she
 thinks it's dark and stays quiet.

JOSEPHINE laughs.

 Sorry about the secret.

JOSEPHINE Bit late now.

HARRY	Yes.
JOSEPHINE	Look at your face, like the bearded lady.
HARRY	A bush ranger!
JOSEPHINE	All that fluff.
HARRY	Your father's going to teach me how to shave.
JOSEPHINE	I bet he is.
HARRY	It's Saturday tomorrow. No school!
JOSEPHINE	We can go and see the freak show. See the porcupine lady.
HARRY	The big fat man. Maybe we'll beat Danny Dart. /POP.
JOSEPHINE	/POP. Maybe not.
HARRY	But if we go we can't tell mother. She doesn't like the fairgrounds, the folk there frighten her. People like that.
JOSEPHINE	People like what?
HARRY	Mother'll make us go to the gardens. For the *fresh air*. She's going to make me trousers, Josephine what's a fuck?
JOSEPHINE	A fuck?
HARRY	Yes.

JOSEPHINE laughs.

JOSEPHINE	You don't know?
HARRY	

JOSEPHINE	I could tell you but I reckon you should ask your mother.
HARRY	Really?
JOSEPHINE	Yes.
HARRY	Thank you. I should let you rest. Goodnight.
JOSEPHINE	Goodnight.

HARRY goes.

MAN	The boy's light snaps shut.
WOMAN	And so does the girl's.
MAN	What do we know about the lady and lord of the manor?
WOMAN	About what do they do? The two of them?
MAN	Yes. What do they do in bed?
WOMAN	They lie under blankets in a candle lit room – looking forever into each other's eyes, a joke, a story /a
MAN	No. He tells her it's time and turns out the light/
WOMAN	He reaches into the drawer for the... *thing.* /Ooh yes!
MAN	/Ooh yes!
WOMAN	He rolls it and slaps it between his hands.
MAN	He covers her mouth as he rips up her gown/
WOMAN	One hand over her eyes, the other clutching the end of it,

MAN	He parts her legs, fumbles a bit and rams it right up her/
WOMAN	No.
MAN	Yes.
WOMAN	No. He doesn't go into the bedroom at all.
MAN	Then what?
WOMAN	She knits, waits, sighs, gives up. Turns out the light.
MAN	Seeing all the lights are off, he creeps through the house, out the back door crosses the grass, goes into the shed.

*CRAWFORD **lights a candle.***

WOMAN	He's reaching about behind the tools to find
WOMAN/MAN	The little tin.
MAN	Butterflies on the lid.
WOMAN	Pale blue wings flutter on the rust.
MAN	Through the crack of the door of the shed.
WOMAN	The whistling man and his butterfly tin.

*CRAWFORD **opens the tin. He slowly goes through the items, looking at them, carefully placing them out.***

	Leave him some privacy.
MAN	Don't you want to see?

*WOMAN **smiles. She does.***

WOMAN A little doll,

MAN A photo of some man and a girl.

WOMAN A cufflink?

MAN A yellow ribbon,

WOMAN A hair brush.

*CRAWFORD **hums softly.***

MAN A handkerchief with an
 embroidered peach.

WOMAN No whistling in there. Is he
 humming under his breath?

MAN In the stillness, yes. The things from
 the tin sitting there next to the tools
 on the bench in the shed.

CRAWFORD I'm sweeping and Mother calls
 me in. My brothers and sisters
 surround her swarming, buzzing;
 mutts needing more attention than
 they'll get – Mama telling – yelling
 that since I am the oldest I will need
 to learn about sacrifice, that she
 cannot do all this alone. The look
 on her face because she knows can
 see father is ill, that father will die
 and when he does, she just sits there
 glaring at his cold body laid out on
 the bed.

 Father's pillow, faint smell of tobacco
 and sweat, reaching for his clothes in
 the wardrobe, his trousers round my
 legs, his cap over my ears and I go
 that night. Take flight while they all
 sleep, run from being my mother's
 slave – free for the first time.

One by one, he puts things back in the tin.

> That salty boat, the smell of
> paraffin, gulls circling, diving – all
> those men – none of them know –
> I'm one of them – me and them and
> then us, the drink and the jokes. I
> realise I am free. Free.

CRAWFORD thinks about the ship and then comes to.

WOMAN	Behind the tools.
MAN	Behind the door.
WOMAN	He hides the tin.
MAN	A quick trip to the dunny.
WOMAN	A quick wee and then into bed with her. /Her.
MAN	He sits on the seat. Door ajar pale yellow light and he's/
WOMAN	Humming something tuneless again/
MAN	Humming something tuneless – and then he's looking down between his legs/
WOMAN	There's a drop of blood in the water and another and another/
MAN	And he's sitting there /cursing
CRAWFORD	*[Muttered.]* Curse this curse – flaming mutt of a friggin cunt

HARRY enters.

WOMAN	Muttering – dabbing with little squares of newspapers/

MAN	He doesn't hear the footsteps pad on the grass.
WOMAN	Doesn't hear the cough. Doesn't see the shadow in the pale spill of light.
MAN	And then /the boy is there.
CRAWFORD/WOMAN	The boy is there.

CRAWFORD and HARRY face to face.

WOMAN	The boy and the blood in the pale yellow light.
MAN	The Harrys.
WOMAN	One looking up.
MAN	One looking down.

They are both frozen in the moment.

CRAWFORD	Harry?

The boy runs.

Harry?

A storm begins.

MAN	What has been said fits into a crack in the earth before the rain.
WOMAN	What hasn't been fills the sky above.
MAN	You can see it all when the lightning cracks.

Lightning cracks.

Saturday morning, sunshine after the storm. We hear Lena crow.

ANNIE unpacks her case. CRAWFORD passes her whistling and gives her a kiss. He heads out to the garden and picks snails from his tomatoes and drops them into a bucket of salt.

HARRY enters with Lena. He has slept outside and he's very wet. He watches CRAWFORD for a time until CRAWFORD notices he's there.

They can't bring themselves to make eye contact so they focus on the bird.

CRAWFORD	Good morning Harry.
	She's a pretty chook isn't she? Something about her. Here's me saying we'll have to do away with her when… she's a part of the family now.
	Your mother's excited about the picnic today. She's been looking for you. I think she wants to measure your legs. For trousers.

HARRY puts Lena down and goes.

	Harry…
	You will be good won't you? You won't…

ANNIE and JOSEPHINE set up a picnic around them. JOSEPHINE scratches her legs.

	Stop scratching. What are you, a dog?
JOSEPHINE	It's the bed bugs.
ANNIE	Not in my house. Tell your daughter to mind her tongue.
CRAWFORD	Mind your tongue.

ANNIE	Things are so fresh after last night's rain. Like it washed everything away. And Daddy found snails on his tomatoes this morning. Tell them.
CRAWFORD	They were sliding up the stem.
ANNIE	Lucky we had the salt.
CRAWFORD	Not for them.
ANNIE	No.
CRAWFORD	A sprinkle's all they need and they foam up and die.

HARRY laughs.

JOSEPHINE	That's just plain mean.
HARRY	What's it matter?
CRAWFORD	He's right. What's it matter?
HARRY	There's animals with no point at all. Stupid animals that show God wasn't concentrating properly. There is no point in any of them living. They just annoy us.
JOSEPHINE	Is that what you think?
HARRY	Yes.
JOSEPHINE	Don't they teach you anything at school?
HARRY	Not about snails. And fleas and bugs and slaters. What is the reason for a slater? I'd kill them all. I'd take them from the dirt and muck and kill them like a fuck.
CRAWFORD	Harry!

ANNIE What's got into you?

HARRY looks at CRAWFORD and exasperated gets up and walks away. CRAWFORD motions for JOSEPHINE to follow. She does.

 Language like that and he'll never get trousers.

JOSEPHINE Harry? Harry?

She catches him.

 What are you doing? What's wrong?

 This isn't like you.

HARRY Everything's going to fall apart again. Just like…

JOSEPHINE What do you mean?

HARRY I can't say.

JOSEPHINE Can't say what?

HARRY Do you know?

JOSEPHINE Do I know what, Harry?

 Harry?

 Tell me.

 Tell me!

HARRY Last night I woke up and went out. I didn't realise but your father was in there and I saw… I can't say what I saw. I can't even think of it – what I saw.

JOSEPHINE What did you see?

HARRY	He was in there and…he bled. Blood on the floor. Blood on his hands and…
	Is he sick? He's sick and he's going to die just like father did and mother will be sad again. And we will have to move and I…
WOMAN	What does she say to him? Does she say;
JOSEPHINE	Are you sure it was blood? He was probably fiddling about with his tomatoes.
MAN	Is it that? Is that what she says? Or does she say;
JOSEPHINE	You were probably half asleep and dreaming Harry. Some vision. Look, he's fine this morning. It'll be fine.
WOMAN	Or is it;
JOSEPHINE	I need to tell you something Harry.
HARRY	What?
MAN	There? She's going to tell him there?
WOMAN	There. Yeah. What do you care?
MAN	What's she going to tell him? What words will she use to say it?

CRAWFORD **approaches them.**

CRAWFORD	You two should come and have something to eat. And Harry?
HARRY	Yes?

CRAWFORD Behave yourself and watch your
 tongue. For your mother's sake.

*There is a moment of uneasiness between the three of them
then we hear a pianola and drunken singing.*

WOMAN Saturday night. Cathedral St.

MAN Pianolas wheeze, ale bottles clink.

WOMAN Rat on a pipe watches through the
 window.

CRAWFORD We should go out.

ANNIE Out?

CRAWFORD Dancing.

ANNIE Where would we go dancing?

CRAWFORD Somewhere with an orchestra and a
 chandelier. You could wear that new
 dress. I'll watch the eyes of every
 man in the room turn and see you
 when we walk in... would you like
 to do that?

ANNIE I'd like to dance with you but...

CRAWFORD reaches out for her.

MAN Is it like this? Between them?
 In there?

WOMAN While the trams rattle past and they
 massacre songs up the road in the
 smoke-filled boarding house.

ANNIE pulls away.

CRAWFORD What's the matter?

ANNIE I thought somebody was watching.

CRAWFORD Watching what?

She turns away to shut the curtains.

ANNIE	It feels queer.
CRAWFORD	Queer?
ANNIE	It's Josephine. She watches us. Sees all sorts of things…
CRAWFORD	Then I shall call out and wake her right now and tell her she should leave.
ANNIE	Don't be silly.
CRAWFORD	Then… What?
ANNIE	She knows.
MAN	The music next door stops.
WOMAN	A clock ticks on the wall.
MAN	A dog barks and the boy comes in.
HARRY	Goodnight.
CRAWFORD/ANNIE	Goodnight.
MAN	A hacking cough in the distance/
ANNIE	Don't let the bed bugs/
WOMAN	Then nothing but the clock again/
ANNIE	Bite.
CRAWFORD	Of course she knows. She knows everything.
ANNIE	But the boy…
CRAWFORD	He doesn't watch us like her.
ANNIE	With her here things get more complicated. She might tell him what she knows. And not just Harry.

CRAWFORD	Why would she do that?
ANNIE	That look she gets in her eyes. I see it. I just worry.
CRAWFORD	Don't worry now. Josephine's asleep. The whole world's asleep, love.
ANNIE	Dreaming about how to get us, no doubt.
CRAWFORD	What do you want us to do? Hide?

They stare at each other.

	Annie? Do you remember that day at Clarke's?
ANNIE	The first day I saw you.
CRAWFORD	I'd seen you before that.
ANNIE	But we'd never…
CRAWFORD	No. When you first saw me, what did you think?
ANNIE	When I first saw you? Harry, I…
CRAWFORD	No, what did you think?
ANNIE	I thought you looked decent.
CRAWFORD	Decent?
ANNIE	Yes. I thought I'd be proud to walk through town with that man on my /arm.
CRAWFORD	/Arm in arm, right through the centre of the city. The two of us together.

CRAWFORD and ANNIE stare into the distance.

MAN	Is it like that?
WOMAN	Or more like the rest?
MAN	Tommy Bracken's back hand swinging after drink.
WOMAN	Moira Murphy sobbing for her son dead in a ditch in Dunkirk.
MAN	The silence of the Snapes as cigarettes burn down and newspapers yellow.
WOMAN	Broken bottles, chipped promises.
MAN	Just like every house on the street.

The light goes out.

JOSEPHINE checks the coast is clear and leaves the house.

CRAWFORD cannot sleep. He returns and drinks at the table.

CRAWFORD	That salty boat, gulls circle and dive and shit on everything – all those men – and their drink and smut/
JOSEPHINE	Slip out in the dark, go down to the freak show – the fairground the dancing lights and the wind-up sounds, know where he'll be. There he is. Danny! Danny? He drags on the last of a cigarette, throws the butt, points a dart. POP. /He don't see me.
CRAWFORD	They don't see. I hide my secret well until one night plain and bright as the stars in the sky – the captain sees. He pulls me aside tells me to report to his cabin. A little drink together and we talk and talk. A slip of the tongue and him locking the

door as he says: *There's something I've noticed about you.*

JOSEPHINE

Then there's this woman this girl in a red dress, big mouth like a dog and Danny's got his arms round her.

CRAWFORD

The cabin rocks and my lips pursed, my legs together, my arms by my side. His hands reach out – his hairy hands tugging at me as he whispers: Let's find out then Mr Crawford. Let's find out.

JOSEPHINE

His arms round her as if she's me. He whispers something to her and the look, the look he gives her and the way she smiles.

CRAWFORD

First, hands on my buttons then ripping at my shirt, the smell of his sweat the whiskey on his breath – my arms by my side me saying no and his breath as he's saying: We'll see about that. We'll see.

JOSEPHINE

He takes her by the hand, nods to the fat woman who doesn't even stop shouting and Danny pulls her up the alley. I follow and stand in the shadows and hear it, smell it. / Trousers falling.

CRAWFORD

Trousers falling. The ring of the brass belt knob as it hits the floor. His dirty fingers inside me, warm spit from his mouth in mine – close my eyes and I rock with the room. In the cabin in the night out at sea under all those stars. /The price.

JOSEPHINE	The price. No more shots for free now. I shrink into the dark.

JOSEPHINE returns.

CRAWFORD	You scared me half to death. Sneaking out all day and night. Where have you been?
JOSEPHINE	Nowhere.
CRAWFORD	You have.
JOSEPHINE	I've been up at the fairgrounds.
CRAWFORD	The freak show? We know that's where you go.
JOSEPHINE	So?
CRAWFORD	Nothing good'll come of going up there.
JOSEPHINE	You can say that again.
CRAWFORD	What are you doing up there girl?
JOSEPHINE	Nothing.
CRAWFORD	Then don't waste time going.
JOSEPHINE	I won't. If I want a freak show I can stay right here. Harry told me what he saw last night.
CRAWFORD	What on earth do you mean girl?
JOSEPHINE	Want me to say it out loud?
CRAWFORD	Say what?

JOSEPHINE shakes her head in disbelief.

JOSEPHINE	Do you think you can keep it a secret forever?

CRAWFORD	We all have secrets. There's no need to talk about them.
JOSEPHINE	But I need to talk about it. I need to /understand.
CRAWFORD	Talking never helped. People do nothing but talk about things and look at where that gets them.
	I did what I thought was best for you Josephine, you know that don't you?
	Now do the same for me. Go to bed.

She goes. CRAWFORD *remains at the table staring at the bottle.*

WOMAN	Early morning on Cathedral St. A young man in uniform; William Thompson!
MAN	Mrs Murphy.
WOMAN	Leaving today? /Going off to fight the war?
MAN	Going off to fight the war.
WOMAN	I remember the day you were born Billy. Your father staggering home from the pub telling everyone he'd finally had a son. God be with you.
MAN	And with you.
WOMAN	The births and the coffins
	The summer, the cold.
MAN	The dogs, the cats.

Lena crows.

| WOMAN | That blasted bird. |

*CRAWFORD **leaving for work passes them and nods and
whistles as he goes.***

Mr Crawford.

*HARRY **enters petting Lena.***

| JOSEPHINE | Harry? I spoke to Father. About the… He's not dying. He's not sick. He said he's fine so…don't worry. Forget what you saw because it was silly. |

*As JOSEPHINE **stares at HARRY **she suddenly feels unwell.**

| WOMAN | The girl turns white as milk, vomits all over the garden. |

| ANNIE | Lovely that is, all over your father's beauties/ |

| MAN | She runs to the dunny for the second round – door slams, swings back and forth. |

| ANNIE | You alright in there Josephine? Josephine? Go to school, boy. I'll handle this. Off you go. |

*HARRY **goes.***

| JOSEPHINE | Something I ate. |

| ANNIE | And what might have that been then? That you ate? |

| JOSEPHINE | The rissoles? |

| ANNIE | And not the first morning like this is it? I know the signs. |

| JOSEPHINE | Signs? |

ANNIE	Yes. How long has it been?
JOSEPHINE	I don't know.
ANNIE	We better get you to a doctor then. To be sure.
JOSEPHINE	I'm fine.
ANNIE	Get yourself changed. If you can't be respectable at least you can look it.
WOMAN	Smell of antiseptic in the silent waiting room. Nothing being said.
MAN	Nothing needing to be said while the boy is at school, the father at work.
WOMAN	Nothing to begin a conversation with in this room with the curtains drawn, wick alight on dynamite burning down.
MAN	Come through, girl.
WOMAN	Doctor's fingers prod and poke.
ANNIE	Hold still girl, let him have a look.
WOMAN	His fat face blank and then /the news.
ANNIE	/The news. Doctor asks/
MAN	How old are you?
JOSEPHINE	Seventeen.
MAN	And the father?

MAN goes.

JOSEPHINE	Walk home and she's saying:
ANNIE	Last thing any of us need.

JOSEPHINE	Yes.
ANNIE	You do know that don't you?
JOSEPHINE	Yes.
ANNIE	If you're quick. If you're quick then you could deal with it.
JOSEPHINE	You mean?

ANNIE nods.

	Then Birkett rushes ahead – so when she gets to the top of our street she isn't too close to me.
WOMAN	Take a look! The girl who came to number three? Everything alright Annie Birkett? Crawford's girl's not looking so well.
ANNIE	Mind your own!
WOMAN	*[Whispers.]* Have you heard?
ANNIE	Josephine! Come inside!
WOMAN	Expecting a little one at number three.
ANNIE	You better get out and clean off the tomatoes.
WOMAN	You can bet we won't be seeing its Daddy.
ANNIE	Shall I tell him or will you?
JOSEPHINE	I will.
ANNIE	So you've decided?
JOSEPHINE	Yes.
ANNIE	And?

JOSEPHINE	I want to keep it.
ANNIE	You want to keep it? Then you better tell him quick. He may ask you questions but I suspect/
JOSEPHINE	What?
ANNIE	That he won't want to know. Tell him though. Best you do. I won't keep your secret. Do you know who the father is?
JOSEPHINE	Yes. No.
ANNIE	Which?
JOSEPHINE	No.
ANNIE	So we'll be sending you to the nuns then?
JOSEPHINE	To the nuns?
ANNIE	How else do you expect to survive? You can't expect your…you cannot expect us to support you, not with a little one.
JOSEPHINE	I'll get a job.

ANNIE laughs hysterically.

ANNIE	A job doing what? You don't even know the father. No hope. Know what they call girls like you?
JOSEPHINE	No.
ANNIE	You'll find out.
JOSEPHINE	You must know this story. Isn't that what happened to you?
ANNIE	It certainly is not.

JOSEPHINE	Well it happened to father. I can be like him.
ANNIE	What did you just say?
JOSEPHINE	You heard. I'll be like father. Get rid of the kid – fob it off to some old woman and then I can meet myself some decent lady and we can make believe for the rest of our lives.
WOMAN	Eyes meet– blood floods faces.
JOSEPHINE	How dare you laugh at me when you're no better.
MAN	Water bubbles, hisses on the stove.
JOSEPHINE	How dare you call this nonsense when your whole life is pretend.
ANNIE	You think all of this is pretend?
JOSEPHINE	What? You think it's real?

JOSEPHINE laughs in ANNIE's face.

MAN	Birkett turns to the stove, picks up the saucepan/
WOMAN	And hurls it at that little vixen.

JOSEPHINE screams.

MAN	Wet walls/
WOMAN	Steam scalds/
MAN	Burns her arms/
WOMAN	Her hands/
MAN	Her legs/
WOMAN	Her face.
JOSEPHINE	How could you do that to me?

ANNIE

Wish I'd killed you. I want you to leave this house. I never want to hear from you again.

JOSEPHINE goes to the street.

WOMAN

See the girl in the street all wet and red and welting, kneeling, hands on her ears.

MAN

What's happened then what's wrong?

WOMAN

Where is your father dear?

MAN

Time stands still/

WOMAN

Lights wince/

MAN

Words sting/

WOMAN

Blisters bubble.

JOSEPHINE shakes her head, her posture limp.

JOSEPHINE

My father?

WOMAN

Yes.

JOSEPHINE

I never knew him.

WOMAN

What dear?

JOSEPHINE

I never knew him. Not my father. You mean that thing walking around the street? He's not my father. He's my mother.

MAN

Everyone stops still on the street.

WOMAN

No curtain moves,

MAN

No dog barks,

WOMAN

No bug bites.

MAN	The door of number three doesn't open.
WOMAN	You heard what the girl said?
MAN	*He's my mother.* I heard.
WOMAN	Everyone crowds around the burnt girl.
MAN	Her words whirr like music and questions dance about in the fading light.
WOMAN	Things repeated behind hands. We never gossip – never speak ill –
MAN	Never speak out about anybody/
WOMAN	Keep things quiet – mind our own business – but the news it spreads in a matter of minutes.
MAN	If that is the case, if the knocked up girl's not mad/
WOMAN	She's not mad/
MAN	If he is a she pretending to be a he then what does that mean about her/
WOMAN	Who?
MAN	The wife? Does that mean she knows?
WOMAN	She must.
MAN	Then what does that make her?
WOMAN	If she knows then that makes her what?
MAN	And him?

WOMAN	Who?
MAN	Him!
WOMAN	Who? Her?

They laugh.

> Nobody asks the girl in. No cold water, no cup of tea.

JOSEPHINE leaves.

> She just disappears with the light of the day. /And it's nearly six. Clock ticks.

MAN	And it's nearly six – clock ticks.

CRAWFORD enters.

MAN/WOMAN	It's him!
MAN	He's coming!
WOMAN	Him?

She laughs hysterically. CRAWFORD stops suddenly as if he senses he's being watched. He sees nothing.

ANNIE sits in the front room in darkness. CRAWFORD enters and turns on the light.

They look at each other. The bulb breaks.

HARRY	Josephine's gone. They fight in hissed whispers. Can't hear what's being said, just her snarling and him snapping back when she does. On it goes through the night. No dinner. And later when I sneak out to the dunny, mother sits at the kitchen table in the dark, only light the blue of the gas burner – he's nowhere to be seen.

Lena crows.

In the morning their door's shut, nobody about. No fire in the kitchen. It's cold and I just go to school. Out on the street I pass a soldier on a crutch. He's still in uniform but not wearing the smile he left with – his leg disappeared with the smile but I don't know in which order – which one got blown away first. Me and the soldier just look at each other. Feels like somebody should sing something for him. But I don't have a song.

ANNIE surfaces, she looks tired, stares at the picture of her mother then cusses, turns away.

Finish school and I go to Bone's store, Virgin Mary scowls at me from the corner. Mrs Bone there with a cup of tea and a bun for me saying;

WOMAN Something wrong with you today?

HARRY No Mrs Bone.

WOMAN No whistling?

HARRY shakes his head.

Have people been saying things?

HARRY What things?

WOMAN Just a whole lot of gossipy claptrap nonsense rumours. So promise me this, young Harry Birkett…if you hear them don't listen, just block your ears and sing 'God save The King'.

HARRY	Yes Mrs Bone.
WOMAN	Or get your whistling right! Now, there's a box of things to take to Mrs Murphy and then... Harry?
HARRY	Yes?
WOMAN	How would you like some time away? I thought we could go to the seaside. Up to Collaroy? Get away for a bit?
HARRY	I'd like that.
WOMAN	I bet you would. Take the box then...

HARRY stands on the street with the box in the stillness.

MAN	A couple passes Harry...
HARRY	Morning Mr and Mrs Snape, how are you both doing /today
MAN	The couple looks away.

HARRY goes.

	Just the two of them in the house now.
WOMAN	Echoes of it all, of /the day they came here.
MAN	The day they came here – how quickly they moved in, became just like everybody else.
WOMAN	Did they? Just like us?
MAN	That first day I met them I thought they were decent enough.
WOMAN	Her hidden away like a bat?

MAN	*Him* whispering sweet nothings to his tomatoes?

They laugh hysterically.

CRAWFORD	What'll we do now?
ANNIE	Will I leave you or will you leave me?
CRAWFORD	What do you mean by that?
ANNIE	Now the boy's away there is hardly any need to pretend. I won't run again. And we can't stay here.
CRAWFORD	We could try.
ANNIE	Try what?
CRAWFORD	To sort things out. Or we can move on.
ANNIE	Again?

ANNIE gets her suitcase out.

CRAWFORD	Annie please.

CRAWFORD attempts to touch ANNIE but she brushes him off.

ANNIE	You're in my way.
CRAWFORD	Shouldn't we give it one more try?
ANNIE	What's the point?
CRAWFORD	How about we get some fresh air. A picnic? Let things sort themselves out – out in the open.
ANNIE	If that's what you think/
CRAWFORD	Let's try and work things out.
MAN/WOMAN	That last day.

MAN	They leave the house together.
WOMAN	Grim-faced with a blanket and a hamper.
MAN	Clinking bottles in the basket.
WOMAN	He always liked the drink.
MAN	The look on their faces as they come out the door.
WOMAN	And steal up the street. Like…
MAN	Just like…
WOMAN	What? What are they like? Just like what?
MAN	Their arguments trailing them almost caught them up/
WOMAN	Their doubts just jumped onto the tram, they're with them on the track,
MAN	Truths chase them through the bush, hear the twigs snap and the bracken bend, flick back/
WOMAN	The lies hidden in pockets and in the picnic basket, peer through the wicker/
MAN	Their secrets giggle and poke fun – whisper how it must look at a distance when really it's like this/
WOMAN	They find a clearing just down from the flour mills.

ANNIE spreads a red tartan rug.

MAN	He gathers kindling, whistles grimly in the bushes.

WOMAN	He screws up the front cover from yesterday's *Truth*, fiddles with matches, **curses as one after the next burn out – black on his fingertips.** Then finally /he fans the flames.
MAN	He fans the flames. She opens the basket. Some bread and some ale.
WOMAN	He swigs, offers her none,
MAN	She snatches bread,
WOMAN	Tears it, gobbles it down.
MAN	They're alone.
CRAWFORD	This is nice then isn't it?
ANNIE	Nice?
CRAWFORD	Yes.
ANNIE	You're behaving like an animal. Drinking straight from the bottle and pulling me about like a bag. What are we doing here anyway? It's way too late for this.
CRAWFORD	Behaving like an animal because that's how you've been making me feel – like a dog when/
ANNIE	When what? What is it you want to say?
CRAWFORD	
ANNIE	For god's sake. You're the one who thought it might do us some good to get out of the house so we could clear the air. Why you dragged me all the way over here I'll never know, but we're here now, so speak.

Silence. ANNIE laughs.

	But it is the same as ever. You've got nothing to say. I thought it'd be different with us. Remember the stories I told you about the first? About how sad and lonely it was? When I met you I thought it would be different, I thought that we could…
CRAWFORD	What?
ANNIE	What does it matter now? I've been such a fool. Wasted so much time and your own devil of a daughter saw it all for what it is. Like some cheap trick in a sideshow. Everybody knows. Everybody sees you for what you are and if they don't laugh at you then they must think how sad you are, how sad I am because…
CRAWFORD	Don't. We've been doing fine. Right as rain.
ANNIE	You can't think that. Dressing like a man is one thing but thinking like one…We're doing fine?

They look at each other for some time.

	I used to look at you and feel something. When I knew you were coming home, I'd sing. Now I sit in the dark and hope it'll swallow me up.
CRAWFORD	Why?
ANNIE	Why do you think?

CRAWFORD We can move and start again, we
 can make a fresh start.

ANNIE We never had that.

CRAWFORD What do you want to do?

ANNIE I want to get away and I don't want
 you following. I'll take my boy
 away and we can start again. I have
 to be done with you.

CRAWFORD What will I do?

ANNIE You've always survived alone Harry
 Crawford.

CRAWFORD I can't survive without /you.

ANNIE You'll find another if that's what
 you want. You can spot them. You
 found me.

They both sit drinking in silence. It gradually becomes dark.

MAN The light is fading. The darkness
 grumbles deep below.

WOMAN Along the river at the picnic
 grounds, row boats get paddled to
 shore, blankets folded, crumbs left
 for birds.

MAN There's no one else left.

ANNIE You know what I think? Nobody
 made you become what you are.

CRAWFORD That's what you think?

ANNIE Yes. You chose.

CRAWFORD I chose? You think that I chose this?

They look at each other for a very long time.

CRAWFORD gets whiskey from the basket and drinks from the bottle. ANNIE joins him drinking but CRAWFORD stands away from her, he looks out into the distance.

WOMAN	The fire flames crackle and rise.
MAN	The arguments and secrets and stories surround them in the glow.
WOMAN	Do they edge closer on that blanket to keep the secrets out?
MAN	Glare at the stories that twist in the dark?
WOMAN	Drain the things they know away in drink?
MAN	Do they smudge as one in some dark dance they can never have in light?

CRAWFORD and ANNIE dance the dance they could never have together.

WOMAN	In the darkness no one sees,
MAN	In the darkness no one knows.
WOMAN	He says he loves her but his voice is strained and hard.
MAN	He reaches towards her, she pushes him.
WOMAN	He falls,
MAN	She runs.
WOMAN	He scrapes for breath, gets up; he's running back to her.
MAN	He's reaching.
WOMAN	For what?

MAN	Hands grab hands.
WOMAN	A punch,
MAN	A slap,
WOMAN	A sob,
MAN	A scream,
WOMAN	But who?
MAN	Cloth tears, buttons fall. Then some sharp blow,
WOMAN	Breaking glass/
WOMAN/MAN	Thud.

Darkness swallows them.

WOMAN	Silence.
MAN	Silence. /And he runs.
WOMAN	And he runs.
MAN	But can't get away.
WOMAN	Surrounded by echoes of laughter, / songs and fights
MAN	Songs and fights. He packs up boxes, secrets in the night.
WOMAN	Some things left scattered.
MAN	Broken.
WOMAN	Torn. Two chipped tea cups at the sink,
MAN	As the rusty tap drips.
WOMAN	Tomatoes on the vines out back/
MAN	Turned pink at all the things that they've been told/

WOMAN	Grow heavy with rumours/
MAN	Burst red with revelations.

EUGENIA FALLENI enters. She stands silent. Head bowed.

	They find him.
WOMAN	They get her.
MAN	Newspaper headlines: /The Manwoman scandal!
WOMAN	The Manwoman scandal!
WOMAN	The questions, the rumours. The court case.
MAN	The crowd outside the court heaves all breathing strained – all pushing, all waiting to see *it*, to catch its eye.
WOMAN	Women not allowed inside the court make smutty jokes about the way *it* lied.
MAN	Man on the corner sells drawings of *it* with an evil smile.
WOMAN	First day of the trial, it being led like a dog by the cops to the court/
MAN	As something red gets thrown/
WOMAN	Something red explodes/
MAN	Hits the ladies in the crowd/
WOMAN	And as they scream – *it* looks up at us for just a moment.

FALLENI lifts her head and looks out to the audience.

	The truths/
MAN	The lies/

WOMAN The husbands/

MAN The wives.

Beat.

MAN/WOMAN The silence.

MAN and WOMAN leave FALLENI alone gazing out exposed in stark white light.

The lights snap. Black.

LITTLE EMPERORS

I am indebted to the thirty-six people who agreed to share their personal stories and the memories of their one-child experience. Many of these people have asked to remain anonymous.

Thanks to translator of the Malthouse production Hongyi Tian, collaborators Chong Wang and Mark Pritchard and the generous community at Cathay Theatre in Ashfield who allowed me to interrupt their rehearsals week after week to ask them questions about their lives.

In addition, I would like to thank the following people for their contribution to the research and development of the script: Felix Ching Ching Ho, Will Dao, Jane Fitzgerald, Alison M. Freidman, Ross Gannon, Jane Golley, Mengtong Guan, Hannah Jiang Lee, Gisele Joly, Kim Ko, Xiao [Alan] Li, Liam Maguire, Alice Muhling, Alice Qin, Bernard Sam Mun-Kin, Miranda Shao, George Spender, Elizabeth Troyeur, Zhaohui Wang, Susan Young, Shuang Zou and the people who generously shared their stories and experiences.

Little Emperors premiered at Malthouse Theatre Melbourne in February 2016.

Cast

Diana (Xiaojie) Lin

Liam Maguire

Alice Qin

Yuchen Wang

Creative Team

Direction Wang Chong

Dramaturg Mark Pritchard

Set & Costume Designer Romanie Harper

Lighting Design & AV Consultant Emma Valente

Sound Designer James Paul

AV Programmer Andre Vanderwert

Stage Manager Harriet Gregory

Assistant Stage Manager Matilda Woodroofe

Script Translation Hongyi Tian

Surtitles Felix Ching Ching Ho

Characters

KAIWEN
28

HUISHAN
31, Kaiwen's sister also a participant in Kaiwen's
multimedia work

BAOHUA
Late 50s, Kaiwen and Huishan's mother, also a
participant in Kaiwen's multimedia work

ALAN
White, early 30s, the sound operator in Kaiwen's
multimedia work

Notes on text:

/ indicates a point of interruption

// indicates lines delivered simultaneously

dialogue in lowercase is to be spoken in English

DIALOGUE IN CAPS IS TO BE SPOKEN IN MANDARIN*

This work draws inspiration from the Chinese soap operas
popular and omniscient in the 1980s and 90s.
It is my hope that the production will riff in and out of its style.

I imagine a large screen for projection at the rear of the stage
that may be used to set the scene but should be used
for conversations in two places, and to show images vital
to the story from these real and imagined worlds.

*The Mandarin translation used for the first production
is by Hongyi Tian. It is available upon request.

ONE

*HUISHAN **is on a crowded subway in Beijing.***

KAIWEN

Father touches me gently, shakes
me, wakes me, tells me to dress
and hurry and we leave the hotel
room. Mother and sister fast asleep
in bed. He has a suitcase. He puts it
between us on the back seat of the
taxi and we drive through the city at
dawn. The only sound the voice on
the taxi radio. I whisper *father where
are we going?* He doesn't reply. The
taxi stops and father says *get out.* I
hear the sound of boys talking and
shouting. We go into a room and
father tells me to sit and wait. I'm
in that room forever waiting and
father doesn't return. He's already
in the taxi crossing back the way he
came. He's left me in a place I don't
know. And the only thing I know is
I'm alone.

In those first weeks my ears fill with
English and Cantonese. I hate that
sound as much as I hate the food, the
other boys. The strangeness of it all.

The teacher's voice drones as the
clouds appear every afternoon
and hang low. The clouds smother
the school and the entire city. The
clouds want to smother me, the
only boy from the mainland.

I keep out of the other boys' way
and as time passes, I become
invisible.

At night we're sent to lay in our beds in rows. Lying there I can hear every breath every lonely little boy makes.

While other boys dream I slip out and climb the stairs to the rooftop of the boarding house. I stare at the sky and try to figure out which way is home.

I imagine I can fly there, up through the clouds over the mountains and villages.

I imagine it is safe for the secret boy to come home.

BAOHUA appears. She stares out at us and holds a suitcase.

And when the lights of a landing plane shine through the clouds, I hope that plane would be bringing you here, that you'd come to get me, to bring me home.

KAIWEN sees BAOHUA with the bag but she doesn't see him.

He watches her for a time and then leaves.

HUISHAN's train is jolted to a stop. She gets up and looks around.

HUISHAN WHAT WAS THAT? WHAT'S HAPPENED?

We hear a train announcement.

ANNOUNCEMENT PASSENGERS ARE TO REMAIN IN THE CARRIAGES UNTIL FURTHER ANNOUNCEMENTS ARE MADE.

HUISHAN is anxious. We hear her heart beat.

She fades and we are left with BAOHUA. She stares out at us, gripping her bag.

BAOHUA hears a rousing musical introduction.

ODE TO MOTHERLAND.

The music distorts and cuts and her bag is ripped away.

TWO

HUISHAN enters wearing a breathing mask.

BAOHUA	YOU'RE LATE.
HUISHAN	SOMETHING HAPPENED AT WANGFUJING.
BAOHUA	//THEN USE YOUR PHONE!
HUISHAN	//A MAN JUMPED OUT ONTO THE TRACKS.
	THERE WAS HARDLY EVEN A BUMP. WE WERE STUCK. EVERYONE WAS ANGRY BECAUSE OF THE DELAY. THEY DIDN'T EVEN ANNOUNCE WHAT HAD HAPPENED.
	IT WAS HARD FOR ME.
BAOHUA	HE HELD YOU ALL UP.
HUISHAN	I DON'T MEAN THAT…
BAOHUA	NOBODY WANTS TO BE CAUGHT UP IN SOMETHING LIKE THAT.
HUISHAN	NO.

BAOHUA leaves her daughter alone. HUISHAN takes a moment to collect herself.

THREE

CHUFEST – IT'S A BOY.

A midwife enters with bloody hands and holds up a male baby.

*There is rousing music and light shines down from the heavens.
The grandmother enters, covering her face with joy. The father
appears and delighted, takes credit for the birth.*

FOUR

HUISHAN is on a screen: Skype call to KAIWEN.

HUISHAN	LITTLE BROTHER! YOU TOOK YOUR TIME TO ANSWER. / BUSY STUDYING?
KAIWEN	/Hey sis.
HUISHAN	YOU GOT MY EMAIL?
KAIWEN	Yes.
HUISHAN	We were caught in the train for hours. It was horrible.
KAIWEN	Why do people do that?
HUISHAN	I don't know. I was worried when you didn't answer me.

The screen goes fuzzy.

	I've lost you.
KAIWEN	Hang on. I'll move to the other room.
	Better?
HUISHAN	Yes. Stay there. How do you deal with the internet there? It would drive me crazy.
KAIWEN	At least we get Google.

HUISHAN doesn't seem impressed by this.

	Are you at work?
HUISHAN	Just finishing.
KAIWEN	What's that behind you?
HUISHAN	It's a new customer attraction.
KAIWEN	Show me?

HUISHAN turns the device around to show a very large wall aquarium.

HUISHAN	For tourists.
KAIWEN	Are there fish in it?
HUISHAN	Just carp. But the boss is getting a beluga whale.
KAIWEN	To put in there? /How big is the tank?
HUISHAN	There's a hotel down south has one and it's bringing in business.
KAIWEN	Right.
HUISHAN	So… Five more sleeps.
KAIWEN	Yeah.
HUISHAN	You're all set?
KAIWEN	Yeah.
HUISHAN	Mum's excited.
KAIWEN	I THOUGHT YOU WEREN'T GOING TO TELL HER.
HUISHAN	YOU KNOW WHAT SHE'S LIKE. SHE GOT IT OUT OF ME.
KAIWEN	But/

HUISHAN	SHE'S GOT YOUR ROOM READY.
KAIWEN	I never had a room.
HUISHAN	She's making all your favourite food…
KAIWEN	Tell her not to.
HUISHAN	Are you serious? She's been going crazy since she found out.
KAIWEN	Which is why you weren't meant to tell her.
HUISHAN	Doesn't matter now. We'll be together again.
KAIWEN	Yeah.
HUISHAN	You don't sound very excited.
KAIWEN	Just a lot going on.
HUISHAN	What's her name? You can tell me…
KAIWEN	I don't have a girlfriend.
HUISHAN	Too much study. Better to meet someone here when you come home. Local girls are better.
	You know, the train thing freaked me out. We were stuck forever waiting for them to clean up. There was no air and people were angry because they were going to be late home. After we'd been there a while the lady next to me took off her earphones and we spoke. You can tell strangers things you wouldn't say to people, you know.

I told her what happened to my friend Jiake and she held my hand and tried to cheer me up. Asked *WHAT DO YOU HAVE TO LOOK FORWARD TO?* I told her you're coming home.

KAIWEN /You told her about me?

HUISHAN Have you ever wondered... I've tried to add up the days I've seen you during my life. You know it's maybe less than a thousand.

KAIWEN Yeah.

HUISHAN Think about it...

KAIWEN Huishan, I'm not coming back.

HUISHAN What did you say?

KAIWEN I can't come back right now.

HUISHAN Good one. You got me.

A silence.

Kaiwen. You have the ticket. You said...you aren't serious?

KAIWEN I'm sorry.

HUISHAN You're sorry?

KAIWEN I have exams.

HUISHAN It's Mum's sixtieth birthday Kaiwen! Everything is arranged.

KAIWEN It's not like she's told everyone I'm coming.

HUISHAN	Dad knows. Gran and Grandad. The ticket's been paid for. You can't waste it.
KAIWEN	Dad's going?
HUISHAN	Of course he is. It's his duty.
KAIWEN	Ha! Don't start this Huishan.
HUISHAN	//Start what?
KAIWEN	//Why would Dad go after /all he's done?
HUISHAN	/Please, don't.
KAIWEN	If Dad's going how could I go anyway?
HUISHAN	Kaiwen.
KAIWEN	No. Dad going wasn't part of the deal.
HUISHAN	This wasn't a deal.
	I get that you're nervous. It's complicated.
KAIWEN	Complicated? Um yeah like who would I have been?
HUISHAN	Kaiwen, things have changed here now.
KAIWEN	Who would I have been?
HUISHAN	We'll get through the party and then it'll be fun. And I'll be there by your side. We can face all the people together.
KAIWEN	I won't come back and slot in.
HUISHAN	The policy has ended. People know now.

KAIWEN	About me? Who? Who told them?
HUISHAN	They've always known. When you get back you'll see things are different. Please? I've taken time off. So has Mum. There are people she wants you to meet and we're going to take you to all the museums. There is so much stuff you need to know about Beijing… We've made plans for a drive to Qinhuangdao…
KAIWEN	I shouldn't have agreed to come in the first place.
HUISHAN	You don't want to come home.
KAIWEN	Home?

A silence.

HUISHAN	I should never expect anything from you.
KAIWEN	Huishan.
HUISHAN	I'M NOT TELLING HER. YOU HAVE TO TELL HER.

BAOHUA appears next to HUISHAN. HUISHAN turns KAIWEN off the screen.

BAOHUA	I BOUGHT YOU A SNACK.
KAIWEN	Is that Mum?
HUISHAN	Yes.
HUISHAN	*[To BAOHUA.]* I WAS GOING TO PICK *YOU* UP.
KAIWEN	//I thought you were at work.
BAOHUA	//WHO ARE YOU TALKING TO?

HUISHAN	Do you want to tell her now?
KAIWEN	No.
HUISHAN	Please reconsider.
BAOHUA	//ARE YOU TALKING TO YOUR BROTHER?
KAIWEN	//Shouldn't she be at work?
BAOHUA	PUT HIM ON.
KAIWEN	No! I'll call her later.
HUISHAN	You better.
KAIWEN	Tonight.
HUISHAN	I have to take her to the hospital.
KAIWEN	What for?
HUISHAN	I'll tell you later Kaiwen.
BAOHUA	//PUT HIM ON NOW!
KAIWEN	//Huishan, I have to go.

BAOHUA holds out her hand but he's gone.

HUISHAN	KAIWEN SAID HI.
BAOHUA	//BUT
HUISHAN	//HE'S STUDYING. MUM. YOU WANT HIM TO DO WELL? YOU'LL SEE HIM SOON ENOUGH.
	I WAS GOING TO COME AND PICK YOU UP.
BAOHUA	BUT YOU NEED FOOD. I DON'T LIKE YOU EATING JUNK. YOU DON'T WANT TO RISK DAMAGING YOUR

	EGGS. THEY NEED EVERY CHANCE THEY CAN GET.
HUISHAN	I'LL FINISH UP.
BAOHUA	YOUR GRANDFATHER CALLED.
HUISHAN	HE CALLED ME TOO.
BAOHUA	HE TOLD YOU ABOUT LUIWEI? HE WORKS FOR LENOVO.
HUISHAN	I'M TOO BUSY FOR THIS RIGHT NOW.
BAOHUA	BULLSHIT.
HUISHAN	I AM NOT MEETING ANYONE /FROM DESPERDO PARK.
BAOHUA	YOU KNOW I CAN'T STAND THAT LI AT WORK. SHE DOES ANYTHING SHE CAN TO TORMENT ME. I TOLD HER I HAD TO LEAVE EARLY AND SHE GIVES ME THIS LOOK AND SAYS WHAT FOR? WHAT'S GOING ON THAT YOU HAVE TO LEAVE EARLY? SHE WAS BORN IN THE WRONG ERA, SHE WOUD HAVE MADE SUCH A LOYAL INFORMER. PLACE WAS AS QUIET AS A MORGUE. WE COULD HAVE BOTH GONE. NOBODY'S INTERETSED IN HISTORY ANYMORE. BUT AFTER LUNCH, WHEN I'M MEANT TO LEAVE, LI COMES IN AND

SHE'S HOLDING HER HEAD
I HAVE A HEADACHE SHE
MOANS IN THIS HORRIBLE
BABY VOICE SHE SAVES FOR
THE BOSS AND HE ASKS
ME TO CHANGE MY PLANS
SO SHE CAN GO AND GET
ACUPUNCTURE. I IGNORED
THEM.

HUISHAN MUM!

BAOHUA I HOPE SHE HAS A BRAIN
TUMOUR.

HUISHAN MUM!

BAOHUA HOPE HER BRAIN EXPLODES
ALL OVER HER DESK. SERVE
HER RIGHT FOR THE WAY
SHE TREATS ME. GIVES ME
ALL THE BORING JOBS JUST
BECAUSE I'M OLD.

I'D ARRANGED TO LEAVE
EARLY, NOT HER.

THOUGHT I'D DO SOME
SHOPPING BUT THESE NEW
MALLS MAKE ME FEEL SICK…
THE AIR. FULL OF PLASTIC
GIRLS AND PILES OF JUNK. I
HATE THIS PART OF BEIJING.

HUISHAN I NEED TO FINISH UP WORK.
WAIT OVER THERE.

BAOHUA looks put out.

WE AGREED I'D COME TO
YOU.

BAOHUA points to the tank.

BAOHUA	WHAT'S THAT?
HUISHAN	THEY'RE GETTING A LITTLE WHALE.
BAOHUA	GOOD FOR BUSINESS.
HUISHAN	I'LL GET MY COAT.

HUISHAN leaves BAOHUA. She watches the carp in the tank.

HUISHAN is back.

READY?

HUISHAN puts on her coat and her breathing mask.

BAOHUA READY.

BAOHUA puts on her breathing mask.

They go.

FIVE

CHUFEST:

There is music, fanfare, excitement.

His first birthday. He's wheeled on by the young female actor in a pram.

ALAN enters with a huge birthday cake with one candle. The young female actor then brings a huge pile of extravagantly wrapped gifts.

They wait on stage. The music dribbles to an end.

The actors smile, waiting.

Nothing.

After a time the actors give up, breaking out of character and0 look to the left for the missing person.

KAIWEN sighs dramatically in the auditorium.

KAIWEN Where the hell is she?

The actors stare out at KAIWEN. They don't know.

An awkward silence. The female actor goes off stage to find her.

KAIWEN makes his way onto the stage.

He crosses and we hear him shouting offstage.

WHERE WERE YOU AND
WHY WEREN'T YOU ON
STAGE? HOW MANY TIMES
DO I NEED TO EXPLAIN? YOU
COME OUT WITH THE RED
ENVELOPES AND THROW
THEM IN THE AIR.

HOW HARD CAN IT BE?

I TOLD YOU TEN TIMES.

NO! IT'S TOO LATE NOW. GET
CHANGED.

KAIWEN returns with his bag.

ALAN Everything alright back there?

KAIWEN We're done for the night.

ALAN Oh, ok.

KAIWEN What is it with old people? They
 never take anything on board.

ALAN She's trying.

KAIWEN I know.

ALAN They're all trying. Maybe you could
 explain your ideas a bit more to
 them.

KAIWEN Or maybe they could listen. I need
 some decent actors.

ALAN gestures for him to keep his voice down.

	Thanks for filling in.
ALAN	It was fun. Reckon I did alright for the sound guy.
	I used to want to act but I don't anymore. Too much pressure. All the things you have to keep in your head.
	So Fong's back tomorrow right?
KAIWEN	Yeah.
ALAN	Well, he's got experience.
KAIWEN	Yeah.
ALAN	He's great.
	Did you see the show last semester?

KAIWEN nods.

	Such a great production. Everything about it. Who directed that?
KAIWEN	Ming.
ALAN	Ming's amazing. Chin up. Fong'll come and whip them into line.

KAIWEN isn't in the mood for advice.

| | Look, I did sound for CHU FEST last year and it was hardly groundbreaking theatre. |

KAIWEN doesn't know where this is going.

| | And like obviously I'm a white guy who doesn't know shit but I think what you're trying to do... Your ideas they're kind of different from the usual stuff. |

KAIWEN They don't get it.

ALAN They will.

KAIWEN I asked them for stories at the start
 because I wanted them to have input
 and they didn't want to share. They
 didn't understand why I wanted to
 do a piece about one-child policy.
 Or maybe they hate me.

ALAN Just go a bit easy on them. This isn't
 Melbourne Theatre Company. Relax.
 It'll come together, always does.

KAIWEN I don't want to work that way.

ALAN smiles.

 What?

ALAN Just…you're kind of funny when
 you're stressed. You get this look in
 your eyes /and

KAIWEN Don't patronize me.

ALAN I wasn't.

KAIWEN What did you have for dinner?

ALAN Spanakopita. Why?

KAIWEN You have something.

KAIWEN points at ALAN's teeth.

ALAN Spinach.

KAIWEN I better lock up.

ALAN goes.

KAIWEN looks around the space and leaves.

SIX

A large fluffy cat fills the screen and watches HUISHAN and BAOHUA in the waiting room at the hospital.

HUISHAN SO IT STARTED AS THIS
 THING A GIRL FILMED AT
 HOME AND IT WENT VIRAL.

BAOHUA VIRAL?

HUISHAN LIKE THE FLU BUT ONLINE,
 YOU KNOW.

BAOHUA WHY?

HUISHAN WHY NOT?

BAOHUA WHY WOULD PEOPLE WANT
 TO WATCH A CAT ON A
 SCREEN ALL DAY?

HUISHAN IT'S NOT *A CAT*. IT'S COPY
 CAT. AND WHEN IT CHANGES
 IT'S VERY LUCKY. JUST FOR
 A MOMENT IT BECOMES A
 RABBIT OR A DOG AND IF
 YOU SEE THAT CHANGE…

BAOHUA's baffled.

BAOHUA IS IT TO DO WITH THE
 ZODIAC?

HUISHAN NO.

BAOHUA AND YOU WATCH IT?

HUISHAN NO YOU EAT IT, MA.

She shows BAOHUA on her phone.

 LOOK.

BAOHUA AMAZING.

HUISHAN	GIVE IT A CHANCE. YOU HAVE TO ADMIT IT'S QUITE COOL. LIKE A BREAK FROM STRESS AND…
BAOHUA	WHAT NEXT?
HUISHAN	THAT'S IT. IT ISN'T MEANT TO BE ANYTHING MIND-BLOWING.
BAOHUA	IT DOESN'T DO ANYTHING.
HUISHAN	IT'S FOR PEOPLE WHO DON'T HAVE A CAT OF THEIR OWN. MAYBE THEY CAN'T KEEP ONE BECAUSE THEY ARE TOO BUSY OR TOO OLD OR… A LOT OF PEOPLE ARE LONELY MA.
BAOHUA	THEY SHOULD GET MARRIED.
HUISHAN	AND THIS HELPS THEM. OR MAYBE IT'S JUST FUN. YOU KNOW FUN? NO? YOU DIDN'T HAVE FUN BACK IN THE CULTURAL REVOLUTION AND YOU'RE STILL STUCK THERE.
BAOHUA	YOU WATCH THIS WHEN YOU HAVE HUNDREDS MORE IMPORTANT THINGS TO DO.
HUISHAN	YES.
BAOHUA	I DON'T UNDERSTAND YOU AT ALL.
HUISHAN	I KNOW.

BAOHUA	YOU KNOW HOW OLD YOU ARE DON'T YOU?
HUISHAN	//REMIND ME AGAIN.
BAOHUA	//THIRTY-ONE AND SINGLE.
HUISHAN	I HAD A BOYFRIEND. REMEMBER THE GUY DAD DECIDED WASN'T GOOD ENOUGH? REMEMBER WHAT JIAKE ENDED UP DOING?
BAOHUA	HE WAS A COWARD AND THAT WAS FOUR YEARS AGO.
HUISHAN	MUM!
BAOHUA	YOU SCOFF AT YOUR GRANDFATHER WHEN HE CALLS AND TELLS YOU ABOUT A CANDIDATE BUT WHAT'S THE ALTERNATIVE?
HUISHAN	I WILL NOT LET GRANDDAD HOCK ME OFF IN TIANTAN PARK.
BAOHUA	THINK IT'S TOO GOOD FOR YOU?

HUISHAN rolls her eyes.

	IT WORKS. YOU HEAR STORIES ALL THE TIME. EVEN FOR SHENGFU LIKE YOU.
HUISHAN	PLEASE DON'T USE THAT WORD.
BAOHUA	SHENGFU?

HUISHAN	DO YOU KNOW HOW IT MAKES ME FEEL WHEN YOU SAY THAT?
BAOHUA	YOU ARE LEFTOVERS. YOU'VE LET YOURSELF GO.
HUISHAN	THAT'S NOT TRUE.
BAOHUA	YOU'VE GOT FAT. YOUR SKIN LOOKS BAD.
	SO YOUR HEART GOT BROKEN. BOO HOO.
HUISHAN	THAT'S NOT FAIR.
BAOHUA	NOBODY MADE HIM DO WHAT HE DID.
HUISHAN	WHO?
BAOHUA	IT WAS AWFUL FOR HIS PARENTS.
HUISHAN	SAY HIS NAME.
BAOHUA	HE WASN'T RIGHT FOR YOU. PLEASE MOVE ON! CALL LUIWEI. YOUR GRANDFATHER'S TRYING TO GIVE YOU CHANCE, TAKE IT.

HUISHAN bites her tongue.

	YOU KNOW THAT HOSPITAL STAFF SOMETIMES TELL PEOPLE THEY HAVE ILLNESSES THEY DON'T? IT'S A SCAM TO GET THEM TO PAY FOR OPERATIONS THEY DON'T EVEN NEED.
HUISHAN	YES.

BAOHUA

THEY KEEP THE TRUTH
FROM PEOPLE. OLD PEOPLE.
BUT THEY WON'T TRICK ME.
THERE'S NOTHING WRONG
WITH ME. I'LL LOOK THE
DOCTOR IN THE EYE AND
SAY DON'T LIE TO ME. DID
YOU HEAR WHAT I SAID?

BAOHUA shrugs and takes a deep breath. HUISHAN knows she is about to rant.

YOU ARE MY FIRST-BORN
CHILD, HUISHAN. IT'S
ALWAYS BEEN ABOUT YOU.
DO YOU KNOW HOW IT
FEELS WHEN FRIENDS
FLAP PHOTOS OF THEIR
GRANDKIDS IN FRONT OF
ME AND I HAVE TO TELL
THEM THAT YOU ARE STILL
ON THE SHELF? HOW LONG
DO I NEED TO WAIT FOR
YOU AND YOUR BROTHER? I
AM ABOUT TO TURN SIXTY.
I HAVE TO RETIRE SOON OR
MAYBE I'LL DROP DEAD.

HUISHAN

PROMISE?

BAOHUA

IT IS MY RIGHT TO HAVE A
GRANDCHILD. AND YOUR
FATHER. WHY AM I, WHY ARE
WE THE VICTIMS OF YOUR
MEANNESS? WHAT DID WE
DO TO YOU?

HUISHAN doesn't say anything for a long time.

The cat stares at them both.

We hear a nurse.

NURSE MRS LEE? WE'RE READY FOR
 YOU.

BAOHUA looks up at the nurse and for a moment is afraid.

HUISHAN DO YOU WANT ME TO COME
 IN WITH YOU?

BAOHUA NO! STAY HERE AND STARE
 AT YOUR CAT.

BAOHUA goes.

The cat stares from the screen.

HUISHAN The day after Jiake died I went to
 visit his parents. I didn't know what
 I would say. I took them cherries.
 They were his favourite fruit. I
 knocked and his father opened the
 door. He looked like he wasn't even
 there. I told him I was sorry that
 he had lost his son. Jiake's mother
 came to the door and they stood
 there and stared at me. I gave them
 the cherries and told them my
 name but they didn't know who I
 was. Jiake hadn't told them. They'd
 never heard my name.

BAOHUA returns looking frazzled.

 WHERE IS THE DOCTOR?

BAOHUA shrugs.

 WHAT DID HE SAY?

BAOHUA DOCTOR IS A SHE. SHE'S
 VERY YOUNG. SHE WENT TO
 PEKING UNIVERSITY AND
 GUESS WHAT? SHE JUST
 MARRIED A SURGEON.

HUISHAN	GOOD FOR HER. WHERE IS SHE NOW?
BAOHUA	SHE'S BUSY.
HUISHAN	WE NEED TO TALK TO HER.
BAOHUA	SHE WON'T TELL US ANYTHING. I SHOULD HAVE BROUGHT YOUR FATHER ALONG. SHE WOULD HAVE MADE TIME TO SPEAK TO HIM. OR YOUR BROTHER. BUT I KNOW I'M FINE.
	TAKE ME HOME?
HUISHAN	I NEED TO SEE THE DOCTOR FIRST.
	STAY HERE.
BAOHUA	I TOLD YOU I'M…

HUISHAN goes and BAOHUA is alone again.

	TREATED WORSE THAN A DOG.

We hear birds call.

	DO YOU HEAR THAT? THOSE BIRDS?
	I USED TO HEAR THEM IN THE PARK. NOT ANYMORE. THIS WHERE THE BIRDS HAVE COME. THEY MUST BE SICK AS WELL.

SEVEN

Rehearsal. ALAN eats alone.

He struggles with chopsticks.

KAIWEN arrives.

ALAN Fanny brought everyone dinner.

KAIWEN Yeah?

ALAN She's washing up. We saved you some. Chicken. It's pretty spicy. So thoughtful. You know once you get talking to her she's funny too. I didn't realise her daughter was in the play.

KAIWEN Cathy dropped out and went back to China.

ALAN She forgot to tell Fanny.

KAIWEN's distracted.

 Not like you to be late.

KAIWEN I had to meet Fong.

ALAN So he's on his way?

KAIWEN He's at rehearsals for *The Hundred Flower Project.*

ALAN Oh.

KAIWEN He said he wants to do both.

ALAN Cool.

KAIWEN I need commitment.

ALAN You made him choose?

KAIWEN I thought he'd choose this. My vision is bigger. Fong supported

that so I put him at the centre of all the scenes.

And when I told him he had to choose he told me he'd rather work with Ming and play Mao. So now I have to find someone new.

ALAN Someone Chinese.

KAIWEN Can you fill in again tonight?

ALAN CHUFEST is Chinese University Theatre Festival.

KAIWEN Just for today. Please. I'll have someone new by tomorrow.

EIGHT

HUISHAN dressed up for the party finishes a phone call. She tries to hide her concern as she sees BAOHUA trying to do up her dress. She can't quite reach around to the back.

BAOHUA THIS DOESN'T FIT.

HUISHAN OF COURSE IT FITS.

BAOHUA THEN WHY WON'T IT DO UP?

HUISHAN looks at the dress and moves the zipper.

HUISHAN THE ZIPPER'S STICKY.

BAOHUA DON'T FORCE IT.

HUISHAN I WON'T.

BAOHUA THE PRICE YOU PAY FOR THINGS AND STILL THEY CUT CORNERS. CHEAP ZIPS AND/

HUISHAN MA!

BAOHUA	WHAT?
HUISHAN	THIS DRESS IS A COPY.
BAOHUA	IT IS NOT!

HUISHAN doesn't argue. She zips up the dress.

HUISHAN	THERE.
BAOHUA	I CAN'T BREATHE. DO I LOOK FAT?
HUISHAN	HUGE.
BAOHUA	NO!
HUISHAN	OF COURSE YOU DON'T! LOOK AT YOURSELF.
BAOHUA	I SHOULD NEVER BUY DRESSES WITH ZIPPERS. YOU KNOW MY ZIP BROKE AT A DINNER JUST AFTER I FOUND OUT I WAS PREGNANT WITH KAIWEN. YOUR FATHER WAS FURIOUS.
HUISHAN	AS USUAL.
BAOHUA	IS YOUR GRANDMOTHER HERE YET?
HUISHAN	AUNTY'S TAKING THEM. THEY'LL MEET US AT THE RESTAURANT.
BAOHUA	ALWAYS TRYING TO OUT-DO ME.
HUISHAN	SHE'S TRYING TO HELP.
BAOHUA	YOUR COUSIN AND HIS WIFE WILL BE THERE. SHE'S DUE SOON.

EIGHT MONTHS PREGNANT
AND SHE STILL LOOKS
BEAUTIFUL.

HOW IS IT YOUR COUSIN
MANAGED TO GET THINGS
SO RIGHT? WHO WAS ON THE
PHONE?

HUISHAN THE HOSPITAL.

BAOHUA NOT TODAY PLEASE.

HUISHAN DID THEY CALL YOU?

BAOHUA IT'S NOTHING.

HUISHAN MORE TESTS.

BAOHUA THEY JUST WANT MORE
MONEY.

HUISHAN reveals a crumpled gift.

HUISHAN KAIWEN SENT THIS FOR YOU.

BAOHUA smiles and takes the gift but doesn't unwrap it.

BAOHUA IT'S THAT PERFUME HE
SENDS.

BAOHUA puts it aside.

HUISHAN IT'S A SHAME HE CAN'T BE
HERE.

BAOHUA IT WAS SILLY OF YOU TO
THINK HE COULD.

HUISHAN THERE WILL BE LOTS MORE
BIRTHDAYS.

BAOHUA looks at HUISHAN in the mirror.

THAT COLOUR'S NICE ON
YOU.

BAOHUA smiles gently at HUISHAN.

HUISHAN	REALLY?
BAOHUA	SOMETIMES WHEN I LOOK AT YOU, YOU REMIND ME SO MUCH OF BOAJIA.
HUISHAN	NO.
BAOHUA	WHEN SHE WAS YOUNG, ALL THE MEN WERE AFTER HER.
HUISHAN	AND LOOK WHO SHE ENDED UP WITH.
BAOHUA	YOUR UNCLE WAS DIFFERENT THEN. HE WAS SUAVE AND THIN. THEY HAD SUCH A BIG WEDDING YOU KNOW.
HUISHAN	PLEASE DON'T TELL THAT STORY AGAIN.
BAOHUA	THE NOA DONGFANG? YOU KNOW IT?
HUISHAN	I'VE HEARD IT HUNDREDS OF TIMES.
BAOHUA	FAMILY HISTORY IS IMPORTANT.
HUISHAN	WHEN IT SUITS YOU.
BAOHUA	I REMEMBER HELPING BOAJIA GET DRESSED FOR THE CEREMONY. TEA GOT SPILT ON HER DRESS AND SHE BLAMED ME AND WE ARGUED AND THAT'S WHEN IT HIT ME. THAT MY BIG SISTER WAS GETTING MARRIED.

HUISHAN	I WISH I'D HAD A BIG SISTER.
BAOHUA	SHE WAS SENT TO TORMENT ME. A BROTHER IS MUCH BETTER.
HUISHAN	AT LEAST YOU GREW UP TOGETHER.
BAOHUA	I WOULD HAVE PREFERRED NOT TO. WE HAD TO SHARE EVERYTHING. BEDROOM, CLOTHES, SCRAPS OF FOOD. YOU NAME IT. SHE WAS A GREEDY OGRE.
HUISHAN	BROUGHT YOU CLOSER TOGETHER.
BAOHUA	//THAT'S ONE WAY OF LOOKING AT IT.
HUISHAN	//CLOSER THAN THEN BEING THOUSANDS OF MILES APART.

BAOHUA looks sad.

HUISHAN	SOME OF THE GIRLS AT WORK CAN'T TALK TO THEIR MOTHERS. THEY HATE THEM SO MUCH.
BAOHUA	WHY?
HUISHAN	BECAUSE OF THE WAY THEY GOT PROTECTED. THEY CAN'T DO ANYTHING FOR THEMSELVES.
BAOHUA	AND IT'S THEIR MOTHERS FAULT? HOW COULD YOU HATE YOUR OWN MOTHER?

HUISHAN	YOU SEE IT ALL THE TIME.
BAOHUA	LIKE THAT CRAZY GIRL FROM HEILONGJIANG.
HUISHAN	IT HAPPENS EVERYWHERE.
BAOHUA	I'M GLAD YOU AREN'T LIKE THAT. YOU'RE RUDE TO ME BUT...
HUISHAN	WHAT?
	IT'S GOOD THAT WE CAN TALK.
HUISHAN	YES.
BAOHUA	WE CAN TALK CAN'T WE?
HUISHAN	YES. DID YOU TALK LIKE THIS WITH GRAN?
BAOHUA	NO.
HUISHAN	SHE DIDN'T TELL YOU THINGS ABOUT THE PAST? WAS SHE KIND TO YOU AND BOAJIA?
BAOHUA	SHE DID WHAT SHE HAD TO. WE SHOULD GO.
HUISHAN	WAS SHE NICE TO YOU? YOU WERE TWO GIRLS, WAS SHE...
BAOHUA	WHERE ARE ALL THESE QUESTIONS COMING FROM HUISHAN?
HUISHAN	I DON'T KNOW.
BAOHUA	I DON'T LIKE THEM. BE NICE TO ME.

HUISHAN I'M JUST ASKING YOU ABOUT
 GRAN.

BAOHUA LET'S ENJOY OURSELVES.
 KAIWEN'S PROMISED TO CALL.

 I DON'T WANT TO BE SIXTY.

HUISHAN THEN WHY ARE WE HAVING
 THIS PARTY?

BAOHUA YOU MADE ME.

HUISHAN I THOUGHT YOU WANTED TO
 CELEBRATE.

BAOHUA I DON'T WANT TO SEE ALL
 THOSE PEOPLE. AND I HAVE
 TO RETIRE. I DON'T WANT TO
 LEAVE WORK.

HUISHAN YOU HATE WORK. YOU SAY
 THAT ALL THE TIME.

BAOHUA I HATE LI. THE MINUTE
 I'M GONE SHE'LL CHANGE
 EVERYTHING I'VE DONE. ALL
 THOSE YEARS PICKING UP
 THE FALLEN FIGURINES IN
 THE DIORAMAS AND SHE'LL
 KNOCK THEM OUT THE
 FIRST CHANCE SHE GETS.
 DIORAMAS ARE IMPORTANT.
 WHAT WILL I DO WITH MY
 TIME NOW?

 I KNOW WHAT'S COMING.

HUISHAN WE NEED TO GO.

NINE

*ALAN **and** KAIWEN **at the tram stop.***

KAIWEN	Thanks for filling in again.
ALAN	It went better tonight. Even Fanny…
KAIWEN	I wish I could replace her.
ALAN	She'd be devastated.
KAIWEN	She's terrible.
ALAN	How did she end up in it?
KAIWEN	She brought an umbrella in for Cathy one night and stayed.
ALAN	She came to Melbourne for her too.
KAIWEN	Cathy didn't need her.
ALAN	It's quiet tonight.
KAIWEN	Up here it is. City'll be busy.
ALAN	Do you like Melbourne?

*KAIWEN **nods.***

	Do you go out much?
KAIWEN	No. Do you?
ALAN	My housemate's crazy. I have to escape.
KAIWEN	Crazy?
ALAN	She thinks she's Bridget Jones. Except she isn't funny and she tells me everything instead of writing it down. And she's kind of hit her word limit.

KAIWEN	Kick her out?
ALAN	She's not that bad. Maybe I'll move, end of semester. Bit further north. Cheaper. Where are you?
KAIWEN	In the city.
ALAN	Nice. So you've got a flat?
KAIWEN	Yeah.
ALAN	Did your parents buy it?
KAIWEN	Yeah. They own the whole building.
ALAN	Really?
KAIWEN	Not every Chinese person's rich.
ALAN	I didn't... Sorry man, just...
KAIWEN	It's ok.
ALAN	If they did own a building it'd be sweet.
KAIWEN	Yeah. I'd give you a car space.
ALAN	I don't have a car.

ALAN's tram approaches.

KAIWEN	You're going that way?
ALAN	I can get the next one. Sixteen minutes. Not that long.

BAOHUA stands in front of a birthday cake with candles lit.

She blows out the candles.

	So... I saw you online.
KAIWEN	Facebook?
ALAN	No.

KAIWEN Instagram?

ALAN Grindr.

KAIWEN Me?

ALAN It was you right?

KAIWEN No.

ALAN Shit man, are you kidding me?

KAIWEN Some Asian dude?

ALAN Yeah but…

KAIWEN What you think all Asians look the same?

ALAN No. Some guys might but shit…

KAIWEN When did you see it?

ALAN The day you were running the auditions. This guy was 20 meters from me which is kind of where you were.

A pause.

You might want to keep the sound on your phone down.

I was going to send you a message that day. A couple of pics of my cock.

KAIWEN frowns.

Joke? You can trust me Kaiwen. I'm not going to tell people. You might want to keep the sound on your phone down.

KAIWEN My family don't know.

ALAN	Ok. Grindr's horrible. The shit guys have on their profiles here. That they aren't into Asians and shit. I hate our racism.
KAIWEN	Same in other places.
ALAN	You'd think gay men'd be open-minded but they're some of the worst.

KAIWEN looks at ALAN for a moment and smiles.

	Have you ever had one of those actor director things?
KAIWEN	No.
ALAN	Well I'm just filling in. So… Fancy a drink?
KAIWEN	I can't.
ALAN	Was that too much?
KAIWEN	It's not that.
ALAN	Don't you drink?
KAIWEN	I'm Chinese not Mormon.
ALAN	You have an early start?
KAIWEN	No.
ALAN	Do you find me dull?
KAIWEN	A bit.
ALAN	Ugly?
KAIWEN	The body hair. You're a bit of an ape.
ALAN	Fuck you. Come for a drink.

KAIWEN hesitates.

One beer and maybe a few acting
tips? Come on.

ALAN smiles. KAIWEN relents and they leave.

TEN

BAOHUA's party. She stands outside a fancy restaurant, at the top of a massive shopping mall in Beijing looking at her phone.

HUISHAN	WHAT ARE YOU DOING OUT HERE MUM?
BAOHUA	IS IT TOO MUCH TO ASK THAT KAIWEN MIGHT REMEMBER ME TODAY?
HUISHAN	HE SENT A NICE GIFT.
BAOHUA	HE DIDN'T SEND THAT. DO YOU THINK I'M AN IDIOT? DON'T TREAT ME LIKE THOSE WOMEN AT WORK DO. I'M NOT SOME DUMB OLD RELIC WHO DOESN'T RECOGNISE THE TRUTH.
	DO YOU KNOW WHAT I SAW THIS MORNING ON MY WALK?
HUISHAN	MUM.
BAOHUA	A DOG GOT HIT BY A TRUCK. BANG. IT GOT UP AND RAN FOR A BIT AND THEN IT FELL AND DROPPED DEAD IN THE DUST. AND DO YOU THINK ANYBODY STOPPED TO HELP IT?
HUISHAN	DID YOU?

BAOHUA	I DON'T LIKE DOGS.
HUISHAN	THEN/
BAOHUA	NO ONE STOPPED. EVEN PEOPLE WHO LIKE DOGS DIDN'T.
HUISHAN	I'M SORRY YOU SAW THAT ON YOUR BIRTHDAY.
BAOHUA	IT'S JUST A DOG. BUT THEN WHAT AM I? WILL I BE LEFT LIKE THAT?
HUISHAN	COME BACK IN, MA.
BAOHUA	IS YOUR FATHER STILL BUSY ON HIS PHONE?
HUISHAN	I DON'T KNOW.
BAOHUA	ALL HIS CARRY ON WITH THE LONG LIFE NOODLES. THAT WAS THE ONLY TIME HE HASN'T BEEN ON THE PHONE. DOES HE THINK ANYONE BELIEVES HE'S CALLING WORK? AND THOSE WOMEN.
HUISHAN	//SIT WITH ME AND GRANDMA.
BAOHUA	//I THOUGHT THEY WERE MY FRIENDS. THEY ONLY CAME SO THEY COULD WAVE PHOTOS OF THEIR GRANDKIDS IN MY FACE. AND YOU...
HUISHAN	WHAT HAVE I DONE NOW?

BAOHUA shakes her head.

BAOHUA YOU TALK TO KAIWEN. AND IT'S LIKE HE SENSES I'VE HEARD. HE SENSES THAT I'M THERE AND THEN HE CLOSES UP. WHY DOES HE RING YOU AND NOT ME? WHAT DID I DO TO HIM?

HUISHAN shakes her head.

IT'S NOT YOUR FAULT.

HUISHAN WHAT DO YOU MEAN BY THAT?

BAOHUA doesn't answer.

BAOHUA DON'T GIVE ME LOOKS LIKE THAT ON MY BIRTHDAY.

HUISHAN breathes.

HUISHAN I WANT YOU TO HAVE A NICE TIME TONIGHT. WE ALL DO.

Fireworks explode.

ARE YOU FEELING ALRIGHT?

BAOHUA YOU SOUND LIKE THAT CONDESCENDING BITCH AT WORK. OF COURSE I'M FEELING ALRIGHT.

HUISHAN THEN…

BAOHUA isn't feeling alright. She shakes her head and HUISHAN supports her.

HUISHAN I'M HERE.

BAOHUA gathers herself again. More fireworks.

BAOHUA I'M THE MOTHER. I DON'T
 NEED YOU TO TREAT
 ME LIKE A CHILD. FIND
 SOMETHING ELSE TO DO.

HUISHAN IT'S JUST THAT… I KNOW.
 THE HOSPITAL RANG AND
 TOLD ME. THE DOCTOR/

BAOHUA /THAT DOCTOR WAS A
 CHILD.

HUISHAN SHE TOLD ME THE SAME
 THING SHE TOLD YOU.

BAOHUA IT'S NONSENSE HUISHAN.
 I DON'T BELIEVE A WORD
 SHE SAID. THEY ALL WANT
 OUR MONEY. DON'T YOU
 GO TELLING ANYONE ELSE
 ABOUT IT. I'M NOT SICK, IT
 ISN'T TRUE. I'M FINE!

BAOHUA goes back in.

The fireworks get louder. And louder. They explode in glorious colours.

HUISHAN watches them alone, crying.

They fizzle out and leave her in an unpleasant light.

HUISHAN The doctor said its pancreatic.
 Stage four.

 No apologies, no cushioning words.
 She seemed to be waiting for me to
 ask something and I didn't know
 what to ask.

 When I was a kid I used to ask
 questions. They gathered under
 my skin like liquid filling up under

a blister, all ready to pop the first chance it gets. And so when I learnt to speak, the questions splattered forth and I drove my mother and father mad.

HOW DID YOU MEET DAD?

DID YOU FALL IN LOVE STRAIGHT AWAY?

SO, IF YOU DIDN'T LIKE DAD THE FIRST TIME WHAT MADE YOU SEE HIM AGAIN?

There were times when Mum must have wanted to throw me off the tiny balcony of our flat and get a new kid who didn't ask questions all the time.

Questions about everything.

WHO LIVES IN THE APARTMENT ABOVE US AND WHY DON'T THEY TALK AT NIGHT? WHY DON'T THEY HAVE A CHILD? WHO WILL LOOK AFTER THEM WHEN THEY GET OLD?

My mother answered my questions in the shortest way and it never satisfied me. She would give me the meat but I wanted the bone as well. My father would give even less but I grew used to that. He never said it aloud but I knew that he wasn't interested in a girl.

I am four. We are on a bus in the city and we pass Mao's mausoleum. I ask lots of questions about him.

My mother answers them all softly,
efficient as ever. When I ask *DID
MAO HAVE BROTHERS AND
SISTERS? OR WAS HE AN ONLY
CHILD LIKE ME?* The woman
in front of us turns and stares at
me and for the first time ever my
mother doesn't respond. She stares
at a yam sticking out the hole in a
bag of groceries and if that yam had
have had eyes then it would have
seen something strange squeeze
onto the bus seat between Mum
and me that day. I start to ask again
but something stops me.

Later in the warmth of our flat as
mum peels the yam I go to speak
again but something has changed
on the bus and that thing the yam
saw between us has followed us
home and its between mother and
I in the kitchen and makes me feel
afraid to ask.

I wake up in the night and see
shadows dance on the wall. I hear
Mum and Dad arguing. His voice
stronger, his shadow bigger. I see
his shadow hit hers and her shadow
fall to the floor and I know I can't
ask anything the next day.

When mother goes to work she
locks me inside so I'm safe there. I'm
meant to stay on the floor not climb
onto the sink and perch at the edge
like a duck but I do. I climb to the top
of the kitchen bench and watch the
tap drip and then I crawl along and

sit on top of the stove like a saucepan
full of questions waiting to boil.

I store the questions in my head for
when school begins. I dream about
my teacher all wide-faced and kind.
She loves all my questions.

But I don't get sent to school.
I get sent away to live with my
grandparents in Sichuan. And the
question I don't get to ask before
I leave is why are you sending me
away? But that's just the start.

***ALAN and KAIWEN enter KAIWEN's place. They have been
drinking and are a bit fresh with each other.***

ALAN	A censor?
KAIWEN	Symbolized with the air masks so when the mask goes on…
ALAN	They're silenced. Got it.
KAIWEN	What do you think?
ALAN	Do you ever stop thinking about the play?
KAIWEN	No. I want to be a director.
ALAN	You are.
KAIWEN	I mean for a job. So I have to have it in my head all the time. You have to be determined to be successful, for people to take you seriously. It's not a hobby or a game.
ALAN	I like to switch off.

ALAN looks around.

It's a nice place. The view.

[Pointing at a photo.] Who's that?

KAIWEN Derek.

ALAN Your boyfriend?

KAIWEN *[Nodding.]* He's away.

 What are you thinking? How old
 is he?

ALAN Doesn't matter to me.

 Didn't you promise me a drink?

HUISHAN When I get to my gran's in Sichuan
 I want to ask how people can live
 the way they do in this village. I
 clean and cook and scrub and it
 is never good enough, Gran tells
 me that every day, she pecks at
 me like a bird and it is only when
 grandfather comes home each night
 that she leaves me and pecks away
 at him instead.

 Gran cuts my hair and dresses me
 like a boy. She says it's time for you
 to go to school. Dressed like that I
 have no choice but to act like the
 other boys. But my teacher sees
 what I am and helps me learn to be
 a boy.

 When I finally get used to being
 there I get sent back to find out
 that Kaiwen had been born. I see a
 happiness on your faces I've never
 seen before and I want to ask why
 did you bring me back? You don't
 need me now. You have a real son.

Why didn't you just forget me and leave me to rot in Sichuan?

KAIWEN *brings the drinks.*

ALAN	Does Derek go away a lot?
KAIWEN	Do you mean do I do this very often?
ALAN	You're on Grindr man.
HUISHAN	You got the son you wanted but why didn't you pay the fine Father? You could afford to pay. So that Kaiwen could go to school and the hospital and… Why did you put yourself first?
KAIWEN	I'm on Grindr 'cause I'm bored.
ALAN	Is that where you met Derek?

KAIWEN *doesn't reply.*

Are you guys open?

KAIWEN	It's complicated.
ALAN	How complicated can it be? Gay couples either fuck around with each other's blessing or they fuck around and lie. Sorry did that hit a nerve?

Does Derek do this too?

KAIWEN	I don't ask.
ALAN	Fair enough.
KAIWEN	I've never brought anyone here.
ALAN	You could have come to mine. Bridget loves a fresh audience.

KAIWEN *pours ALAN another drink.*

Cheers.

They scull. ALAN draws KAIWEN in and kisses him.

HUISHAN — Why do you walk twenty paces ahead or make us leave him at home. When he runs to hug you why do you turn away? Why do you let me treat my little brother with such contempt for so long? Do you see the things I do to him because he's been born?

BAOHUA comes out and finds HUISHAN.

BAOHUA — I WANT TO GO HOME NOW.

They leave the party.

ALAN and KAIWEN take a breath.

ALAN — I've been wanting to do that for a while.

KAIWEN — Me too.

KAIWEN goes back in but ALAN slows him down.

ALAN — So, who collects the signs?

KAIWEN — We both do.

ALAN — I love that one. Do not disturb. Tiny grass is dreaming.

Where do you get them?

KAIWEN — We get them for each other when we go away. Started with this.

KAIWEN shows ALAN a can of drink labeled bottled water.

It's funny hey? It was in the mini bar in a place where we were stayed, we both laughed our asses off. So when one of us travels somewhere we have to bring back a sign or something fucked up.

	They're getting harder to find now.
ALAN	I don't really get why you find them funny.
KAIWEN	Some dumb peasant fucking up.
ALAN	Right.
KAIWEN	My parents would hate them. Anything that mocks the greatness of China.
ALAN	Do these do that?
KAIWEN	They mock Chinese aspiration and our capacity to measure up and compete.
	What?
ALAN	I don't get it, that's all.

KAIWEN shrugs. ALAN caresses KAIWEN's arm.

	Where are your parents?
KAIWEN	You want to talk about my mum and dad?
ALAN	Do they think about things like you do?
KAIWEN	How could they? They've had propaganda forced down their throats most of their lives.
ALAN	And you're a one-child policy kid right? I mean that's the reason you're making this piece?
KAIWEN	I never said that.
ALAN	You never said much at all. I thought…

KAIWEN What? That's how I ended up with the spoilt kid thing.

Because that's not me.

ALAN I'm not saying it is.

KAIWEN You are.

ALAN /No.

KAIWEN That isn't my story. I wasn't doted on. Do you know what day I was born? June 4 1989.

ALAN Sorry, dates aren't/

KAIWEN Tiananmen.

ALAN I didn't know the date.

KAIWEN Nor do most Chinese. My parents don't.

ALAN Aren't they educated?

KAIWEN It's not about education. They've just never acknowledged Tiananmen.

ALAN But they must know.

KAIWEN Of course they know. They're from Beijing. But Dad's a low-ranking bureaucrat who thinks he's very important. Mum works for a state museum nobody visits. Acknowledging what happened that day would be too complicated. Do you know what my mother does at the museum? She writes the signs. She's one of the republics cultural historians who can render actual history redundant by turning our heads the other way. Instead of telling

you how much blood was spilled or who was betrayed or whose heart was broken she tells you the height and the width of the wall behind it all and what year it was erected. And all my parents seem to care about is money and marrying me and my sister off.

ALAN Hang on… You have a sister?

KAIWEN Let's talk about your family.

ALAN Why?

KAIWEN My family is fucked up. I bet yours is perfect.

ALAN You reckon? Dad died when he was forty-four and Mum discovered his debts. She took an extra job and brought me and my brothers up. We were little shits and it must have been rotten for her. She lives alone now and she's depressed. I go and see her and it depresses me.

HUISHAN calls. KAIWEN ignores her call

Is that Derek?

KAIWEN No.

ALAN Get it if you want I'll stay quiet.

KAIWEN Na. It's fine.

The call ends.

HUISHAN calls again.

ALAN Really, if you need to get it…

KAIWEN *[Raising his voice.]* It isn't Derek OK?

ALAN	OK. Chill. No need to raise your voice.

KAIWEN calms down a bit.

KAIWEN	It's all these questions. What do you want from me?
ALAN	What do you mean?
KAIWEN	What do you want?
ALAN	To hang out a bit, get to know you. I don't know.

KAIWEN approaches him.

KAIWEN	Let's go into the bedroom. Get naked, come on. You're clean right?
ALAN	What?
KAIWEN	Clean, you know…

KAIWEN looks at ALAN and doesn't know what to say.

ALAN	Hang on Kaiwen…
KAIWEN	Come on, let's go.
ALAN	No. I can't.
KAIWEN	What?
ALAN	Doesn't feel right.
KAIWEN	Isn't this what you want? We've come this far now don't you…

KAIWEN throws himself at ALAN.

It is not what ALAN wanted, not like this. He pulls back.

ALAN	Sorry man.
KAIWEN	What?
ALAN	It's pretty late.

KAIWEN	I don't care.
ALAN	//I don't think I can…
KAIWEN	//Stay. Please.
ALAN	No. I need to get home.
KAIWEN	What did I do?
ALAN	I just really need to go.
KAIWEN	*[Softly.]* Please. I don't want to be alone.
ALAN	Look, I like you Kaiwen… But I reckon I need to go.

ALAN goes.

KAIWEN	Ape.

HUISHAN stares into space until his phone rings again.

It rings and rings and rings and finally…

HUISHAN	YOU PROMISED YOU'D CALL HER.
KAIWEN	SHIT.
HUISHAN	DON'T SHIT ME. YOU DON'T COME OVER AND NOW YOU DON'T EVEN BOTHER TO CALL? I PHONE YOU AND YOUR PHONE RINGS AND RINGS. MUM'S DEVASTATED.
KAIWEN	IT'S THREE AM HERE, HUISHAN.
HUISHAN	I STARTED RINGING YOU AT NINE. WHAT HAVE YOU BEEN DOING THAT'S SO IMPORTANT YOU MISS MUM'S BIRTHDAY?

KAIWEN	I SAID I'M SORRY.
HUISHAN	YOU'RE SORRY?
KAIWEN	I'LL CALL HER TOMORROW. MAKE UP FOR IT.
HUISHAN	I WAS WITH HER ALL DAY. NOTHING I DID MATTERED.
	AND AT THE PARTY SHE KEPT WAVING HER PHONE AROUND AND BOASTING TO HER FRIENDS *MY SON WILL CALL*.
KAIWEN	And /I didn't.
HUISHAN	And I hate that when you call her tomorrow she'll be fine about it. Even though she's hurt she won't tell you.
KAIWEN	//You've always hated me.
HUISHAN	//She'll take it all out on me.
	What did you just say?
KAIWEN	I said you've always hated me.
HUISHAN	You think that?
KAIWEN	Yes.
HUISHAN	Because of what I did?
	Because I told somebody about you? You don't think I blame myself for that. I've always wondered what would have happened if I had have kept my mouth shut.
KAIWEN	Would they have sent me away?

HUISHAN	I was young. I didn't think.
KAIWEN	Huishan, I never blamed you for that.
HUISHAN	But it was my fault. If I had have…
KAIWEN	No it wasn't. It/
HUISHAN	I'm sorry… I can't do this now.

A moment of quiet. The cat comes onto the screen.

	You know, I don't know anything about your life. Where were you tonight?
KAIWEN	I was studying.
HUISHAN	Good. And is it going well?
KAIWEN	It's never gone well. You know that. Do you know what it feels like to be the dumb one in the class? Of course you don't. You were always smart at school.
HUISHAN	And look where it got me. Working in that terrible hotel. Mum's given up on me but she knows you'll make her proud. You'll get a good job and be the one to give her a grandson. And at least there are two of us to support them.
KAIWEN	I wasn't studying tonight. I'm directing a play.

Silence from HUISHAN, then…

HUISHAN	A play? Like you used to do at school? As a hobby?
KAIWEN	You sound like Dad.
HUISHAN	No. It's just…

KAIWEN

I have to get some sleep Huishan.
I'll call Mum tomorrow. Goodnight.

KAIWEN ends the call.

BAOHUA enters in a hospital gown. Her hands behind her back.

Radioactive flashes and blasts continue...

This guy waits until the coast is
clear and gets out his pen. He draws
in secret on the shit-stenched smoky
rotting cubicle walls of the public
toilet. It's his gallery, he draws
things that haven't even got words,
acts that he can only dream of
doing to another but can never say
or own. Everybody has secrets.

HUISHAN

When I was ten and Kaiwen was
six, I told that little girl in the park
about my baby brother. Mum found
out, Dad went pale and silent and a
few weeks later Mum took us away
to Hong Kong. Then Dad came and
met us there.

KAIWEN

Secret bank accounts.

HUISHAN

The four of us in public together
like a family for the first time ever.

KAIWEN

Secret histories.

HUISHAN

We walked around Hong Kong
together. I remember father walking
next to Kaiwen. Reaching out and
holding his hand.

KAIWEN

Things that were said but never
written down. Things that were
written down and printed and
edited and written and printed

again and burned and forgotten
and found and changed and erased
altogether.

HUISHAN We go to Ocean Park and it is the
 perfect day. I don't even remember
 the rides.

KAIWEN Secret hopes. Secret dreams.

HUISHAN It was the best day because we were
 together.

KAIWEN Secret affairs. Secret births and
 deaths. Secret towns in people's
 heads and places now underwater
 that are just sunken memories
 under the mud. Babies killed before
 they've tasted their mother's milk,
 lives never recorded to erase.

HUISHAN The following day my mother took
 me shopping and my father took
 my brother somewhere else. But
 when Dad came back to the hotel,
 he was alone. He'd left Kaiwen at a
 boarding school.

KAIWEN Things between the walls of houses
 that can never escape out the door.
 People buried with secrets. Buried
 deep deep down because if they
 weren't deep, the things they have
 done or haven't done would find
 the light. They would grow legs
 and arms like zombies and climb to
 the surface and walk the earth with
 slashing tails and gnarling mouths
 that yell secrets from between their
 sharp teeth.

 There are many ways of forgetting.

Keeping secrets helps forgetting.

Secrets like me.

BAOHUA reveals her hands. She's wearing Minnie Mouse gloves.

She dances to traditional music and as it snows a harsh penetrating light from her scans flashes.

She gets a call on her phone but she can't answer it in the gloves. She tries and fails and gives up to dance again.

A nurse in a gas mask enters, stops her dancing and leads her away.

ELEVEN

CHUFEST rehearsal without ALAN.

An actor enters with a massive cake, ten candles blazing.

Balloons fall.

Another actor enters with a massive gift, it's too big to carry and needs to be pushed. The actor returns with another larger gift.

They stop and wait, drop out of character. Finally another pushing a HUGE gift.

It's too much.

The actors stare out and wait.

TWELVE

HUISHAN is on the train again.

BAOHUA calls her.

BAOHUA WHERE ARE YOU?

HUISHAN ON A ROCKET TO THE MOON.

BAOHUA	I HOPE THEY HAVE FOOD THERE 'CAUSE YOU FORGOT YOUR LUNCH.
HUISHAN	I LEFT IN A RUSH.
BAOHUA	I'LL DROP BY WTH IT.
HUISHAN	//DON'T.
BAOHUA	//I'LL SEE YOU SOON.
HUISHAN	NO. THEY TOLD YOU TO REST, MA.
BAOHUA	I'M FINE.
HUISHAN	I'LL BUY SOMETHING HERE.
BAOHUA	YOU CAN'T TRUST THE FOOD /IN THAT AREA.
HUISHAN	THEN I WON'T EAT. YOU TOLD ME I'M FAT.
BAOHUA	WHY DIDN'T YOU WAKE ME BEFORE YOU LEFT.
HUISHAN	YOU WERE SNORING LIKE A LION.
BAOHUA	YOUR BROTHER CALLED AND I DIDN'T HEAR IT. HE LEFT A VERY SWEET MESSAGE.
HUISHAN	I BET.
BAOHUA	HE WAS BUSY STUDYING AND HE LOST TRACK OF TIME. HUISHAN, WHAT ARE YOU WEARING TODAY?
HUISHAN	WHY?
BAOHUA	THE PLANS FOR LATER.

HUISHAN	PLANS?
BAOHUA	FOR TONIGHT YOU CLOD. WITH THE CANDIDATE LUIWEI. YOUR GRANDFATHER SENT YOU THE /DETAILS.
HUISHAN	//I'LL POSTPONE.
BAOHUA	//I HOPE YOU DON'T LOOK FRUMPY HUISHAN. WILL I BRING IN SOME FOOD AND A CHANGE OF CLOTHES FOR YOU? THE PINK DRESS IS YOUR BEST CHANCE IF YOU WANT TO MAKE A GOOD IMPRESSION. HE'S THIRTY-TWO. HE WENT TO TSINGHUA.
HUISHAN	MUM.
BAOHUA	NICE STRAIGHT TEETH AND HE OWNS A FLAT WITH DECENT SQUARE METERAGE. PLEASE MAKE AN EFFORT THIS TIME. SOME LIPSTICK BEFORE YOU LEAVE WORK. FOR YOUR FATHER AND I… WE WOULD BE VERY HAPPY IF THIS WORKS OUT.

HUISHAN has arrived at work. She stands in front of the tank.

A carp swims past and then her face changes when she sees the beluga in the tank.

THIRTEEN

KAIWEN waits before rehearsal. ALAN arrives.

KAIWEN	Hey.

ALAN	Hey. I got your message.
KAIWEN	But you didn't come last night.
ALAN	No.

KAIWEN moves close to ALAN.

KAIWEN	Because of what happened at my place?
ALAN	Yeah.
KAIWEN	It really doesn't matter.
ALAN	Cool.
KAIWEN	Forget it Alan. I forgive you.
ALAN	You forgive me? What for?
KAIWEN	For how you treated me. You led me on and then you freaked out and left. It felt kind of shitty but maybe you're right. We shouldn't mix things up. And now you're back.
ALAN	I/
KAIWEN	And I can't find anyone to do Fong's role. I really need you.
ALAN	I can't do that.
KAIWEN	It'd mean a lot to me.
ALAN	Sorry but I won't do your play.
KAIWEN	You're just moving cakes and presents around on stage.
ALAN	Is that what it is now? Because the way you've been carrying on you'd think it was something different.
KAIWEN	It was meant to be.

ALAN You know what I was going to tell
 you I'll do the sound but I can't be
 involved in this. And it's not about
 being attacked by the pc squad
 because I'm not Chinese. It's about
 you.

KAIWEN Me?

ALAN I don't do this sort of shit. Games of
 forgiveness and…

KAIWEN Let's forget the other night
 happened. We'd been drinking.

 I'm just asking you to do a small
 part in my play. For one night.

ALAN And I said I won't.

KAIWEN You only got involved because you
 wanted to fuck me.

ALAN That's not true.

KAIWEN And then you find out I have a
 boyfriend and you can't cope.

ALAN You think that this is about him?

KAIWEN Yes.

ALAN It was a casual thing for me. Why
 would your boyfriend worry me?

KAIWEN Then what is it?

ALAN It's you.

KAIWEN Me?

ALAN It's the way you manage people.

KAIWEN Manage people? What does that
 mean?

ALAN shakes his head.

Say.

ALAN

Have you wondered why the actors keep dropping out? I mean you have all this ambition to be a director and maybe you have some great vision...but when you don't get your way, you yell and stamp your feet.

Manage, manipulate call it what you like, I've seen it's what you do. Like what you just did then – telling me you forgive me.

KAIWEN

I don't know what you're talking about.

ALAN

You twist things around. I did nothing that needs to be forgiven. I liked you. I went back with you to have a bit of fun but it got complicated.

KAIWEN

Sorry I'm not as simple as all the other fucks you have.

ALAN

You don't know anything about me.

KAIWEN

And you don't know me.

ALAN

But I saw you even if you didn't want me to. I saw a sad lost little boy who is afraid to be alone. You want to keep people near but only on your terms, so you pull them in and you push them away.

KAIWEN

That's not true.

ALAN	You only wanted me there because you didn't want to be alone.
	It didn't matter who I was. You're too involved in yourself to notice.
KAIWEN	Who do you think you are, coming in and saying you can help me and offer advice about the show I'm directing. What would you know?
ALAN	I was trying to help you.
KAIWEN	I don't need your help or your offers or advice. I'm better than you'll ever be and this play isn't about you.
ALAN	I know. It's about you and you can't even see it. You don't even know who you are, so how could you?
	And I can't help you with that, Kaiwen. No one can.

FOURTEEN

HUISHAN returns from the date in her pink dress.

HUISHAN	DID YOU HAVE TO CALL ME IN THE MIDDLE OF THE DATE? I THOUGHT…
BAOHUA	WHAT? I'M FINE.

HUISHAN gets close to BAOHUA.

WHY ARE YOU STANDING SO CLOSE TO ME? DON"T CROWD ME JUST TELL ME ABOUT LUIWEI.

HUISHAN moves away.

HUISHAN	HE LOOKED JUST LIKE HIS PHOTOGRAPH.
BAOHUA	DID HE PAY?
HUISHAN	I PAID FOR MYSELF.
BAOHUA	BUT HE OFFERED TO PAY?
HUISHAN	I WANTED TO PAY FOR MYSELF.
BAOHUA	TELL ME...
HUISHAN	HE WAS NICE. WE HAD A LOT IN COMMON.
BAOHUA	YOU BOTH WATCH THAT CAT?

HUISHAN rolls her eyes.

HUISHAN	YES. BUT NOT JUST THAT. HIS GRANDFATHER SPENDS HIS TIME IN THE PARK TRYING TO SET HIM UP. HIS PARENTS SPENT YEARS TRYING TO KEEP HIM APART FROM GIRLS AND NOW THEY'RE OBSESSED WITH MATCHING HIM UP.
	THEY'RE ALSO ASHAMED OF HIM. HIS MOTHER'S AT HIM TO LOWER HIS STANDARDS, WHICH I IMAGINE IS THE REASON HE AGREED TO MEET ME. HE STUDIED SOMETHING HE NEVER WANTED TO DO AND NOW HE HAS TO DRAG HIMSELF TO WORK EVERY DAY AND ENDURE IT SO HE CAN GO HOME AND GET MORE PRESSURE FROM HIS MOTHER WHO THINKS HE'S A LOSER WHO WILL NEVER

	EARN ENOUGH MONEY TO CARE FOR HER IN HER OLD AGE.
BAOHUA	HE SOUNDS LIKE YOUR PERFECT MATCH.
HUISHAN	HE SMOKES A LOT.
BAOHUA	SO WHAT?
HUISHAN	IT'S MADE HIS SKIN GREY.
BAOHUA	HE CAN STOP SMOKING AND IT'LL BE FINE.
HUISHAN	WHEN I LOOKED INTO HIS EYES I FELT NOTHING. AND HE FELT NOTHING WHEN HE LOOKED AT ME.
BAOHUA	BOO HOO. WHAT DID YOU BOTH EXPECT?
HUISHAN	HE HAS A GUT AND NEEDS TO EXCERCISE. HE POINTED OUT THAT I AM TOO SHORT.
BAOHUA	WHY DOES HE NEED SOMEONE TALL?
HUISHAN	THERE WAS NO ATTRACTION. ONCE WE AGREEED ON THAT WE WERE FREE TO TALK ABOUT ALL SORTS OF THINGS.
BAOHUA	WHAT A WASTE OF TIME.
HUISHAN	AND MONEY. THAT PLACE GRANDAD CHOSE ISN'T CHEAP, MA.
BAOHUA	//HE SHOULD HAVE PAID.

HUISHAN //AT LEAST IT WAS CLOSE
TO WORK. LUIWEI MET
ME THERE AND SAW THE
BELUGA THEY INSTALLED
TODAY. THEY HAVEN'T
ADVERTISED, SO IT ISN'T
AS BUSY YET. I THOUGHT
LUIWEI'D BE GRATEFUL
FOR THE CHANCE TO SEE
IT UP CLOSE WITHOUT THE
CROWDS BUT A BUSLOAD
OF TOURISTS FROM GANSU
ARRIVED AND STARTED
SNAPPING PHOTOS OF IT
STARING OUT. THE FLASHES
UPSET IT, BUT IT DIDN'T
BLINK. WE HAD A DEBATE
ABOUT WHETHER WHALES
CAN BLINK. DO YOU KNOW?

WE WATCHED THE WHALE
FOR AGES BUT IN THE END
LUIWEI WAS AS CONFUSED
AS ME ABOUT WHY IT'S
THERE IN A TANK IN THE
FOYER OF THE GRAND
PALACE HOTEL.

BAOHUA THE LAST THING YOU WANT
TO DO IS MAKE TROUBLE
AND JEPORDIZE YOUR JOB.

HUISHAN WE WENT TO KARAOKE
AFTER THE RESTAURANT. HE
HAD TO MEET SOME FRIENDS
THERE AFTER THE DATE...

BAOHUA *YOU* DIDN'T SING?

HUISHAN THERE WAS A TALL GIRL
THERE WHO SEEMS TO LIKE

	LUIWEI. A SMOKER. SHE KEPT LIGHTING HIS CIGARETTES FOR HIM. IT WAS TOUCHING WATCHING THEM PUFFING AWAY. SHE KEPT STARING AT HIM. SHE WANTED TO DO A DUET WITH HIM. BUT LUIWEI DOESN'T SING. SHE WENT TO THE BATHROOM AND I TOLD LUIWEI SHE WAS PERFECT.
BAOHUA	WHY?
HUISHAN	IT WAS TRUE. BUT THEN LUIWEI TOLD ME HE'S A-SEXUAL.
BAOHUA	WHY ON EARTH IS HE TELLING YOU THAT?
HUISHAN	HE FELT THAT HE COULD.

BAOHUA shakes her head in disapproval.

BAOHUA	ARE YOU TRYING TO UPSET ME?
HUISHAN	LUIWEI'S TRAVELLED A LOT. YOU SHOULD HEAR WHAT HE HAS TO SAY ABOUT AUSTRALIA.
BAOHUA	I THINK I'VE HEARD ENOUGH NOW.
HUISHAN	HE'S SPENT A LOT OF TIME IN MELBOURNE. I WAS THINKING THAT MAYBE HE PASSED KAIWEN ONE DAY IN THE STREET.
BAOHUA	YOU TOLD HIM ABOUT KAIWEN?

| HUISHAN | IT'S WHAT I DO ISN'T IT? AND WHY SHOULDN'T I NOW? |

BAOHUA gets up to go to bed.

	ON THE WALK BETWEEN THE RESTAUARNT, SOMETHING STRANGE HAPPENED.
BAOHUA	WHAT DO YOU MEAN?
HUISHAN	I THINK IT WAS SEEING THAT WHALE IN THE TANK. BECAUSE IT LOOKS SO OUT OF PLACE. IT AFFECTED ME ALL DAY. I WAS LUCKY LUIWEI WAS THERE BECAUSE I WENT WOBBLY AND HE HELD ME UP. HE ASKED ME WHAT WAS WRONG AND I TOLD HIM ABOUT JIAKE AND KAIWEN AND HOW I FEEL TRAPPED LIKE THAT WHALE.
BAOHUA	WHY WOULD YOU SAY STUFF LIKE THAT TO A STRANGER?
HUISHAN	NOBODY ELSE WANTS TO TALK ABOUT ANYTHING. IT JUST CAME OUT.
BAOHUA	NO WONDER HE DOESN'T FIND YOU ATTRACTIVE.
HUISHAN	HE OFFERED ME ONE OF HIS CIGARETTES. I DON'T SMOKE. I HATE SMOKING BUT I HAD FIVE.
BAOHUA	WHY?
HUISHAN	I WANTED YOU TO SMELL IT ON ME.

BAOHUA	WHY?
HUISHAN	SO YOU WOULD REACT.
BAOHUA	WHAT WOULD I CARE NOW? YOU'VE MISSED THE BOAT. SMOKE ALL YOU WANT.
HUISHAN	YOU ARE IN DENIAL ABOUT WHAT'S GOING ON.
BAOHUA	I DIDN'T WAIT UP FOR THIS. I'M GOING TO BED.
HUISHAN	IT WON'T GO AWAY. I DON'T UNDERSTAND WHY YOU DON'T WANT TREATMENT. WHY WON'T YOU DO SOMETHING? WHY DON'T YOU LISTEN TO ANYONE?
BAOHUA	WHY DON'T YOU STOP YELLING AT ME?
HUISHAN	I...
BAOHUA	IT'S MY DECISION NOT YOURS! AND YOU SHOULD BE ASHAMED OF YOURSELF. YELLING AT ME LIKE THAT.
HUISHAN	IT'S BECAUSE I CARE.
BAOHUA	YOU HAVE A FUNNY WAY OF SHOWING IT. EVERYTHING WE WANT FOR YOU YOU SET OUT TO DESTROY. AND IT'S BECAUSE YOU ARE TOO BUSY MEDDLING IN EVERYONE ELSE'S LIFE.
HUISHAN	MEDDLING? I'M TRYING TO BE THERE FOR YOU.

BAOHUA	YOU KNOW WHAT I WANT FOR YOU AND IT ISN'T THIS. WHAT IS WRONG WITH YOU?
HUISHAN	I DON'T KNOW.
BAOHUA	WHAT HAPPENED TO YOU TO THAT BRIGHT LITTLE GIRL?
HUISHAN	SHE'S GONE.
BAOHUA	WELL, FIND HER AGAIN.
HUISHAN	I CAN'T.
BAOHUA	NOT TRUE.
HUISHAN	IT IS.
BAOHUA	I HAVE ALWAYS LOVED YOU.
HUISHAN	I'M NOT SAYING YOU DON'T. AFTER YOU LEFT KAIWEN IN HONG KONG YOU WERE NEVER THE SAME.

AND I ALWAYS FEEL
LIKE I HAVE TO ATONE.
FOR BEING FIRST BORN.
FOR BEING A GIRL. FOR
TELLING THAT GIRL ABOUT
KAIWEN AND THEN BEING
A DISAPPOINTMENT IN
ALMOST EVERYTHING
AFTER THAT. AND BECAUSE
OF THAT I FEEL LIKE I HAVE
TO DO EVRYTHING RIGHT
AND ALL YOU DO IS MAKE
ME FEEL LIKE IT'S WRONG
BECAUSE ALL YOU WANT IS
TO BE NEAR YOUR SON.

This wounds BAOHUA.

THIS GIRL AT WORK HAS JUST HAD A BOY.

BAOHUA DON'T TALK ABOUT HER.

HUISHAN LISTEN!

NOW THAT THEY'VE ANNOUNCED SHE CAN HAVE A SECOND I ASKED HER IF SHE WOULD DO IT. AND SHE SAYS SHE WON'T HAVE A SECOND BECAUSE SHE'S WORRRIED SHE COULDN'T DIVIDE HER LOVE LIKE THAT. SHE COULDN'T SHARE IT. IS THAT HOW IT WAS FOR YOU? I KNOW YOU WOULD NEVER SAY IT, BUT IS IT? SHE SAID SHE CAN'T DO IT BECAUSE THERE WOULD ALWAYS BE ONE WHO FELT MORE LOVED, NO MATTER HOW HARD SHE TRIED TO MAKE IT FEEL DIFFERENTLY.

BAOHUA THAT'S NONSENSE.

HUISHAN I ASKED HER ABOUT THE SHIDU. ALL THOSE PEOPLE WHO LOST THEIR ONLY ONE. ALL THOSE PARENTS IN PLACES LIKE SICHUAN AND SHE SHRUGGED AND TOLD ME SHE LIVES IN THE CITY AND THINGS HAVE CHANGED. SHE WOULD RATHER PUT EVERYTHING SHE HAS INTO ONE AND RISK IT ALL THAN HAVE TO DIVIDE HERSELF LIKE THAT.

BAOHUA

I NEVER WANTED THAT FOR YOU OR KAIWEN. I NEVER WANTED TO SEND EITHER OF YOU AWAY. YOU DO KNOW THAT?

HUISHAN

HOW COULD I?

BAOHUA

DO YOU THINK IT WAS EASY FOR ME? THAT DAY I TOOK YOU TO THE STATION TO SEND YOU TO YOUR GRANDMOTHER'S...

YOUR FATHER BLAMED ME FOR THE PREGNANCY. HE MADE THE PLANS AND I COULDN'T SAY NO TO HIM YOU KNOW WHAT HE'S LIKE. THE NIGHT BEFORE I WAS DUE TO TAKE YOU ON THE TRAIN, WE HAD A TERRIBLE FIGHT AFTER YOU'D GONE TO BED.

HUISHAN

I REMEMBER IT WOKE ME UP. I GOT OUT OF BED AND SAW HIM HIT YOU.

This affects BAOHUA.

She has never acknowledged this happened, even to herself.

BAOHUA

I WANTED TO TAKE YOU AND RUN AWAY. I WAS GOING TO GO TO HONG KONG AND HIDE BUT I LAY AWAKE ALL NIGHT TRYING TO FIGURE OUT HOW I COULD MAKE THINGS WORK. YOUR FATHER MUST HAVE SENSED IT BECAUSE THE NEXT

MORNING WHEN I WENT TO
TAKE YOU TO THE STATION
HE CAME AS WELL AND HE
TOOK THE TICKET AND
SAID HE WOULD TAKE YOU
INSTEAD OF ME. I INSISTED
I GO WITH HIM TO SEE
YOU OFF. WE WERE ON THE
TRAIN AND I COULDN'T
LEAVE YOU WITH HIM. YOUR
FATHER TOLD ME TO GET
OFF THE TRAIN AND GO
HOME. I COULDN'T BRING
MYSELF TO GO. THE GUARD
CAME AND YOUR FATHER
MADE A SCENE. HE TOLD
THE GUARD THAT HE DIDN'T
KNOW WHO I WAS AND
THAT I WOULDN'T LEAVE
HIM AND HIS DAUGHTER
ALONE. I COULDN'T BELIEVE
IT. I DIDN'T KNOW WHAT
TO DO. I BEGAN TO CRY
AND THEY DRAGGED ME
OFF THE TRAIN, I COULD
HEAR YOU SCREAMING AS I
STUMBLED TO MY FEET ON
THE PLATFORM BUT YOU
WERE GONE. I WATCHED
THE TRAIN DISAPPEAR AND I
HAVE NEVER FELT SO EMPTY.

IT IS ME WHO SHOULD
ATONE.

I'VE SPENT TOO MUCH TIME
APART FROM YOU AND YOUR
BROTHER. THERE HAVE
BEEN TOO MANY GOODBYES.

HUISHAN	MUM…
BAOHUA	WHAT?
HUISHAN	THIS SICKNESS.
BAOHUA	IT'S NOTHING.
HUISHAN	IT'S SERIOUS.

BAOHUA sighs.

	IT ISN'T GOING TO GO AWAY. THE DOCTOR SAID THAT IT WILL GET WORSE. YOU'LL NEED TO BEGIN TREATMENT.
BAOHUA	NO.
HUISHAN	IF IT IS AS FAR ADVANCED AS SHE SAYS… YOU HAVE TO BEGIN IT SOON.
BAOHUA	I DON'T WANT TO. IT'S MY CHOICE.
HUISHAN	WE SHOULD TELL KAIWEN. HE NEEDS TO KNOW.
BAOHUA	HE DOES NOT.
HUISHAN	YOU MUST WANT TO SEE HIM.
BAOHUA	HE DOESN'T NEED TO KNOW.
HUISHAN	I BET IF HE TOLD YOU TO GET TREATMENT…
BAOHUA	I DONT WANT ANYONE ELSE TO KNOW. IT'S MY CHOICE. JUST SHUT UP ABOUT IT NOW, PLEASE.

HUISHAN	I'VE BEEN SHUT UP FOR A LONG TIME. I WON'T DO THAT NOW.
	LUIWEI TOLD ME ABOUT THE TEA TREE LAKES THEY HAVE IN AUSTRALIA.
BAOHUA	THE WHAT?
HUISHAN	THE TEA TREE LAKES.
	THE LEAVES FROM THE TEA LEAVES FALL INTO THE WATER AND THE TEA TREE OIL MAKES THE WATER BROWN AS TEA AND YOU CAN SWIM IN THE LAKE AND IT'S HEALING.
BAOHUA	IT SOUNDS AWFUL.
HUISHAN	WE COULD GO THERE.
BAOHUA	TO SOME BROWN LAKE?
HUISHAN	TO AUSTRALIA. TO SEE KAIWEN. TO SWIM IN THOSE LAKES. /TO
BAOHUA	HE'S STUDYING.
HUISHAN	MAYBE YOU'LL LISTEN TO HIM.
BAOHUA	IF YOU TELL HIM, I'LL…
HUISHAN	WHAT ELSE IS LEFT TO BE DONE?
BAOHUA	HE'S TOO BUSY.
HUISHAN	LET'S GO ANYWAY. YOU NEED TO SEE YOUR SON.

*BAOHUA **is about to argue with** HUISHAN **but she wants to go.***

FIFTEEN

*KAIWEN **waits for Fanny.***

KAIWEN

The day I arrived here I remember how hot it was.

I took a taxi from the airport to the middle of nowhere and the car stopped and the taxi driver said *here we are.*

Taxi drives off and I'm in the middle of a dead-end street, everything totally silent right in front of a wall with red graffiti that reads *Asians – go home.* I wish.

These birds watch me from the wires. And in that first week they are the only creatures that seem to notice me. These big black birds watching ready to what?

Rooms full of cockroaches and students all living the same way. I understand why people live like that but I don't want to, so I make a choice. Like my dad. I put things on the scales and I weigh them up.

The cat appears and watches.

I find out where to look, it doesn't take long. Works the same everywhere. I know what to look for. I can tell who's looking for me. I'm not ashamed. I just do what I need to do. Make the best of things. Like my mother and her mother

did before me. The choice becomes clear.

ALAN arrives.

ALAN	I haven't come back.
KAIWEN	Didn't think so.
ALAN	I thought I'd return this.

He passes over an air mask.

KAIWEN	Thanks.
ALAN	Yeah, don't need it in Melbourne.
KAIWEN	Not yet.
ALAN	How's it going?
KAIWEN	There's just me and Fanny now.
ALAN	Has she got any better?
KAIWEN	No. But it's too late to pull the piece even though there's not much left.
ALAN	Shit happens. CHUFEST'll be on again next year.
KAIWEN	Yeah.

KAIWEN turns to go.

ALAN	Kaiwen, I wanted to say sorry for what I said.
KAIWEN	Why? What you said was true.
ALAN	But it wasn't for me to say.

A pause.

	Is your boyfriend back?
KAIWEN	Tonight.

ALAN	That'll be nice.
KAIWEN	Yeah.
ALAN	He'll bring you back a sign.
KAIWEN	Yeah.
ALAN	Is he coming to the play?
KAIWEN	I hope not. Are you?
ALAN	There's a singles night at a club in the city. Promised my housemate I'd hold her hand.

KAIWEN nods.

So…break a leg. And say Ni Hao to Fanny.

KAIWEN watches ALAN go.

SIXTEEN

HUISHAN and BAOHUA on the plane.

BAOHUA	HOW'S YOUR DINNER?
HUISHAN	TASTES LIKE RUBBER.
BAOHUA	YOU AREN'T GOING TO FINISH IT?
HUISHAN	HELP YOURSELF.

BAOHUA takes it.

BAOHUA	*[Mouth full of food.]* I HAVE BEEN THINKING ABOUT THAT CAT.
	I SAW A WOMAN WATCHING IT AT THE AIRPORT.
HUISHAN	LOTS OF PEOPLE WATCH IT.

BAOHUA	SHE LOOKED PERFECTLY NORMAL.
HUISHAN	YEAH.
BAOHUA	THERE WAS NO TIME TO DO THINGS LIKE THAT WHEN I WAS YOUR AGE...
HUISHAN	YOU'RE ABOUT TO RETIRE.

BAOHUA nods.

WATCH A MOVIE OR SOMETHING MUM. THERE ARE SOME IN MANDARIN, LOOK.

BAOHUA doesn't notice HUISHAN put on her earphones and start a film.

BAOHUA WHEN YOU WERE A CHILD, I HUGGED YOU, DIDN'T I?

YOU FELT LOVED? IT'S JUST I WAS WONDERING IF IT'S ME. EVERYONE ELSE LOVES THIS CAT BECAUSE IT'S SO CUTE. I DON'T UNDERSTAND THAT. SO THIS MIGHT BE SOMETHING IN ME. SOMETHING ICY. COLD. BECAUSE I DON'T LOOK AT IT AND MELT.

MY MOTHER NEVER TOUCHED ME OR BOAJIA. I USED TO THINK SHE HATED US BOTH, SHE NEVER ONCE TOLD ME SHE LOVED ME. AND WHAT I DID TO YOU AND YOUR BROTHER...

HUISHAN laughs at the film and BAOHUA realises she hasn't been listening.

HUISHAN feels her mother's stare.

HUISHAN WHAT?

BAOHUA shakes her head and lets it go. She pretends she's falling asleep. HUISHAN puts a blanket over her and goes back to her film.

SEVENTEEN

KAIWEN is wrapped in a towel on the phone.

KAIWEN How was the flight? Oh yuck. That's
 not good. So you're in customs. Is
 it… Shame. I'm just getting in the
 shower.

 It's tonight, I told you that.

 It doesn't matter.

 No seriously. Come if you want but
 you're probably tired so…

The intercom buzzes.

 Are you pissing about with me? Did
 you forget to take your keys? Yeah,
 very funny, I'm buzzing you up.

 Yeah yeah. Well someone is. See
 you in a second.

KAIWEN tries to strike a sexy position. He sees himself in the mirror and adjusts and giggles to himself.

There is a knock at the door. KAIWEN looks confused.

He goes to the door.

HUISHAN is there holding a suitcase. KAIWEN cannot believe his eyes.

Huishan?

BAOHUA joins HUISHAN with a suitcase.

Mum.

BAOHUA	SURPRISE!
KAIWEN	What are you doing here?
HUISHAN	//What does it look like?
BAOHUA	//WHY AREN'T YOU DRESSED?
KAIWEN	Have I missed something?
HUISHAN	It's a surprise.
BAOHUA	YOU'VE GOTTEN FAT SON

KAIWEN realises he is shirtless and wrapped in a towel.

HUISHAN	Are you going to let us in?

They pass. KAIWEN gets a t-shirt. There are no hugs, nothing physical.

Nice place.

BAOHUA	DO YOU EVER SWEEP THE FLOORS? WHAT'S WITH THE SIGNS?
HUISHAN	Is your housemate here?
BAOHUA	WHICH ONE'S YOUR ROOM, I'LL PUT MY STUFF IN THERE.
KAIWEN	HANG ON. BOTH OF YOU STOP.

KAIWEN gets between HUISHAN and BAOHUA.

YOU BETTER LEAVE YOUR
STUFF IN THE HALL FOR THE
MOMENT.

BAOHUA puts down her bag.

BAOHUA I NEED THE BATHROOM I'M
 ABOUT TO BURST.

KAIWEN It's there.

BAOHUA goes.

 What in the hell are you doing here?

HUISHAN WE NEEDED TO SEE YOU.

KAIWEN Why didn't you warn me? You can't
 arrive here like this and expect to
 stay.

HUISHAN Where is your roommate?

KAIWEN Derek's on his way home.

HUISHAN Is all this stuff his?

 Where does he sleep?

KAIWEN Sis.

HUISHAN Where does he sleep?

KAIWEN points to the bedroom.

 There's only one bed.

KAIWEN nods.

HUISHAN But…you…you're.

KAIWEN Yes. I'm gay.

 You can't stay here.

KAIWEN's phone rings.

HUISHAN We have to.

KAIWEN You can see why you can't.

HUISHAN We've come all this way.

KAIWEN Without warning. How long are you
 here for?

HUISHAN Answer it.

KAIWEN It's Derek.

HUISHAN Good. Tell him he can't stay here.

KAIWEN What?

HUISHAN Tell your… *roommate* to stay
 somewhere else.

KAIWEN He lives here.

KAIWEN answers.

 I have to call you back.

KAIWEN and HUISHAN stare at each other.

HUISHAN This can't be. You have to have.
 You have to…

 This will hurt Mum and Dad they
 can't know this.

KAIWEN //Which is why you can't stay here.

HUISHAN //SHE CAN'T FIND OUT.

KAIWEN NOT LIKE THIS.

HUISHAN NO /NOT AT ALL

KAIWEN /Why did you come here?

HUISHAN IS IT BECAUSE THEY SENT
 YOU TO A BOYS' SCHOOL?

KAIWEN What?

HUISHAN Keep him away and we will figure
 out a plan.

The toilet flushes.

KAIWEN	I have to go out. My play is on tonight.
HUISHAN	Your play! I should have known.

BAOHUA comes out and they are hit by the smell.

BAOHUA	WHAT DO THEY PUT IN AIRLINE FOOD?
KAIWEN	And I have to go now.
	You'll have to come along.
HUISHAN	We just arrived.
KAIWEN	You can't stay here by yourselves. You'll have to come. We can figure out the rest after that. I HAVE TO GET DRESSED AND LEAVE NOW OR I'LL BE LATE.

KAIWEN gets dressed.

HUISHAN	But... WE'RE GOING OUT MA.
BAOHUA	NO. I'LL STAY HERE. THE BATHROOM IS A DISASTER.
KAIWEN	NO MA. YOU HAVE TO COME.
BAOHUA	WE JUST ARRIVED AND YOU ARE ALREADY YELLING AT ME.
KAIWEN	She'll need a jacket. And warn her what she's about to see.
HUISHAN	How can I do that?
KAIWEN	This was your idea, Huishan. I need you to help me.

KAIWEN goes.

BAOHUA	WHAT'S WRONG WITH HIM?

HUISHAN is still.

	HUISHAN? WHAT'S WRONG?
HUISHAN	Kaiwen has surprised me.
BAOHUA	WHAT?
HUISHAN	We are going to go to see a play.
BAOHUA	A PLAY?
HUISHAN	KAIWEN IS INVOLVED IN A PLAY AND/
BAOHUA	WHAT ARE YOU TALKING ABOUT? KAIWEN DOESN'T DO THINGS LIKE THAT.

KAIWEN returns.

| KAIWEN | Come on. |

They go.

EIGHTEEN

CHUFEST

KAIWEN stands alone on the stage.

| KAIWEN | WE WERE MAKING A PLAY CALLED LITTLE EMPERORS. YOU'RE MEANT TO BE WATCHING IT NOW. I WANTED TO EXPLORE THE BIGGEST SOCIAL EXPERIMENT IN THE HISTORY OF THE WORLD. TO SHOW WHAT A DISASTER IT HAS BEEN. NO STORIES OF WALLS OR RIVERS, NO PARAGONS. I SAID; LET'S TELL THE STORY OF THE GIRLS ALL OVER CHINA WHO |

NEVER EVEN GOT TO DRAW
BREATH. GIRLS DROWNED IN
RIVERS AND SLOP BUCKETS
BECAUSE THEY WEREN'T
BOYS. LET'S MAKE A LIST OF
KIDS WHO NEVER EVEN GOT
TO LOOK THEIR MOTHER
IN THE EYES, WHO NEVER
LEARNT TO READ, WHO
NEVER HAD ENOUGH TO EAT.
LET'S TALK ABOUT THE LIVES
OF CITY KIDS WHO WERE SO
INDULGED, SO PAMPERED,
THEY WERE NEARLY
SMOTHERED TO DEATH BY
TWO PARENTS AND FOUR
GRANDPARENTS, WHOSE
EVERY COMMENT WAS
SAVOURED AND REPEATED,
THEIR EVERY WISH
INDULGED. I WANTED TO
SHOW THE SPACE BETWEEN
ALL THESE THINGS.

I WANTED OTHERS TO
SHARE THEIR STORIES. BUT
NOBODY THOUGHT THEIR
STORIES FITTED THE BILL.

WHEN WE STARTED, THERE
WERE SIX ACTORS AND MY
GRAND VISION TO CHANGE
CHUFEST, TO TELL IT LIKE
IT REALLY IS. I DIDN'T WANT
TO DO SHAKESPEARE IN
TANGZHUANG OR SOME
OLD PLAY FROM CHINA.
I WANTED TO USE OUR
STORIES TO MAKE A PIECE

ABOUT OUR HOMELAND.
I WAS THE DIRECTOR AND
LOOKING BACK, I MADE A
LOT OF MISTAKES. I WANTED
THE PEOPLE WHO WERE
PART OF THE PROCESS TO
TELL ME THEIR STORIES.
I WANTED TO USE THEIR
STORIES TO MAKE THE PLAY.
I EXPECTED THEM TO OPEN
UP STRAIGHT AWAY AND
WHEN THEY DIDN'T, WHEN
THEY COULDN'T SPILL IT ALL
AND SHARE THEIR STORIES
I GOT FRUSTRATED WITH
THEM AND IN THE END I
SCARED THEM OFF SO THEY
DROPPED OUT ONE BY ONE.

SOME WENT TO DO
A PIECE THAT WAS
MORE ORGANISED AND
STRAIGHT-FORWARD. MORE
IMPORTANT.

BUT WHAT'S MORE
IMPORTANT THAN
REMEMBERING? WHAT'S
MORE IMPORTANT
THAN USING WHAT
YOU REMEMBER TO SAY
SOMETHING?

I WAS GOING TO SHOW
A LOT OF MOTHERS ON
STAGE. SILLY MOTHERS WHO
AGREED TO DO EVERYTHING
THE STATE TOLD THEM
TO DO NO MATTER HOW
MUCH IT HURT. MOTHERS

WHO AGREED TO DO
EVERYTHING HER HUSBAND
AND FAMILY AND CHILDREN
TOLD HER. I WANTED TO
SHOW YOU WHERE IT GOT
THEM. THE PAIN IT LEFT.
THE LAST ACTOR LEFT WAS
PLAYING HER BUT SHE
DIDN'T SHOW UP TONIGHT.

AND THEN TODAY, JUST
BEFORE I LEFT TO COME
HERE, MY OWN MOTHER
ARRIVED FROM BEIJING.

THE WOMAN I BLAME FOR
SO MANY THINGS. THE
WOMAN I IGNORE WHEN
SHE CALLS. THE WOMAN
WHO PRETENDS TO BELIEVE
I STILL STUDY ECONOMICS,
EVEN THOUGH I HAVEN'T
BEEN TO A CLASS IN OVER A
YEAR.

I HAVEN'T SEEN MY MOTHER
FOR SO LONG AND I LOOK
AT HER THERE AT THE
DOOR. THAT WOMAN WHO
IS TOUGH AS ALL CHINESE
MOTHERS ARE, THAT
WOMAN WHO I CAN'T TELL
SO MANY THINGS BECAUSE
IN MY HEAD SHE IS SO BIG
AND YET THERE AT MY
DOOR SHE LOOKS SO SMALL
AND FRAIL AND TIRED. SHE'S
OUT THERE WITH YOU BUT
DON'T LOOK AROUND IN
CASE SHE'S FALLEN ASLEEP.

AND I'M PLEASED TO SEE
YOU MUM BECAUSE ALL MY
LIFE I GOT SENT AWAY AND
ALL I WANTED WAS FOR YOU
TO ARRIVE AND TAKE ME
HOME. THAT'S MY STORY.

I'D LIKE TO SAY THAT THIS
SURPRISE VISIT WILL
CHANGE EVERYTHING.
THAT ME SAYING ALL THIS
TO HER WILL OPEN UP
COMMUNICATIONS WITH US
AFTER ABOUT EVERYTHING.
THAT WE CAN TAKE OFF FOR
A WEEK IN A CAR AND DRIVE
DOWN THE COAST AND
WHEN WE GET ABOUT AS
FAR AS GEELONG WE WILL
START TO TALK AND WE WILL
TALK ABOUT HER MUM AND
DAD AND THEIRS BEFORE
THEM. THAT WE WILL HAVE
LONG CONVERSATIONS AS
WE WALK ALONG THE BEACH
ABOUT EVERYTHING THAT'S
BEEN BEFORE. AND IT WILL
ALL MAKE SENSE LIKE OUR
FOOTPRINTS DO NEXT TO
ONE ANOTHER IN THE SAND.

BUT I'M CHINESE. WE'RE NOT
GOOD AT LOOKING BACK.

BUT WHEN I LOOK BACK ON
THIS PIECE, MY BIGGEST
MISTAKE WASN'T YELLING
AT PEOPLE WHEN THEY
MADE MISTAKES, OR HAVING
DELUSIONS OF GRANDEUR,

IT WAS FORGETTING ABOUT
MY OWN STORY, BECAUSE AT
THE BACK OF MY MIND BUT I
THOUGHT MY STORY DIDN'T
COUNT SO I DIDN'T SHARE
IT. AND I SHOULD HAVE.

I WAS BORN ON JUNE 4
1989. IT WAS A BUSY DAY IN
CHINA.

ON THE DAY I WAS BORN
THOUSAND OF PEOPLE'S
LIVES WERE TAKEN OR
DESTROYED. NEXT TO
THEIR STORIES, THE STORY
OF SOME BOY WHO WAS
BORN IN SECRET IN HONG
KONG AND COULDN'T GET
A HUKOU ISN'T MUCH.
MY EXPERIENCE OF THE
ONE-CHILD POLICY WAS
BEING LOCKED INSIDE.
IT WAS NEVER BEING
ACKNOWLEDGED BY MY
FATHER IN PUBLIC, IT WAS
FINDING OUT MY SISTER
HAD LET THE SECRET SLIP
IN A PLAYGROUND AND
GETTING SENT AWAY TO A
BOARDING SCHOOL AT AGE
SIX. IT IS BEING ENDLESSLY
LONELY WHICH IS FUNNY
BECAUSE I HAD THE SIBLING
SO MANY KIDS MY AGE
NEVER DID.

MY MUM AND MY SISTER
ALWAYS ASK ME WHERE IS
HOME TO YOU. THEY WANT

ME TO SAY BEIJING. BUT I'VE
NEVER BEEN ABLE TO LIVE
IN CHINA IN THE OPEN. I'VE
NEVER EVEN SEEN IT. THEY
WANT ME TO SAY HOME IS
BEIJING BECAUSE THAT IS
THEIR HOME. MAYBE I WANT
TO SAY THAT TOO: BUT I'M A
HEIHAIZI.

CAN A HEIHAIZI HAVE A
HOME OR ARE WE JUST
MORE UNACKNOWLEDGED
LOST CHINESE SOULS? IS
THIS PLACE HOME FOR
ME? THIS CITY OF TRAMS
AND AFL, HIPSTERS AND
COFFEE AND OVERPRICED
DUMPLINGS? CAN ONE OF
CHINA'S GHOST CHILDREN
FIND A HOME HERE?

I BETTER GET OFF STAGE
NOW.

Stage manager's waving, sorry
Hannah.

I'm sorry you didn't get to see Little
Emperors as I imagined it.

So…there will be a break before we
continue with CHUFEST. There
is tea and snacks available in the
front of the theatre. The campus is
non-smoking but you can just stand
around the side. Everyone else
does. Thanks for listening.

NINETEEN

HUISHAN finds KAIWEN.

KAIWEN	WHERE'S MUM?
HUISHAN	BATHROOM.
KAIWEN	AGAIN. IS SHE OK?
	DID SHE SEE IT?
HUISHAN	SOME OF IT MAYBE.
KAIWEN	SHE FELL ASLEEP?
HUISHAN	IN AND OUT. SHE STAYED AWAKE FOR THE FIRST ONE BUT THE SECOND WAS QUITE LONG. THE GUY WHO PLAYED MAO WAS VERY GOOD. BY THE TIME YOURS CAME UP...
KAIWEN	SHE DIDN'T SEE IT.
HUISHAN	I THINK IT'S FOR THE BEST. I KNOW YOU WANT HER TO KNOW ALL THOSE THINGS ABOUT YOU BUT... NOT THAT WAY.
KAIWEN	I didn't mean for it to come out that way.
HUISHAN	If you want her to know...
KAIWEN	There are better ways to tell.
HUISHAN	Yes.
	I didn't expect this city to be cold.

They stand there for a moment.

I know we can't stay with you.

KAIWEN I've been trying to figure out what we can say to explain to Mum about that.

HUISHAN Me too.

KAIWEN Tell her the truth or/

HUISHAN Not yet. Not…

KAIWEN Then…

HUISHAN Did you mean what you said about getting away?

KAIWEN Taking a drive?

HUISHAN You could get a car.

KAIWEN Go down the coast.

HUISHAN You and Mum could walk on the beach. You can tell her whatever you want there. And she can tell you.

KAIWEN What about you?

HUISHAN I can get a hotel room here.

KAIWEN No. You should come too. We should do this together.

HUISHAN smiles.

You know, I really wanted to come home.

HUISHAN All the things you said on the stage. There are so many questions I have to ask you.

KAIWEN Same.

HUISHAN We can figure out what to say to Mum.

KAIWEN	Yes. You know at this time of year there are whales?
HUISHAN	In the sea?
KAIWEN	No, in the fields.
	She's taking her time.
HUISHAN	Be patient. For now just being here with you is fine.
	What you said. What you tried to do. I think it was brave. I'm proud of you Kaiwen.

HUISHAN is bursting with love and pride and wants to express this physically.

She grabs her brother in an embrace. KAIWEN doesn't know what to do at first but very slowly reciprocates.

BAOHUA appears behind them. She watches KAIWEN and HUISHAN in a rare moment together. The embrace is long and warm.

BAOHUA stays where she is and watches it from a distance.

The cat appears behind them and stares out.

KAIWEN and HUISHAN release one another and they turn and see BAOHUA, go to her and leave.

The cat stares at us.

The cat turns into a panda.

The panda blinks and watches us as the lights fade.

By the same author

The Trouble with Harry
9781783190829

M. Rock
9781783191123

WWW.OBERONBOOKS.COM

Follow us on Twitter @oberonbooks
& Facebook @OberonBooksLondon